# TEKNO LOGICAL

THE PEPIN PRESS / AGILE RABBIT EDITIONS
AMSTERDAM & SINGAPORE

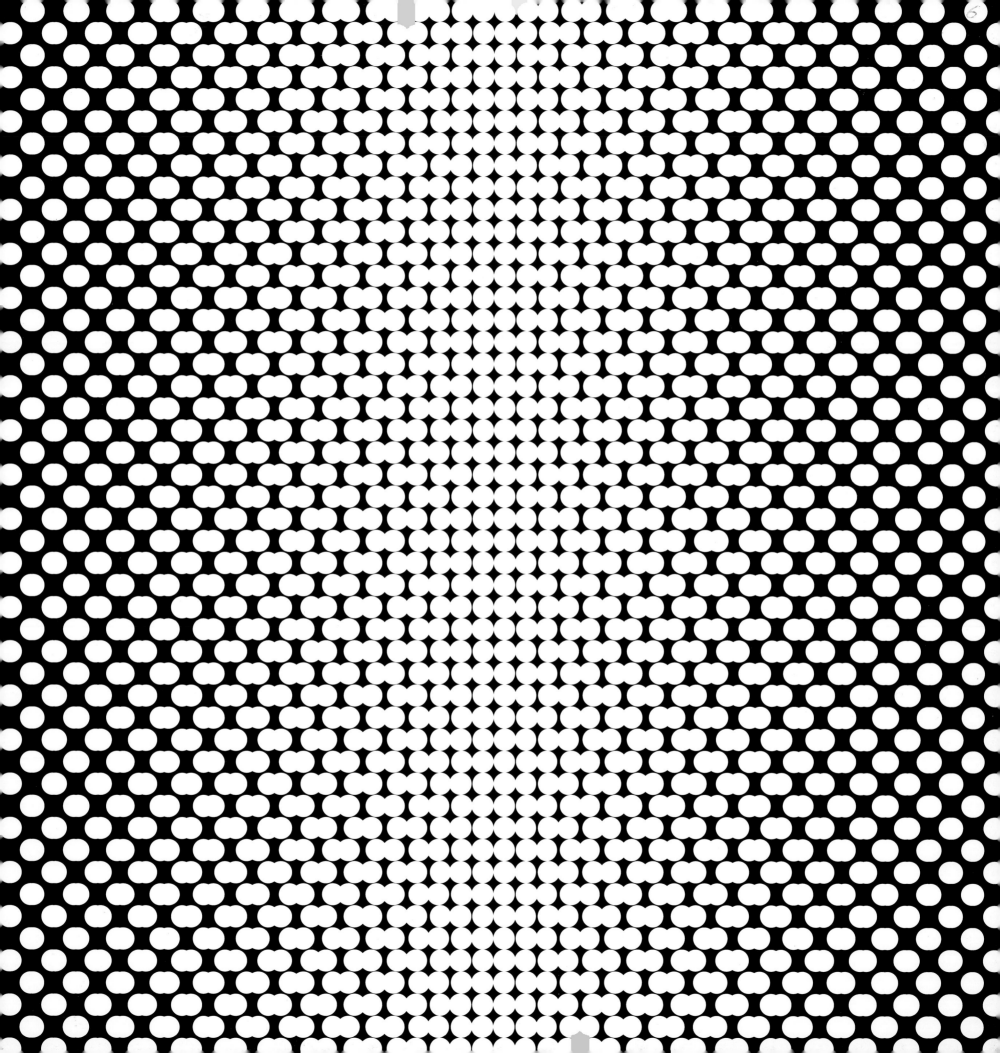

# The Pepin Press – Agile Rabbit Editions

Tekno Logical

**Graphic Themes & Pictures**

| | |
|---|---|
| 90 5768 001 7 | 1000 Decorated Initials |
| 90 5768 003 3 | Graphic Frames |
| 90 5768 007 6 | Images of the Human Body |
| 90 5768 012 2 | Geometric Patterns |
| 90 5768 014 9 | Menu Designs |
| 90 5768 017 3 | Classical Border Designs |
| 90 5768 055 6 | Signs & Symbols |
| 90 5768 024 6 | Bacteria And Other Micro Organisms |
| 90 5768 023 8 | Occult Images |
| 90 5768 046 7 | Erotic Images & Alphabets |
| 90 5768 062 9 | Fancy Alphabets |
| 90 5768 056 4 | Mini Icons |
| 90 5768 016 5 | Graphic Ornaments (2 CDs) |
| 90 5768 025 4 | Compendium of Illustrations (2 CDs) |
| 90 5768 021 1 | 5000 Animals (4 CDs) |

**Textile Patterns**

| | |
|---|---|
| 90 5768 004 1 | Batik Patterns |
| 90 5768 030 0 | Weaving Patterns |
| 90 5768 037 8 | Lace |
| 90 5768 038 6 | Embroidery |
| 90 5768 058 0 | Ikat Patterns |

**Miscellaneous**

| | |
|---|---|
| 90 5768 005 x | Floral Patterns |
| 90 5768 052 1 | Astrology |
| 90 5768 051 3 | Historical & Curious Maps |
| 90 5768 061 0 | Wallpaper Designs |
| 90 5768 066 1 | Atlas of World Mythology |

**Styles (Historical)**

| | |
|---|---|
| 90 5768 027 0 | Mediæval Patterns |
| 90 5768 034 3 | Renaissance |
| 90 5768 033 5 | Baroque |
| 90 5768 043 2 | Rococo |
| 90 5768 032 7 | Patterns of the 19th Century |
| 90 5768 013 0 | Art Nouveau Designs |
| 90 5768 060 2 | Fancy Designs 1920 |
| 90 5768 059 9 | Patterns of the 1930s |

**Styles (Cultural)**

| | |
|---|---|
| 90 5768 006 8 | Chinese Patterns |
| 90 5768 009 2 | Indian Textile Prints |
| 90 5768 011 4 | Ancient Mexican Designs |
| 90 5768 020 3 | Japanese Patterns |
| 90 5768 022 x | Traditional Dutch Tile Designs |
| 90 5768 028 9 | Islamic Designs |
| 90 5768 029 7 | Persian Designs |
| 90 5768 036 X | Turkish Designs |
| 90 5768 042 4 | Elements of Chinese & Japanese Design |

**Photographs**

| | |
|---|---|
| 90 5768 047 5 | Fruit |
| 90 5768 048 3 | Vegetables |
| 90 5768 057 2 | Body Parts |
| 90 5768 067 x | Images of the Universe |

**Web Design**

| | |
|---|---|
| 90 5768 018 1 | Web Design Index 1 |
| 90 5768 026 2 | Web Design Index 2 |
| 90 5768 045 9 | Web Design Index 3 |
| 90 5768 063 7 | Web Design Index 4 |
| 90 5768 068 8 | Web Design Index 5 |

**Folding & Packaging**

| | |
|---|---|
| 90 5768 039 4 | How To Fold |
| 90 5768 040 8 | Folding Patterns for Display & Publicity |
| 90 5768 044 0 | Structural Package Designs |
| 90 5768 053 x | Mail It! |
| 90 5768 054 8 | Special Packaging |

**More titles in preparation**

In addition to the Agile Rabbit series of book+CD-ROM sets, The Pepin Press publishes a wide range of books on art, design, architecture, applied art, and popular culture.

Tekno Logical is a design studio based in Amsterdam. The studio specializes in graphic and web design, as well as in digital imaging and visual art.

For more information visit www.teknological.tk

# Copyright

# Contents

The Pepin Press BV
P.O. Box 10349
1001 EH Amsterdam
The Netherlands

Tel +31 20 4202021
Fax +31 20 4201152
mail@pepinpress.com
www.pepinpress.com

ISBN 90 5768 065 3

Book designed by Pepin van Roojen
Texts by Jakob Hronek and Pepin van Roojen

10 9 8 7 6 5 4 3 2 1
2010 09 08 07 06 05 04

Manufactured in Singapore

# Introduction

Jakob Hronek was born in Vienna, Austria in 1972. After studying Physics at the University of Applied Technologies in Vienna, he followed his passion for harmonious, geometric design and pursued an education in graphic design and digital imaging. In 1998, he founded Sheherazade, a design studio specializing in web design, advertising and games.

In 1999, he moved to Amsterdam and established Tekno Logical. In addition to graphic and web design, this studio creates various forms of digital imaging and visual art. Jakob's desire for creative freedom led to a greater focus on the latter activities, in which he combines his scientific training with a distinctive artistic vision.

The series of digitally-conceived designs in this book have been exhibited in several European cities. Furthermore, Jakob uses them as backdrops, slide shows, and video projections for different types of events and modern theatre.

## Book and CD-ROM
This book contains images for use as a graphic resource or simply for inspiration. The illustrations are stored on the enclosed CD-ROM and can be used in many types of applications. The CD-ROM comes free with this book and is not sold separately. The publishers accept no responsibility should the CD-ROM not be compatible with your system.

For commercial and/or professional use of the files contained on the CD – including any type of printed or digital publication – permission must be obtained from The Pepin Press/Agile Rabbit Editions.

# Einführung

Jakob Hronek wurde 1972 in Wien, Österreich geboren. Nach einem Physikstudium an der Technischen Universität Wien, folgte er seiner Passion für harmonische Strukturen und geometrische Formen und absolvierte eine Ausbildung in Grafik, Design und digitaler Bildbearbeitung. 1998 gründete er das Designstudio Sheherazade mit Webdesign, Werbung und Spielen als Schwerpunkten.

1999 ging er nach Amsterdam und startete dort das Studio Tekno Logical. Zusätzlich zu Grafik- und Webdesign bietet dieses Studio digitale Bildbearbeitung und bildende Kunst in verschiedenen Formen an.

Seinen Drang nach kreativer Freiheit zeigt Jakob Hronek ganz besonders bei den beiden letzteren Aktivitäten, wobei er seine wissenschaftliche Ausbildung mit seinen prägnanten künstlerischen Visionen kombinieren kann.

Die Serien der digital konzipierten Designs in diesem Buch sind in verschiedenen europäischen Städten ausgestellt worden. Außerdem verwendet Jakob Hronek sie als Hintergrundmaterial, Diashows und Videoprojektionen für Events und moderne Theaterprojekte.

## Buch und CD-ROM
Dieses Buch enthält Bilder, die als Ausgangsmaterial für graphische Zwecke oder als Anregung genutzt werden können. Die Abbildungen sind auf der beiliegenden CD-ROM gespeichert und eignen sich für eine Vielzahl von Anwendungen. Die CD-ROM wird kostenlos mit dem Buch geliefert und ist nicht separat verkäuflich. Der Verlag haftet nicht für Inkompatibilität der CD-ROM mit Ihrem System.

Die Bilder dürfen ohne Genehmigung von The Pepin Press/Agile Rabbit Editions nicht für kommerzielle oder sonstige professionelle Anwendungen einschließlich aller Arten von gedruckten oder digitalen Medien eingesetzt werden.

# Introduction

Jakob Hronek est né à Vienne, en Autriche, en 1972. Après des études de physique à l'université de technologies appliquées de Vienne, il s'adonne à sa passion pour l'harmonie et le dessin géométrique et poursuit une formation en arts graphiques et imagerie numérique. En 1998, il fonde Sheherazade, un studio indépendant de création spécialisé dans la conception de sites Web, la publicité et les jeux.

En 1999, il part pour Amsterdam et crée Tekno Logical. Outre les arts graphiques et la conception de sites, ce nouveau studio est consacré à diverses formes d'imagerie numérique et d'arts visuels. L'enthousiasme de Jakob pour la liberté de création le conduit à se concentrer surtout sur ces dernières activités qui lui permettent de combiner sa formation scientifique à une vision artistique sensible.

Les séries de motifs conçus numériquement qui apparaissent dans cet ouvrage ont été exposées dans plusieurs villes européennes. Jakob s'en sert également comme toiles de fond, lors de diaporamas et de projections vidéo pour diverses manifestations artistiques et expériences de théâtre moderne.

## Livre et CD-ROM
Cet ouvrage renferme des illustrations destinées à servir de ressources graphiques ou d'inspiration. Elles sont stockées sur le CD-ROM inclus et peuvent servir à de multiples applications. Le CD-ROM est fourni gratuitement avec le livre, mais ne peut être vendu séparément. L'éditeur décline toute responsabilité si ce CD n'est pas compatible avec votre ordinateur.

Pour les applications de type professionnel et/ou commercial (y compris les publications numériques ou imprimées), il est impératif d'obtenir une autorisation préalable de The Pepin Press/Agile Rabbit Editions.

# Introducción

Jakob Hronek nació en 1972 en Viena, Austria. Tras estudiar Física en la Universidad de Ciencias Aplicadas de su ciudad natal y movido por su pasión por el diseño armónico y geométrico, completó su formación realizando estudios de diseño gráfico y fotografía digital. En 1998 fundó Sheherazade, un estudio especializado en diseño de páginas web, publicidad y juegos.

En 1999 se trasladó a Amsterdam y creó Tekno Logical, una empresa que además de ofrecer diseño gráfico y de páginas web se dedica a la creación de imagen digital y arte visual. El deseo de libertad creativa de Jakob ha hecho de estos dos últimos campos el centro de su actividad y en ellos ha combinado su formación científica con su particular concepción del arte.

Las series de diseños digitales incluidos en este libro han sido expuestas en varias ciudades europeas y utilizadas como telones de fondo, pases de diapositivas o proyecciones de vídeo en diferentes tipos de eventos y obras de teatro modernas.

## Libro y CD-ROM
Este libro contiene imágenes que pueden servir como material gráfico o simplemente como inspiración. Además, en el CD-ROM adjunto se encuentran los archivos de las ilustraciones, que pueden importarse a diferentes tipos de programas. El CD-ROM es gratuito y no puede venderse por separado. Los editores no asumen ninguna responsabilidad en el caso de que el CD no sea compatible con su sistema operativo.

Para aplicaciones de tipo profesional o comercial de los archivos contenidos en el CD (incluido cualquier tipo de publicación impresa o digital), es necesario obtener la autorización previa de The Pepin Press/Agile Rabbit Editions.

# Introduzione

Jakob Hronek è nato a Vienna, Austria, nel 1972. Ha studiato Fisica all'Università delle tecnologie applicate di Vienna, quindi ha seguito la sua passione per il design armonico e geometrico continuando la sua formazione nel design grafico e trattamento digitale delle immagini. Nel 1998 ha creato Sheherazade, uno studio di design specializzato in web design, pubblicità e giochi. Nel 1999 si è trasferito ad Amsterdam dove ha costituito Tekno Logical. Oltre al web design e design grafico, questo studio offre varie alternative di trattamento digitale delle immagini e di arte visuale. Il bisogno impellente di raggiungere la libertà crea-tiva fa sì che Jakob si dedichi con maggiore interesse alle attività precedentemente menzionate, in cui combina la sua formazione scientifica con una visione artistica particolare che è il suo tratto distintivo.

La serie di disegni creati con tecniche digitali presenti in questo libro sono stati esposti in molte città europee. Jakob, inoltre, li usa come fondali in rappresentazioni di teatro moderno e come diapositive e proiezioni video in occasione di diversi eventi.

## Libro e CD-ROM

Questo libro contiene immagini che possono essere utilizzate come risorsa grafica o come fonte d'ispirazione. Le illustrazioni sono contenute nel CD-ROM allegato e possono essere utilizzate per diverse finalità. Il CD-ROM è gratuito e non può essere venduto separatamente. L'editore non può essere ritenuto responsabile qualora il CD non fosse compatibile con il sistema posseduto.

Per l'utilizzo delle immagini a scopo professionale e/o commerciale, comprese tutte le pubblicazioni digitali o stampate, è necessaria la relativa autorizzazione da parte della casa editrice The Pepin Press/Agile Rabbit Editions.

# Introdução

Jakob Hronek nasceu em Viena, Áustria, em 1972. Após estudar Física na Universidade de Tecnologias Aplicadas de Viena, seguiu sua paixão pelo design harmónico e geométrico, estudando design gráfico e imagens digitais. Em 1998, fundou o Sheherazade, um estúdio de design que se especializou em design para a Web, publicidade e jogos.

Em 1999, mudou-se para Amesterdão e criou o Tekno Logical. Além do design gráfico e do design para a Web, o estúdio cria diversas formas de imagens digitais e arte visual. O desejo de liberdade criativa de Jakob levou-o a dedicar uma maior atenção a essas actividades, nas quais combina os seus conhecimentos científicos com uma visão artística diferenciada.

A série de desenhos concebidos digitalmente que é apresentada neste livro foi exposta em várias cidades europeias. Além disso, Jakob utiliza-os como panos de fundo, diaporamas e projecções de vídeo para diferentes tipos de eventos e peças de teatro contemporâneas.

## Livro e CD-ROM

Este livro contém imagens que podem ser utilizadas como recurso gráfico ou simplesmente como fonte de inspiração. As ilustrações estão armazenadas no CD-ROM anexo e podem ser utilizadas em muitos tipos de aplicações. O CD-ROM é fornecido gratuitamente com o livro, sendo proibido vendê-lo em separado. Os editores não assumem nenhuma responsabilidade no caso de o CD não ser compatível com o seu sistema.

O uso comercial ou profissional dos ficheiros contidos neste CD – incluindo todos os tipos de publicações impressas ou digitais – carece da prévia permissão de The Pepin Press/Agile Rabbit Editions.

# 紹 介

Jakob Hronek は 1972 年オーストリアのウイーン生まれです。ウイーン応用工業大学で物理を学んだ後、調和と幾何学に基づくデザインの世界に魅せられ、グラフィックデザインとデジタル映像を学びました。1998 年、インターネットでのデザイン、広告、ゲームを専門に手がけるデザインスタジオ「シェヘラザード」を設立しています。

1999 年、Jakob はアムステルダムに活動の拠点を移し、スタジオ「テクノ・ロジカル」を設立しました。このスタジオでは、グラフィックやウェブデザイン以外の様々なデジタル映像やビジュアルアートの制作も開始しました。Jakob は次第にビジュアルアートの世界が与えてくれる創造的自由への傾倒を深め、ビジュアルアートにおいて自己の自然科学的教養と際だったアート的ビジョンの統合を果たしました。その一連のデジタル・デザインはヨーロッパ諸都市のエキジビションで公開されました。さらに Jakob はこうしたデザインをバックドロップ、スライドショー、イベントやモダンシアターのビデオ映写用にも使用しています。

## 本書と CD-ROM

この本にはグラフィックの資料やインスピレーションの源として利用できる様々なイメージが掲載されています。添付の CD-ROM にはイラストレーションが入っており、色々なタイプのアプリケーションで使用できます。この CD-ROM は本書に無料で付いている付録なので、別売りはされていません。 この CD がユーザーのシステムでご利用頂けない場合でも発行者は責任を負いません。

この CD 中のファイルを商業目的又は営利目的で使用なさる場合（あらゆる種類の印刷とデジタルパブリケーションを含む）は、ペピン・プレス/アジャイル・ラビット・エディションズの事前許可が必要です。

# 前 言

Jakob Hronek 於 1972 年出生於奧地利的維也納。在維也納應用技術學院完成物理專業的學習之後，出於對調和設計及幾何設計之熱愛，他繼續接受了裝幀設計及數位成像教育。 1998 年，他創立了專門從事網站設計、廣告及遊戲的設計工作室 Sheherazade 。 1999 年，他來到了阿姆斯特丹並開設了 Tekno Logical 。除了裝幀及網路設計之外，這間工作室還可以提供各種類型的數位成像及視覺藝術服務。對創造性自由的追求使得 Jakob 更關注於與後者有關的活動，從而將自己所接受的科學培訓融合到了獨特的藝術視角之中。本書中的數位設計系列作品已在歐洲多個城市展出。此外， Jakob 還將其製成用於各種場合及現代劇院中的背景、幻燈及視頻投影。

## 電腦及 CD-ROM

本書的構圖可作為讀者的圖片庫或參考。其中的插圖均儲存在隨附的 CD-ROM 中，可用於多種用途。 CD-ROM 隨書免費提供，並不另行銷售。如果此 CD 與您的系統無法相容，出版商不應承擔任何責任。

因商業及/或專業用途而使用此 CD 中的文件時 - 包括所有類型的印刷或數位出版物 - 必須得到 Pepin Press/Agile Rabbit Editions 的許可。

# FRACTALS

Fractales
**Fraktale**
Los fractales
**Frattali**
Fractais
フラクタル図形
碎形

# Fractals

A fractal is a complex geometric figure generated through a mathematical formula. A typical characteristic of a fractal is that its parts are smaller copies of the whole (at least approximately), and that this carries on indefinitely; when one zooms in on a specific area, the initial design eventually reappears. Fractal images are highly irregular and fragmented, regardless of the scale of examination.

Interestingly, fractal structures are omnipresent in nature and the universe. For example, rocks and mountains, trees and foliage, cloud formations, and so forth, all share the characteristic that sweeping views of them have very similar features to their most minute details. And perhaps even more fascinating is the fact that the picture of an atom is akin to that of a galaxy.

To obtain a fractal, the following process is applied: the coordinates of a point (x,y) are processed in a mathematical formula in order to obtain new coordinates. The result is again processed within the same formula and so forth; this process is called iteration.

There are two possible outcomes of this process:

1. Convergence, in which the computed points come closer and closer to a fixed endpoint. In this case, the original point with coordinates (x,y) is black.

2. Divergence, in which the computed coordinates expand indefinitely. In this case, the original point is any color other than black, this color being determined by the iteration's speed of divergence.

# Fraktale

Ein Fraktal ist eine komplexe geometrische Figur, die durch einer mathematischen Formel erzeugt wird. Ein typisches Merkmal eines Fraktals besteht darin, dass seine Teile kleinere Kopien des Ganzen sind (zumindest annähernd) und dass dies sich unendlich wiederholt. Beim Einzoomen an einem bestimmten Punkt erscheint schließlich wieder die ursprüngliche Form. Unabhängig vom Maßstab bei der Betrachtung sind fraktale Bilder sehr unregelmäßig und fragmentiert.

Interessanterweise sind fraktale Strukturen in der Natur und im Universum allgegenwärtig. So haben beispielsweise Felsen und Berge, Bäume und Laubwerk oder Wolkenformationen gemeinsam, dass ihre Großansichten Merkmale aufweisen, die denen der kleinsten Details sehr ähneln. Noch mehr mag vielleicht die Tatsache faszinieren, dass das Bild eines Atoms dem einer Galaxis ähnelt.

Um ein Fraktal zu erhalten, wird folgendes Verfahren angewandt: ausgehend von den Koordinaten eines Punkts (x,y) werden mit einer mathematischen Formel neue Koordinaten berechnet. Die daraus resultierenden Koordinaten werden erneut mit der Formel behandelt und so fort; dieser Vorgang wird als Wiederholung oder Iteration bezeichnet.

Der Prozess kann auf zweierlei Art ablaufen:

1. Er kann konvergieren, wobei sich die berechneten Punkte immer mehr einem vorgegebenen Grenzpunkt nähern. In diesem Fall ist der Ausgangspunkt mit seinen Koordinaten (x,y) schwarz.

2. Er kann divergieren, und dann erstrecken sich die berechneten Koordinaten bis ins Unendliche. In diesem Fall hat der Ausgangspunkt jede beliebige von Schwarz verschiedene Farbe. Die Farbe wird von der Geschwindigkeit bestimmt, mit der die Iteration divergiert.

# Fractales

Une fractale est une figure géométrique complexe obtenue au moyen d'une formule mathématique. Elle a pour caractéristique principale que chacune des parties qui la compose est une copie (au moins approximative) plus petite de l'ensemble, le tout formant un système qui se poursuit à l'infini ; le motif de base peut réapparaître si une zone spécifique de l'image est grossie. Les images fractales sont extrêmement irrégulières et fragmentées, quelle que soit l'échelle à laquelle elles sont observées.

Il est intéressant de noter que les structures fractales sont omniprésentes dans la nature et dans l'univers. Ainsi les roches et les montagnes, les arbres et leur feuillage, les formations de nuages, etc. ont tous en commun une vue d'ensemble dont les caractéristiques sont très proches de celles des plus petits détails. Encore plus fascinant sans doute, l'image d'un atome ressemble beaucoup à celle d'une galaxie.

Pour obtenir une fractale, on applique la méthode suivante : les coordonnées d'un point (x,y) sont transformées selon une formule mathématique pour obtenir de nouvelles coordonnées, le résultat est ensuite de nouveau transformé au moyen de la même formule, et ainsi de suite, ce procédé est appelé itération.

On distingue deux possibilités d'itération :

1. Elle peut converger, en d'autres termes, les points calculés se rapprochent de plus en plus d'un point-limite déjà fixé. Dans ce cas, le point d'origine aux coordonnées (x,y) est noir.

2. Elle peut diverger, et les coordonnées calculées vont alors s'étendre à l'infini. Dans ce cas, le point d'origine est d'une couleur autre que noir et les couleurs sont déterminées par la vitesse de divergence de l'itération.

# Los fractales

Un fractal es una figura geométrica compleja generada mediante una fórmula matemática. Los fractales presentan la particularidad de que las partes que los componen son copias reducidas de la figura entera (como mínimo de forma aproximada), particularidad que además se reproduce indefinidamente, es decir, si se amplía una zona determinada del fractal volverá a aparecer el diseño inicial. Las imágenes fractales presentan una forma muy irregular y fragmentada, independientemente de la escala a la que se examinen.

Curiosamente, las estructuras fractales se encuentran por doquier en la naturaleza y en el universo. Rocas y montañas, árboles y hojas, formaciones nubosas... en todos ellos se observa una gran similitud entre la totalidad y el más mínimo detalle. Aún más fascinante es comprobar que la imagen de un átomo es similar a la de una galaxia.

El proceso para obtener un fractal es el siguiente: las coordenadas de un punto (x, y) se procesan mediante una fórmula matemática para obtener nuevas coordenadas. A continuación, el resultado se vuelve a procesar mediante la misma fórmula, y así sucesivamente. Este proceso recibe el nombre de iteración y tiene dos posibles resultados:

1. Convergencia, es decir, los puntos obtenidos se van acercando hasta llegar a un punto límite determinado. En este caso, el punto de coordenadas inicial (x, y) es negro.

2. Divergencia, es decir, las coordenadas obtenidas se expanden indefinidamente. En este caso, el punto original puede presentar cualquier color a excepción del negro. El color dependerá de la velocidad de divergencia de la iteración.

# Frattali

Il frattale è un elemento geometrico complesso generato da una formula matematica. La caratteristica distintiva del frattale è che le sue parti sono copie più piccole della figura intera (perlomeno in modo approssimativo), e che continua all'infinito; quando si ingrandisce una zona definita, il disegno iniziale appare di nuovo. Le immagini frattali sono altamente irregolari e frammentate, a prescindere dalla scala in esame.

Stranamente, le strutture frattali sono onnipresenti nella natura e nell'universo. Ad esempio le rocce e le montagne, gli alberi e il fogliame, le formazioni nuvolose, e così via, tutte condividono lo stesso tratto e cioè che la visione d'insieme ha caratteristiche molto simili a quella che è un'analisi al dettaglio. Ed è forse ancora più affascinante constatare che l'immagine di un atomo è simile a quella di una galassia.

Per ottenere un frattale si deve applicare il seguente processo: le coordinate di un punto (x,y) sono processate in una formula matematica per ottenere delle coordinate nuove. Il risultato viene nuovamente processato con la stessa formula e così via; questa procedura di calcolo è chiamata iterazione.

L'iterazione può avere due risultati:

1. La convergenza, in cui i punti calcolati vengono avvicinati fino ad un punto finale fisso. In questo caso il punto iniziale con coordinate (x,y) è nero.
2. La divergenza, in cui le coordinate calcolate si espandono all'infinito. In questo caso il punto iniziale ha un colore diverso dal nero, definito dalla velocità di iterazione della divergenza.

# フラクタル図形

フラクタル図形は数式によって生み出される複雑な幾何学的図形です。フラクタル図形の主な特徴は、個々の部分が（少なくとも概ねは）その全体をより小さくしたコピーとなっており、これが無限に反復されている点です。つまり、ある領域をズームで拡大して眺めると、そこにまた最初のデザインが現れるのです。フラクタル図形はどのスケールで調べても非常に不規則的かつ断片化した図形です。

興味深いのは、このフラクタル構造が自然界や宇宙に遍在する点です。例えば、岩石、山脈、木々、木の葉、雲の形状など様々な自然物において、全体像がその極めて微細な部分に非常に類似した特徴を示しています。それにもまして銀河の形状が原子の形状に近似しているという事実には心を惹かれます。フラクタル図形は次の手順で作成することができます：ある一点（x, y）の座標を１つの数式で処理し、新たな座標を導きます。この結果を同前の数式で再び処理し、これを繰り返します。このプロセスを反復と呼びます。

このプロセスには２つの可能性があります。

1. 収束の可能性。つまり、演算処理された点が次第に一定の限界点に近づいていく場合です。この場合には、座標（x, y）の原点は黒です。
2. 発散の可能性。つまり、演算処理された座標が無限に拡大していく場合です。この場合には、原点の色は黒以外の色を持っています。その色は反復の発散速度によって定められます。

# Fractais

Um fractal é uma figura geométrica complexa gerada através de uma fórmula matemática. Uma das características típicas de um fractal é as partes serem pequenas cópias do todo (pelo menos, de forma aproximada) e que esse processo se prolonga indefinidamente; quando se amplia uma determinada área, o design inicial acabará por reaparecer. As imagens fractais são muito irregulares e fragmentadas, independentemente da escala utilizada.

Curiosamente, as estruturas fractais estão omnipresentes na natureza e no universo. Por exemplo, as rochas e as montanhas, as árvores e a folhagem, as formações nebulosas, e assim por diante, todas têm em comum a seguinte característica: a visão global de cada um desses elementos é muito semelhante aos pormenores mais ínfimos do mesmo elemento quando são ampliados. Ainda mais fascinante, provavelmente, é o facto de a imagem de um átomo ser semelhante à de uma galáxia.

Para se obter um fractal, emprega-se o seguinte processo: as coordenadas de um ponto (x,y) são processadas numa fórmula matemática com o objectivo de obter novas coordenadas. O resultado é novamente processado dentro da mesma fórmula e assim sucessivamente, num processo denominado iteração.

Há dois resultados possíveis para este processo:

1. A convergência, na qual os pontos calculados se aproximam cada vez mais de um ponto final fixo. Neste caso, o ponto original com as coordenadas (x,y) é preto.
2. A divergência, na qual as coordenadas calculadas se expandem indefinidamente. Neste caso, o ponto original apresenta uma cor diferente de preto, sendo determinada pela velocidade da divergência da iteração.

# 碎 形

碎形是透過數學公式產生的複雜幾何圖形。碎形的一個典型特徵為：局部係對整體之小規模複製（至少相似），並且這種複製將無限往復；在對某一區域進行放大時，最終將再次出現原有的圖案。不論檢查比例之大小，碎形將呈現極度的不規則及碎片特性。

有趣的是，自然界與宇宙中普遍存在碎形結構。例如，岩石及山脈、樹木及葉片、雲彩的構成、等等，在其最微小的細節上都具有非常相似的特徵。而更讓人歎為觀止的是，原子的圖片也類似於星系的圖片。透過以下步驟即可獲得碎形：採用數學公式對一個點的座標（x，y）進行處理，從而獲得一個新座標。採用該公式對結果進行再次處理並不斷往復；這一過程稱為迭代。

這一過程存在兩種可能性：

1. 會聚，即計算所得指點越來越接近於一個固定的極限點。在此情況下，座標為（x，y）的初始點呈黑色。
2. 發散，表示計算所得之座標將無限擴展。在此情況下，初始點並不呈黑色。其顏色將根據迭代發散之速度而定。

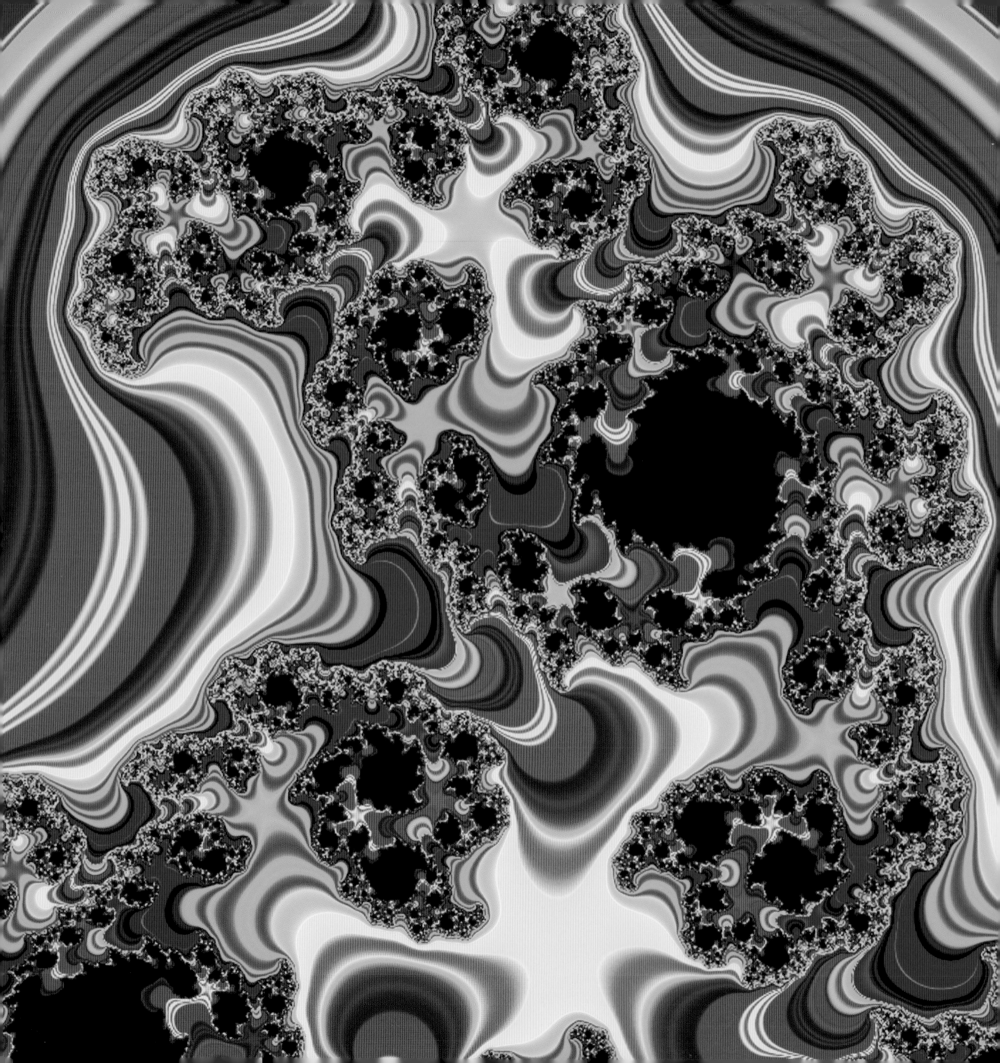

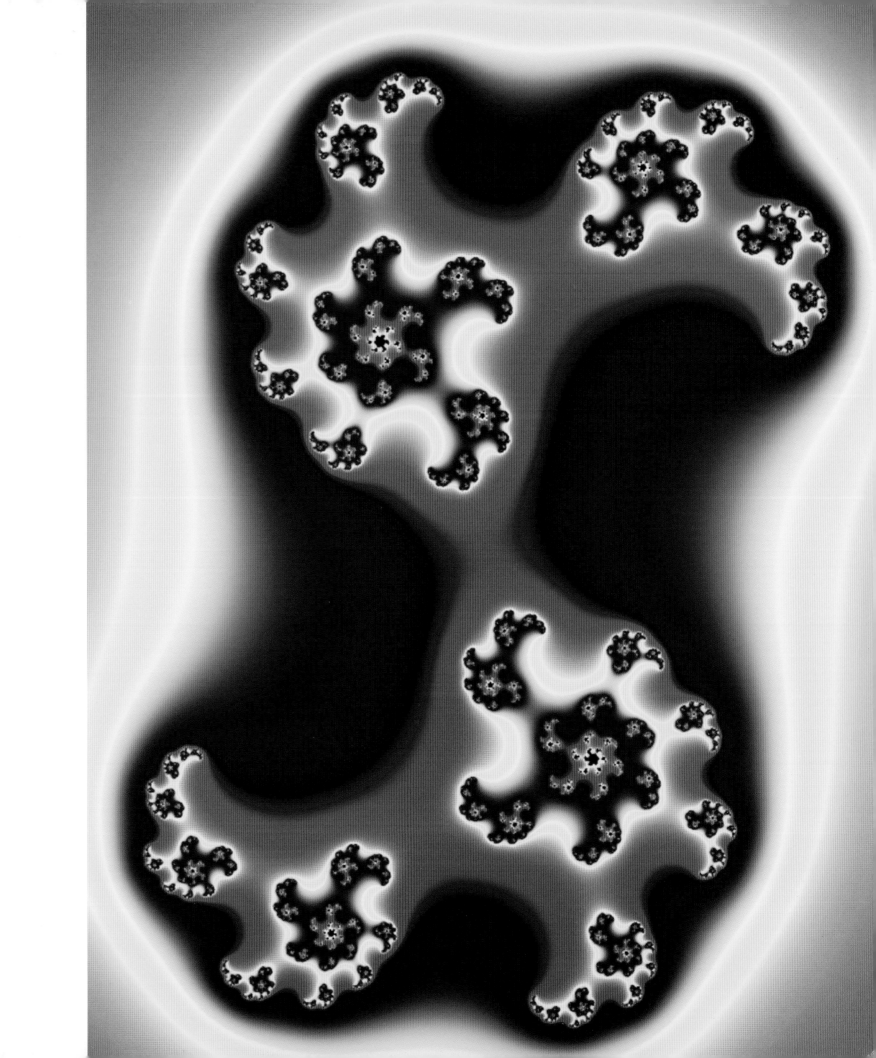

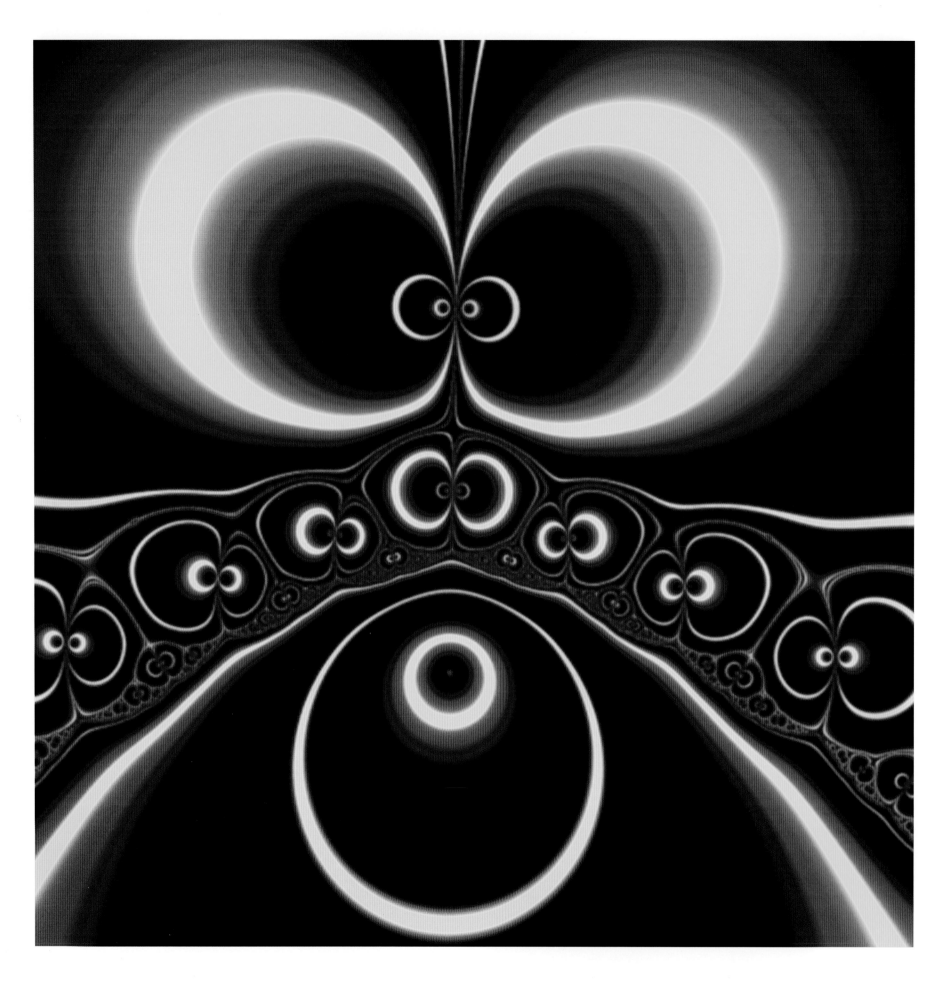

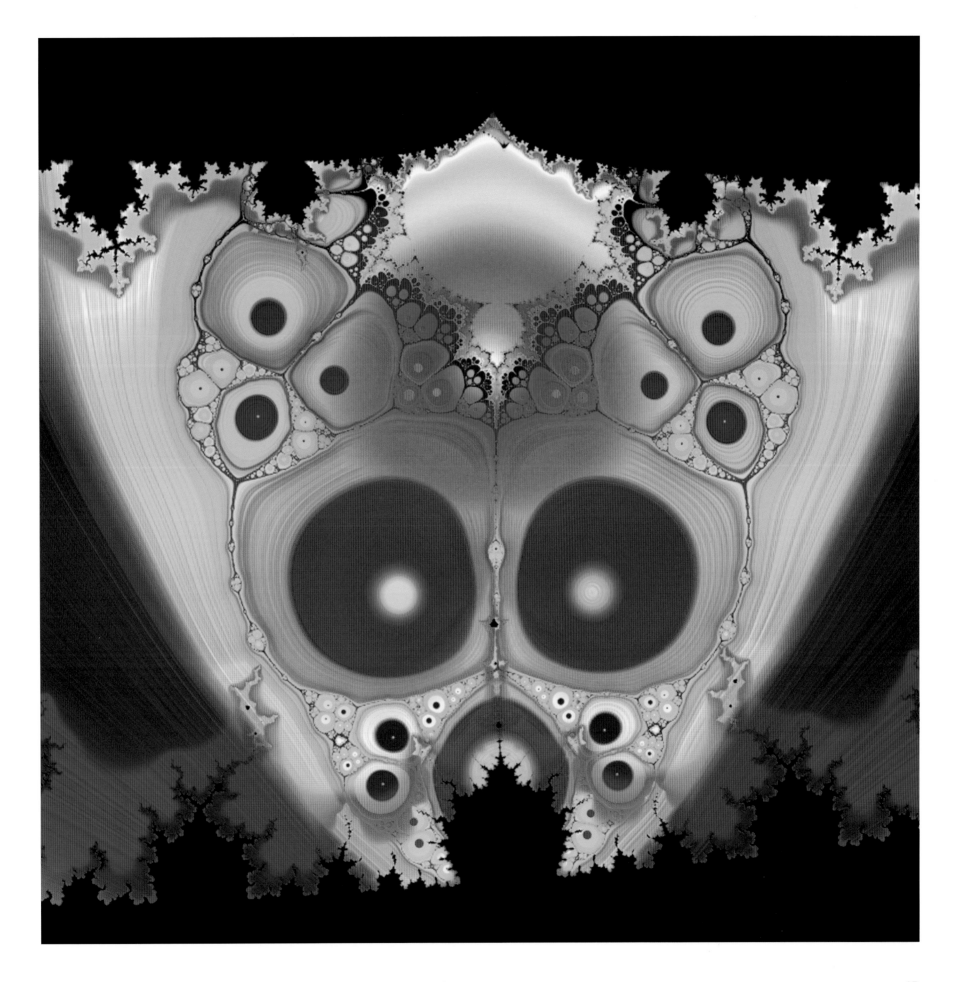

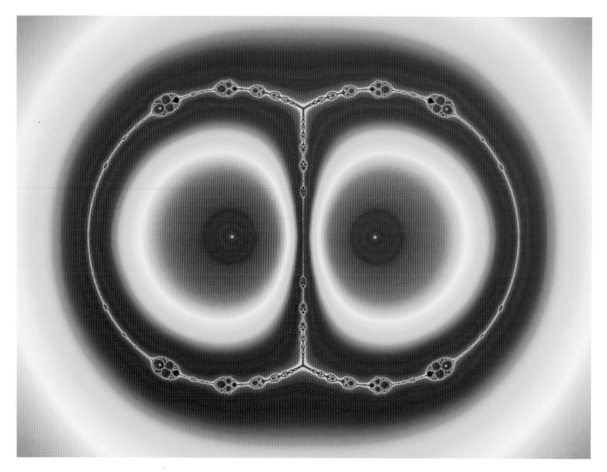

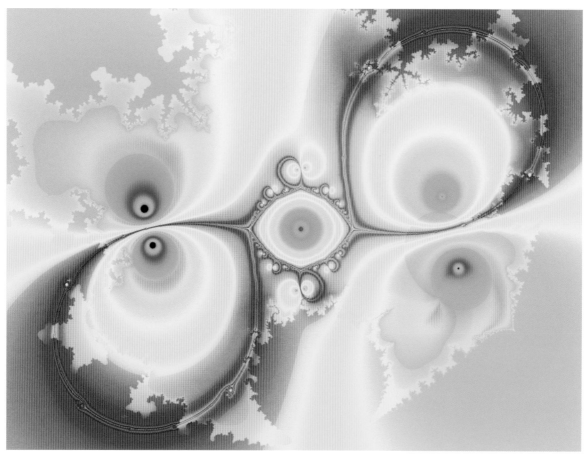

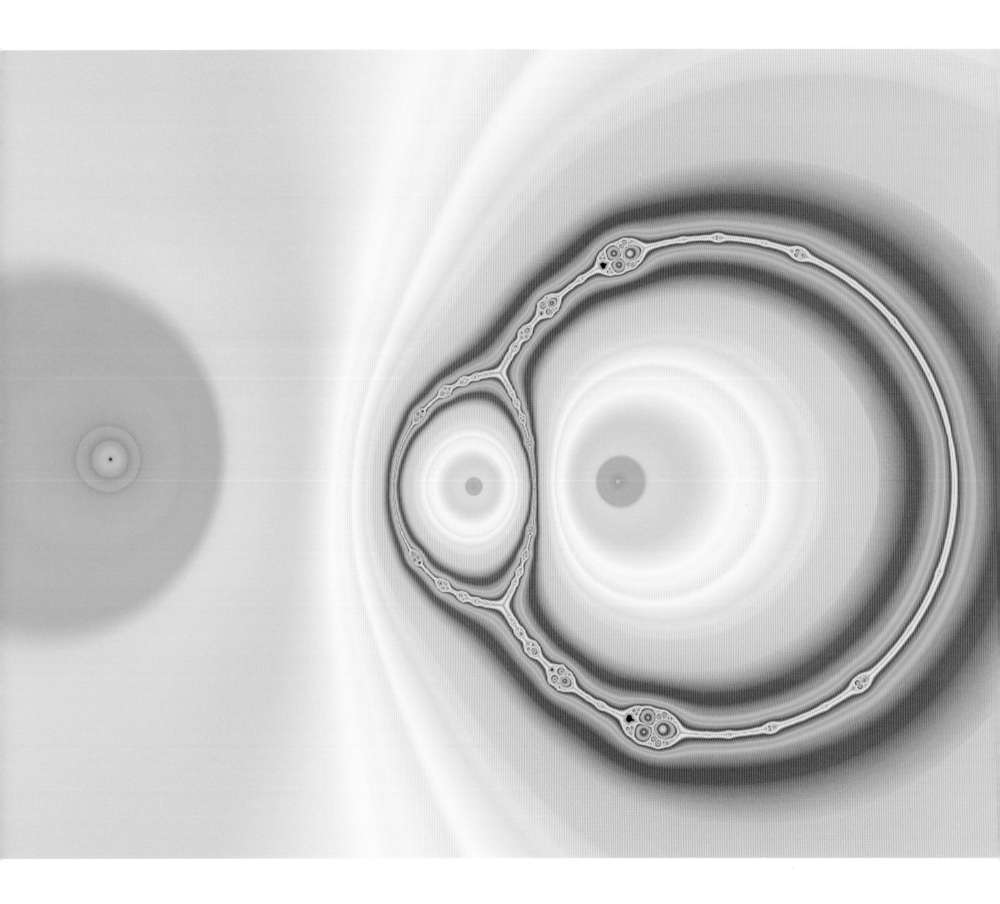

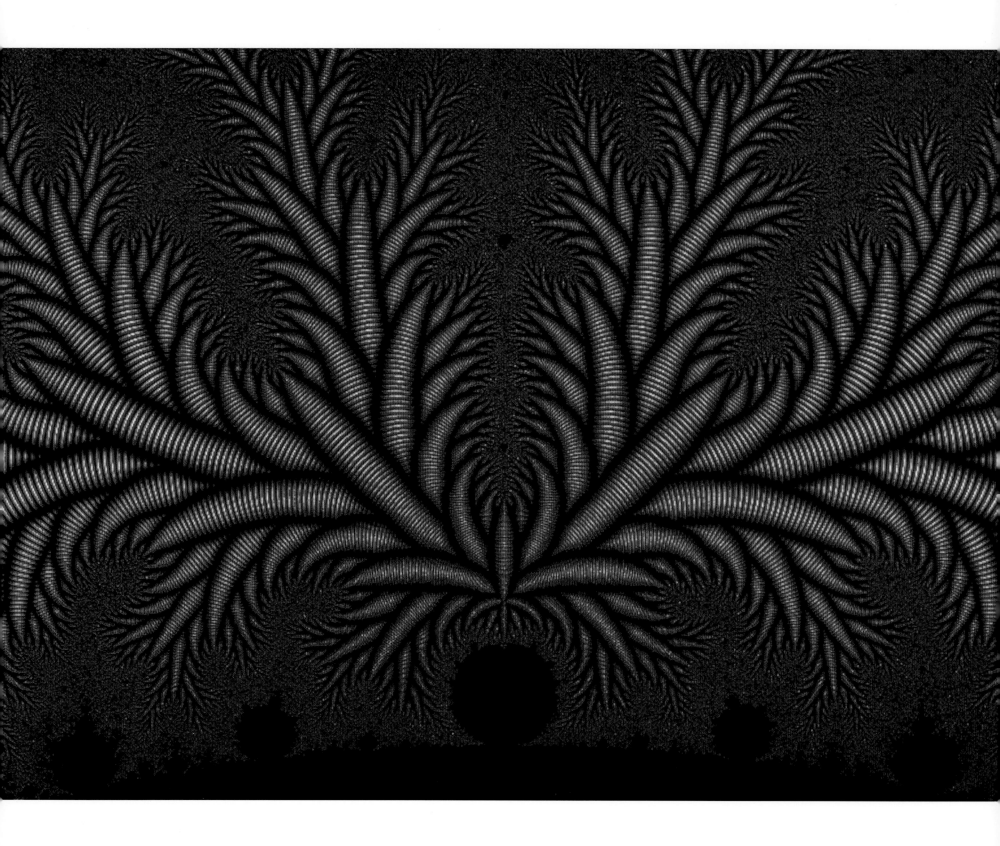

18

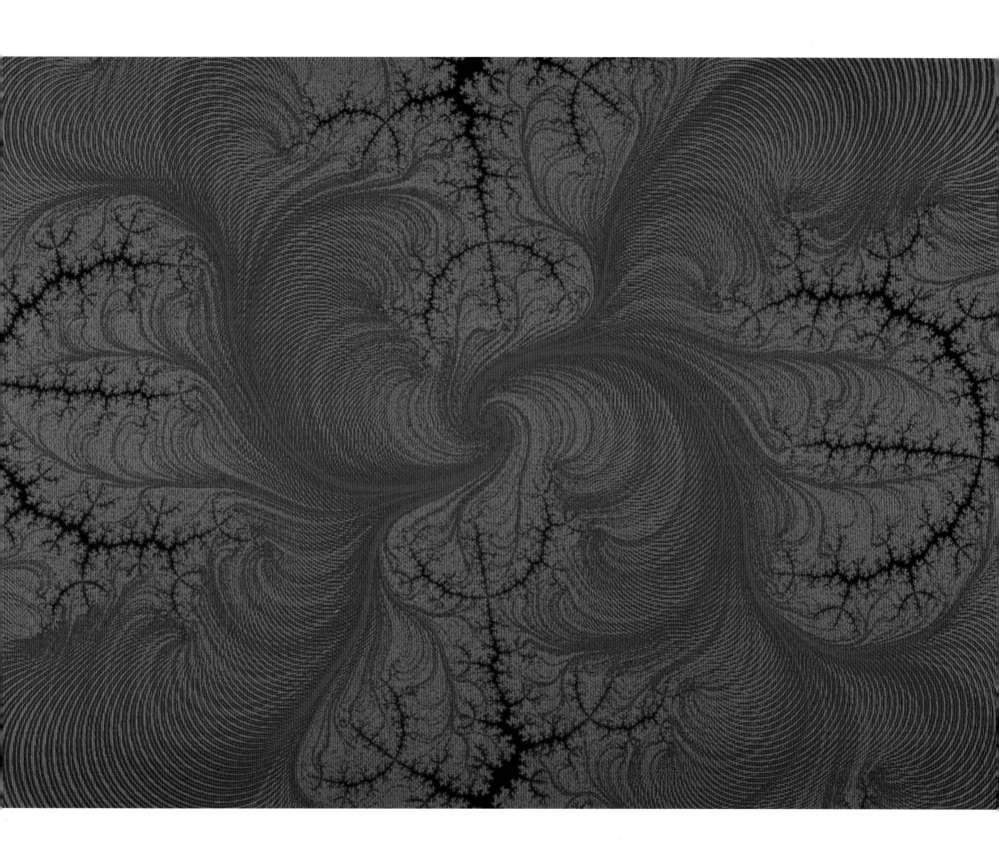

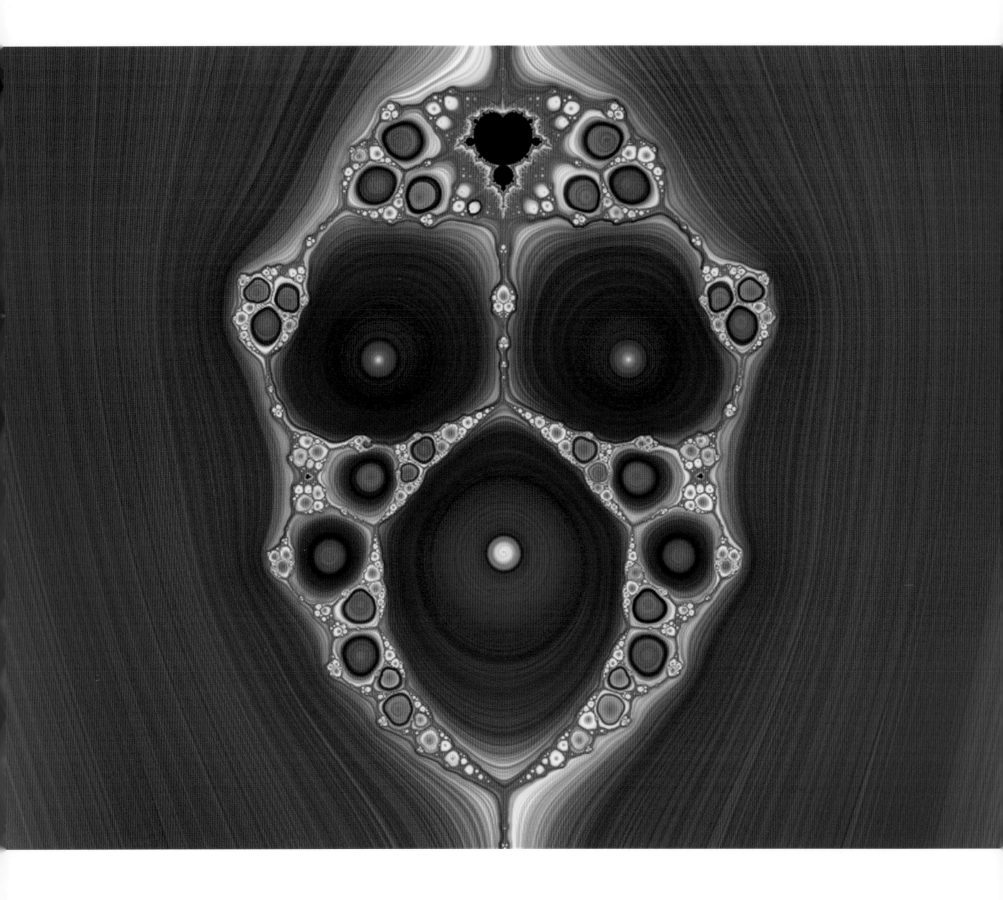

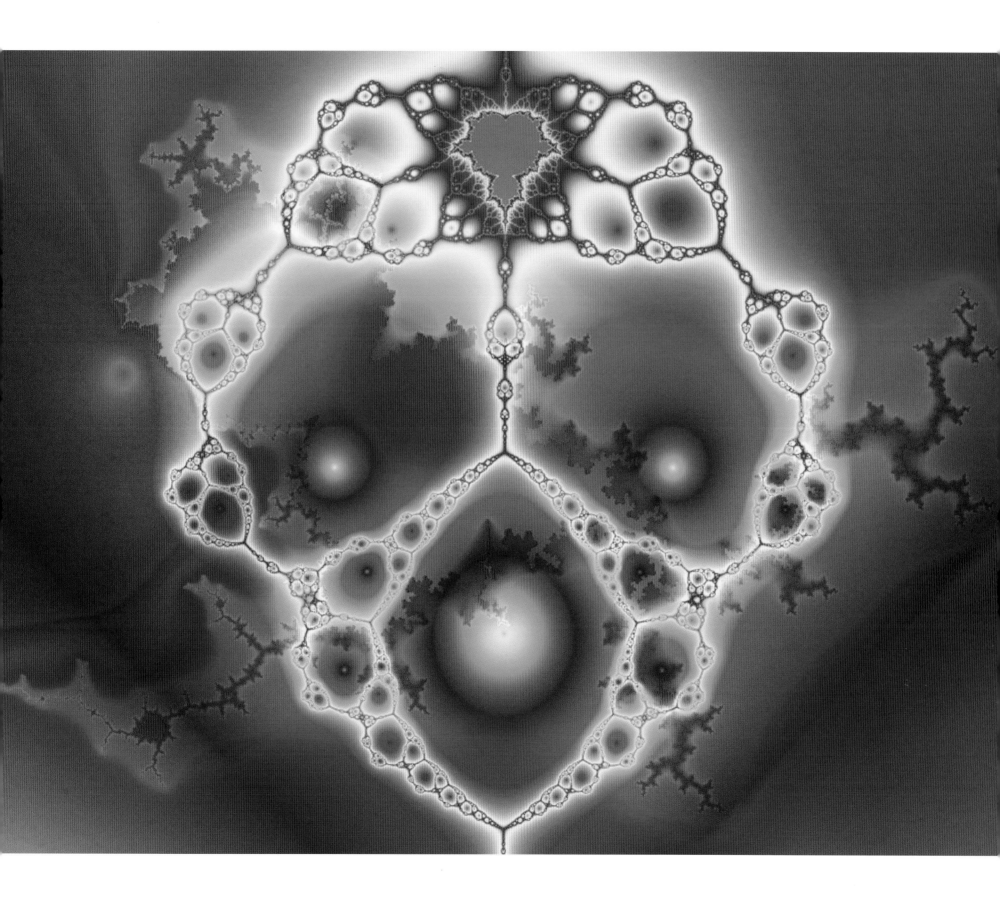

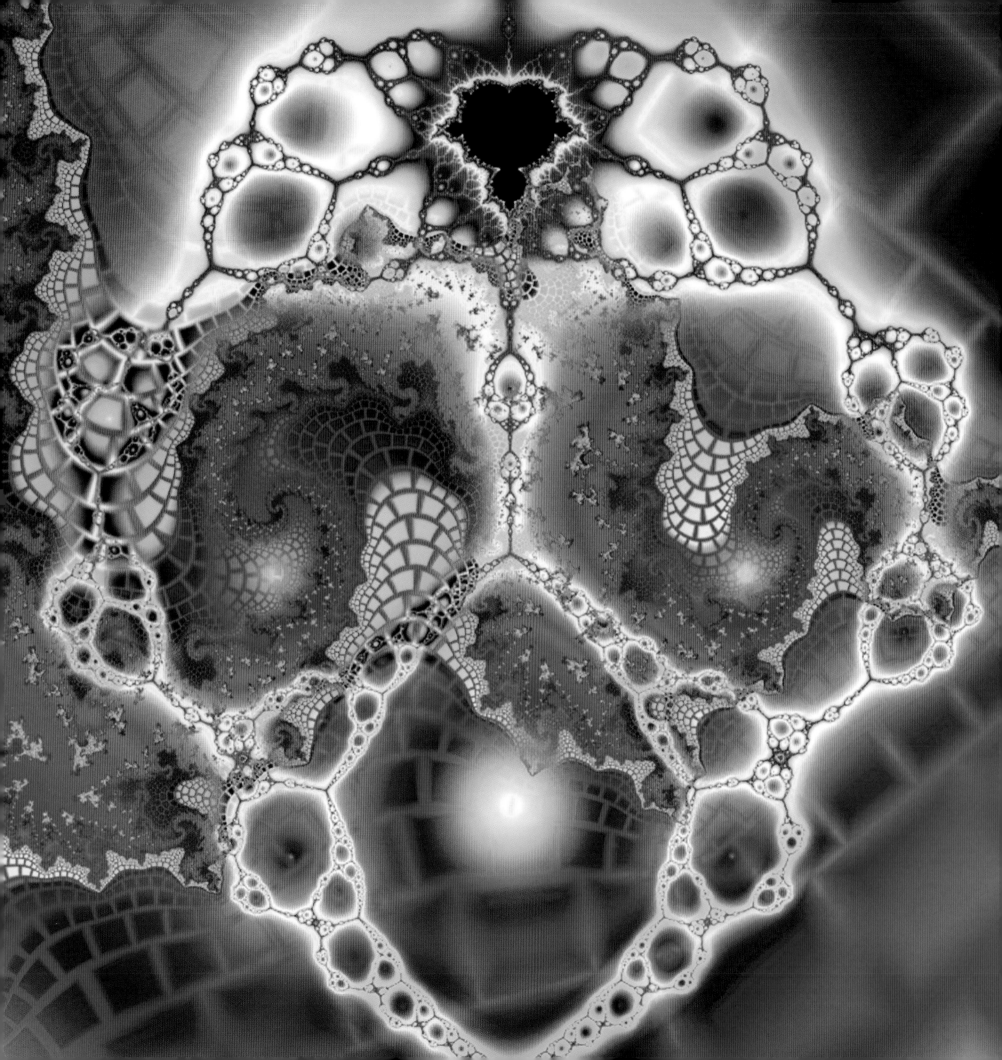

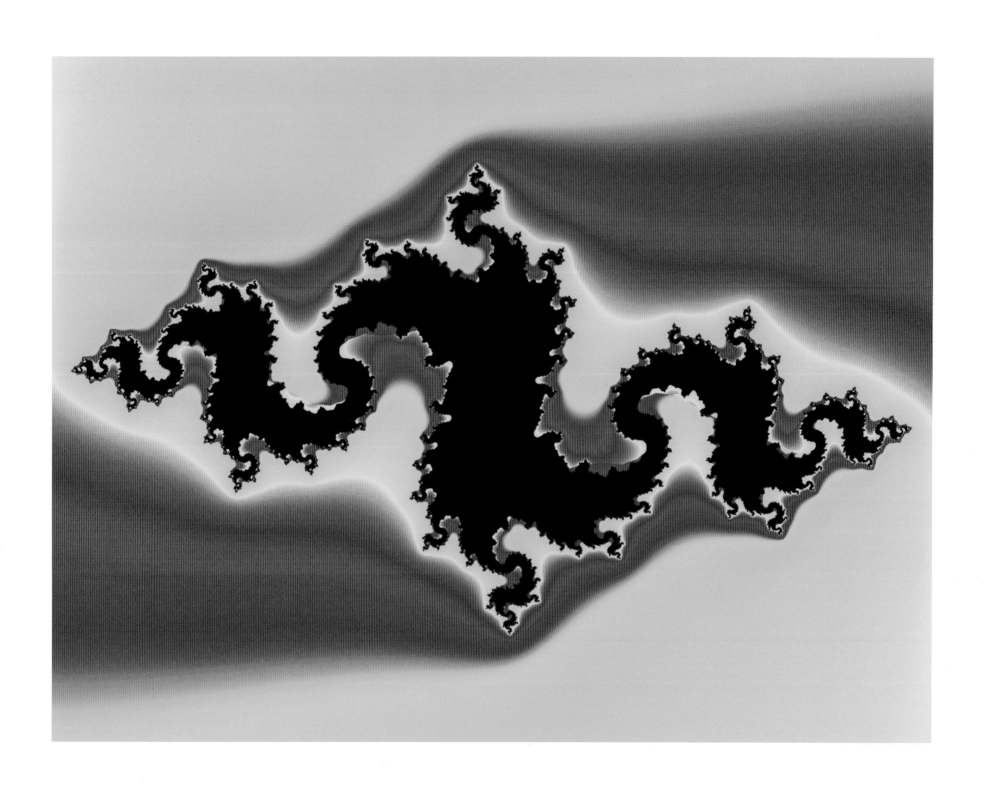

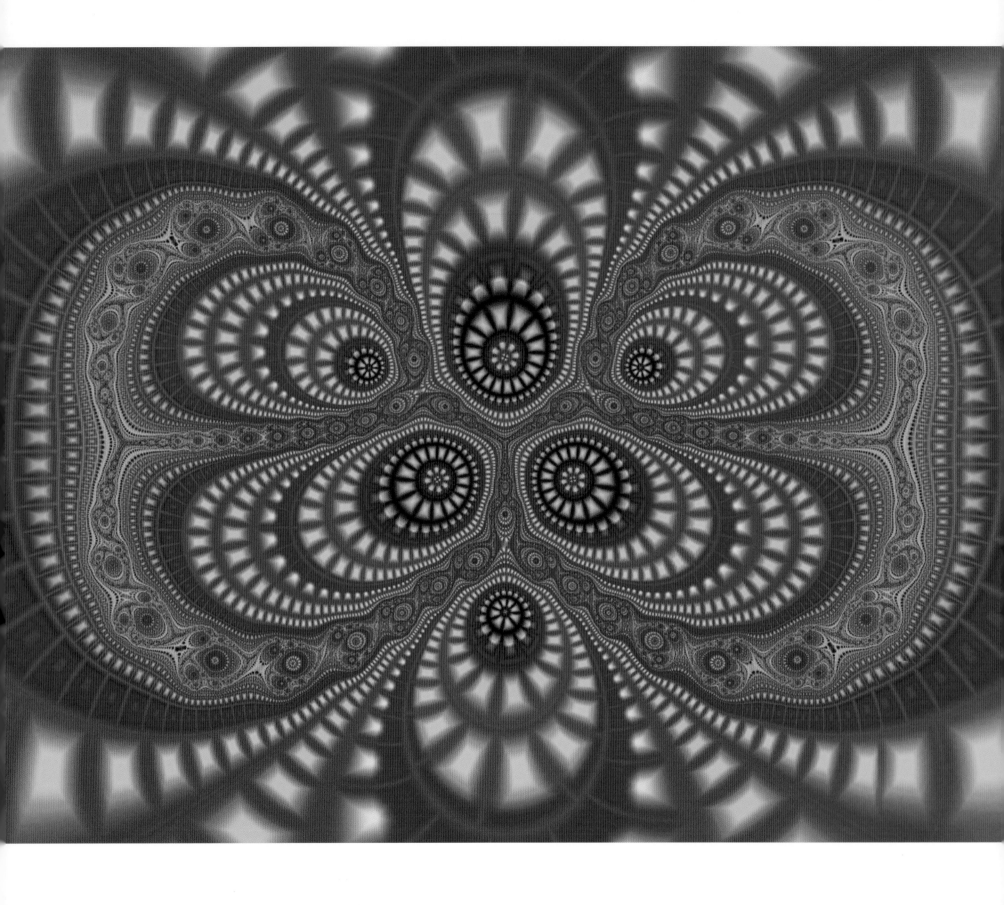

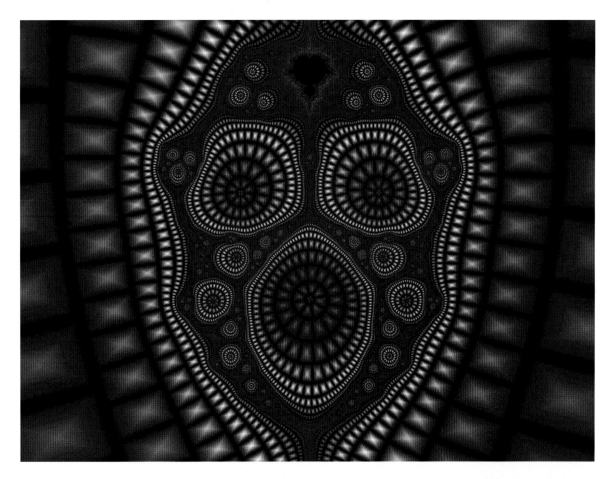

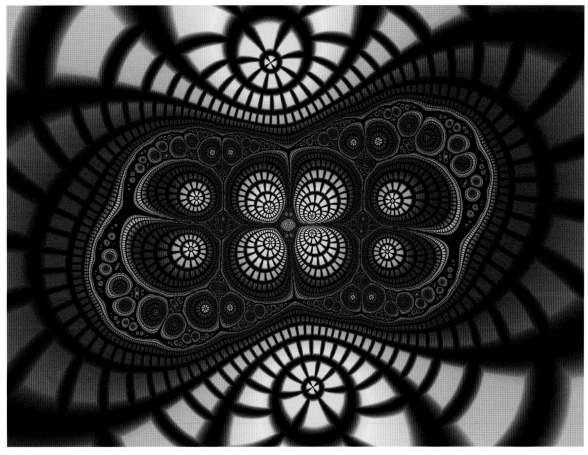

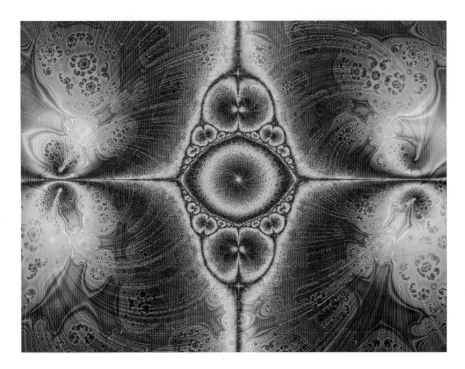
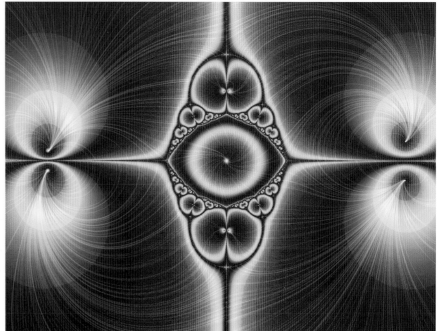

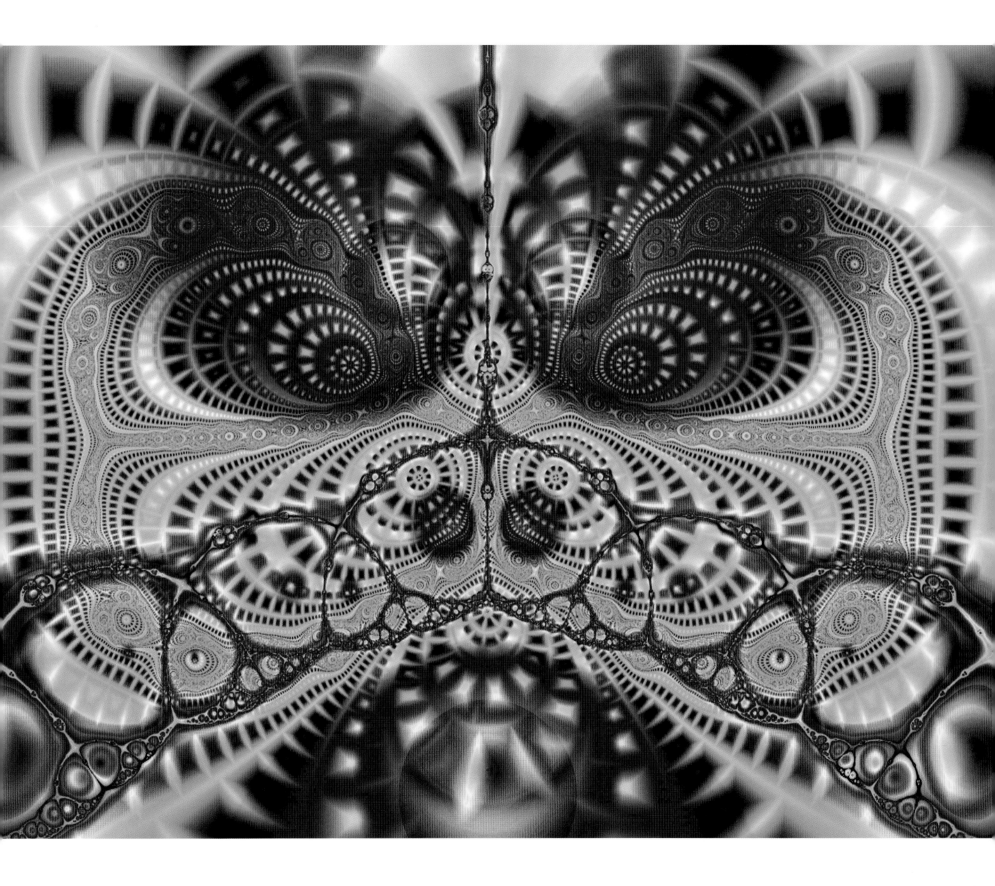

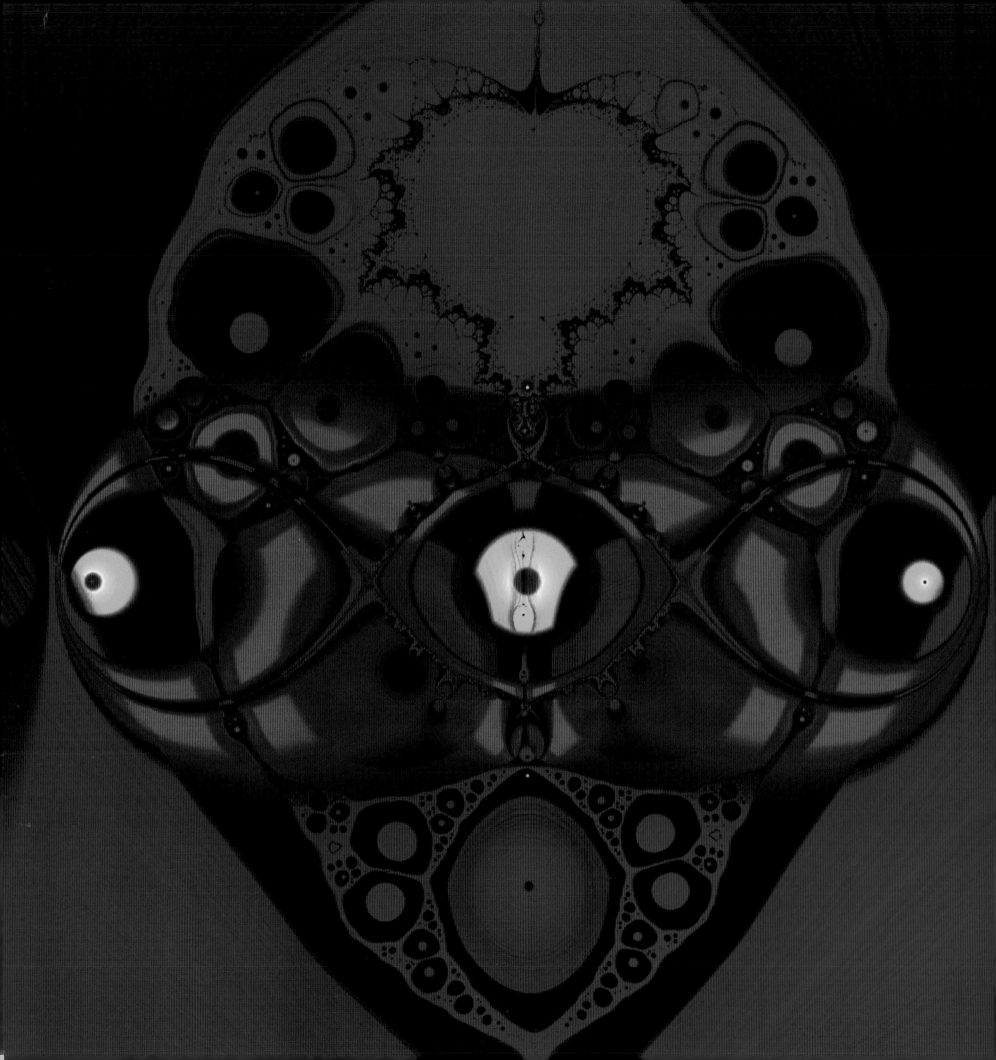

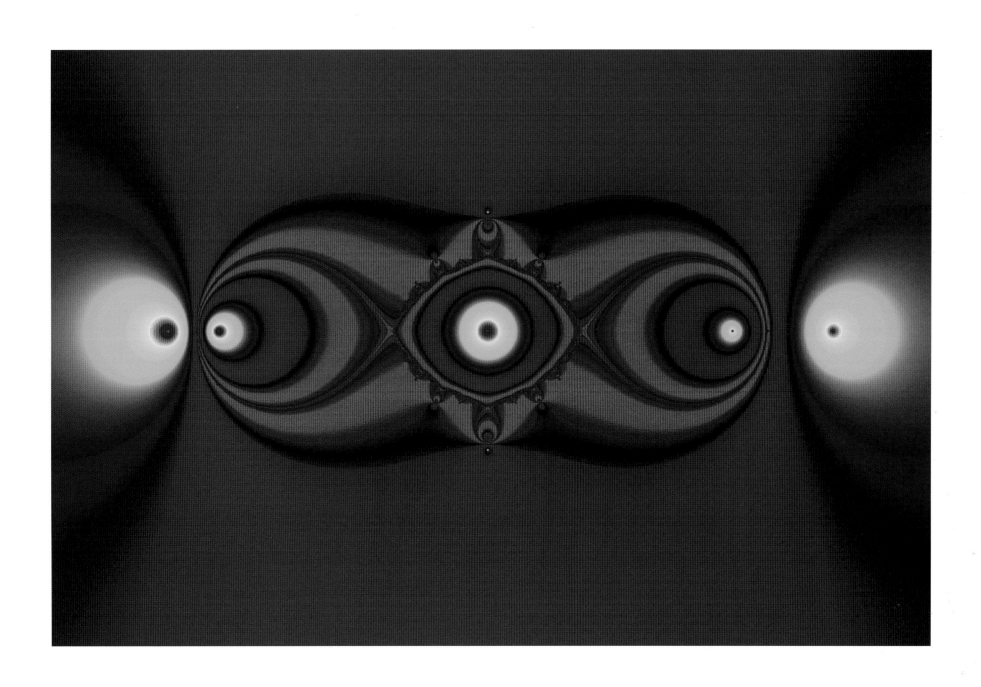

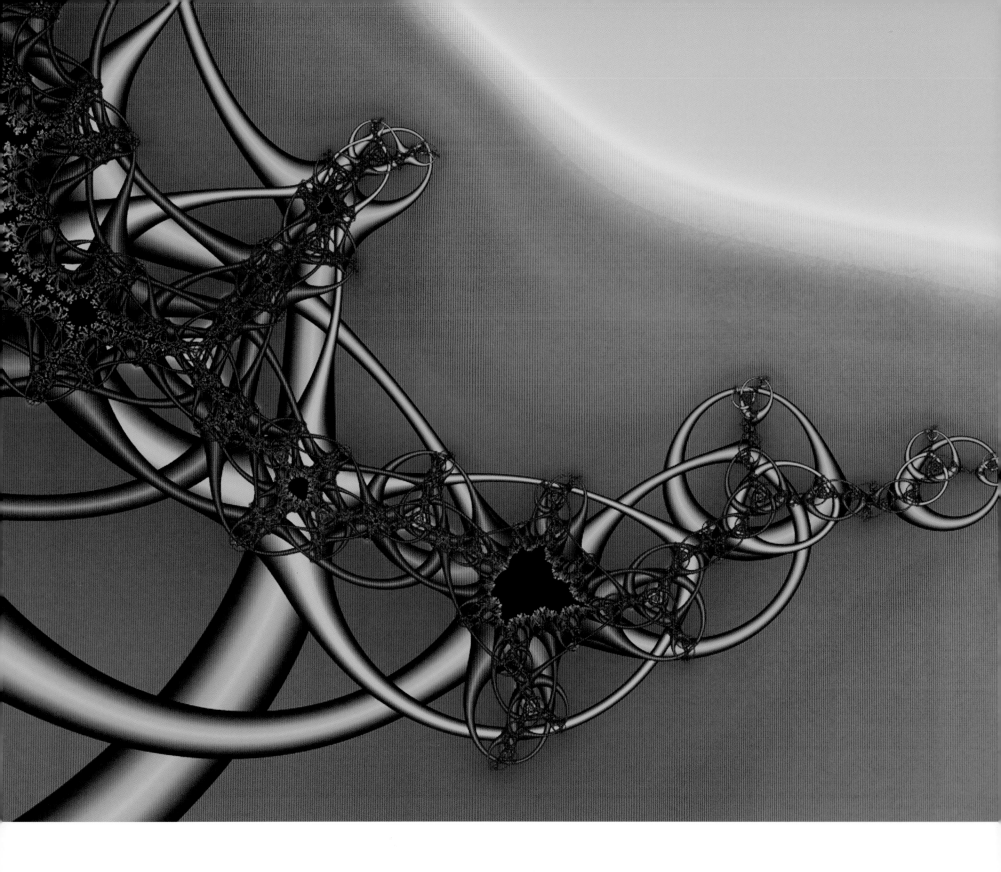

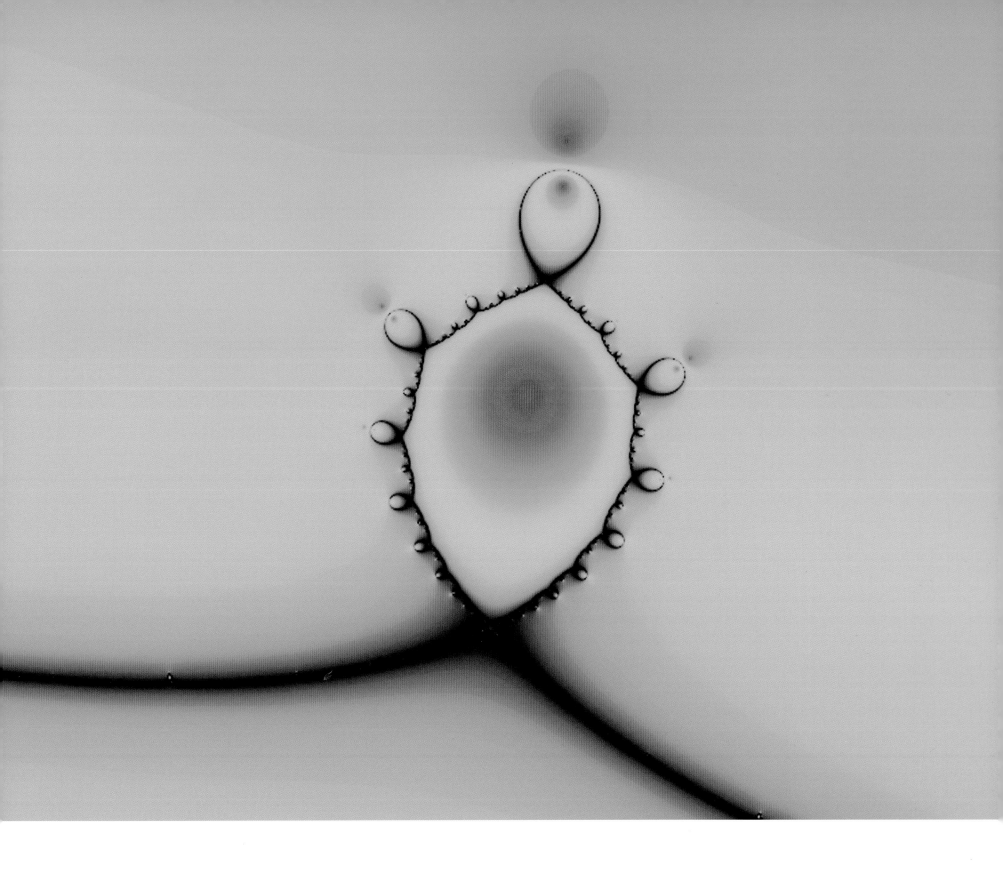

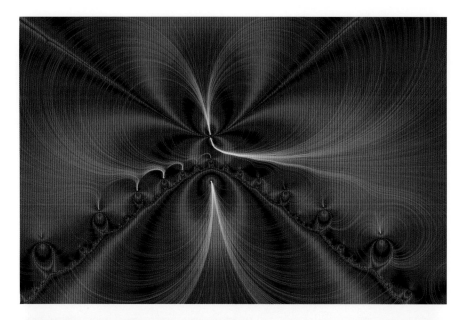

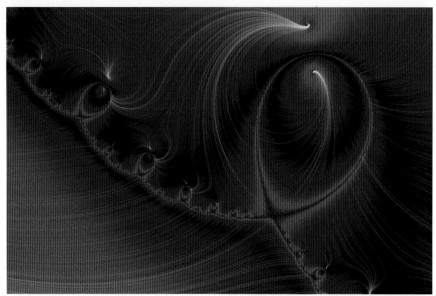

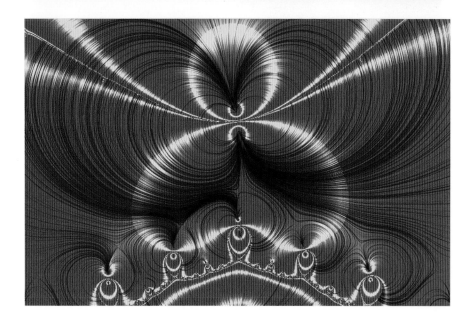

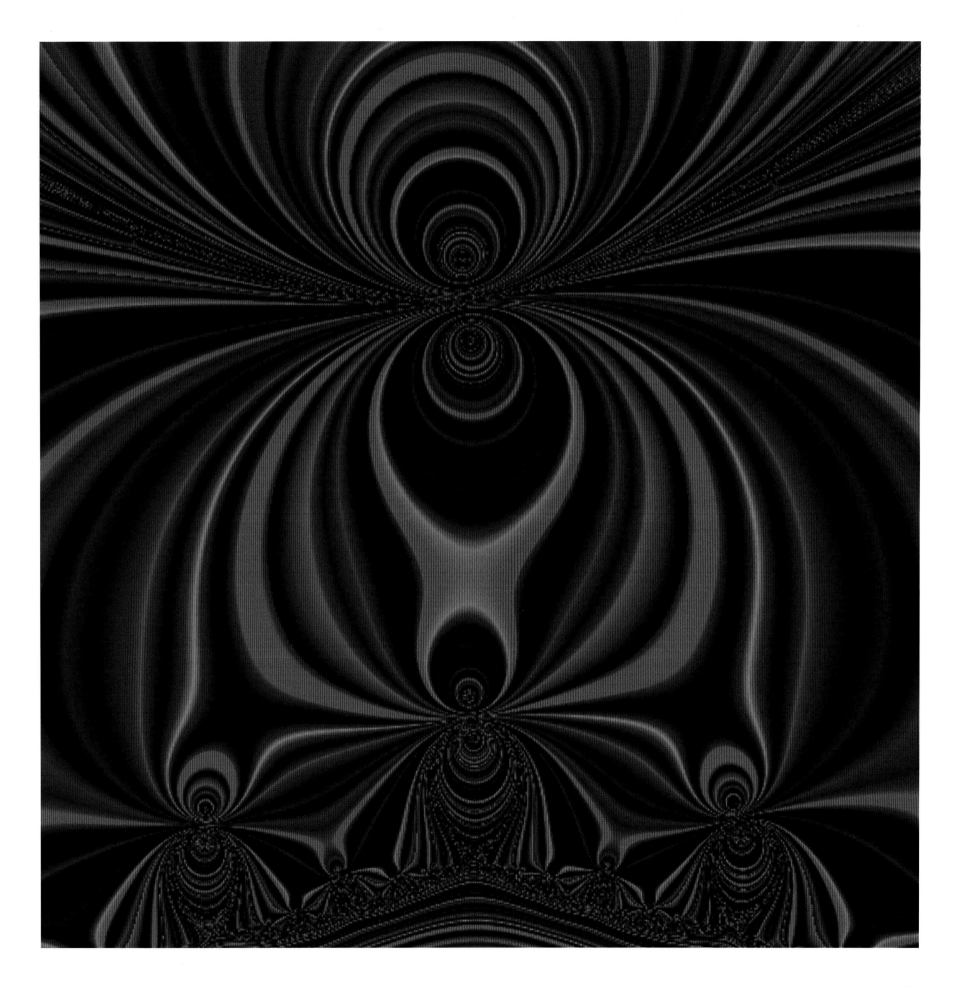

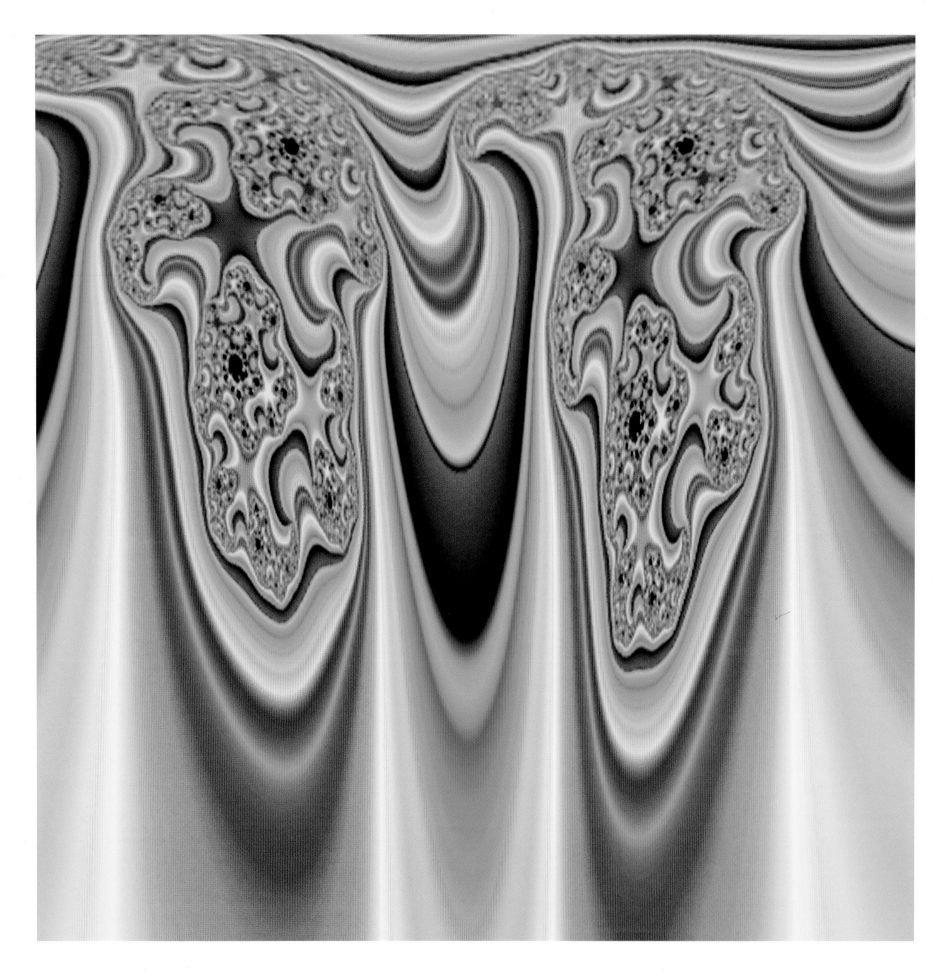

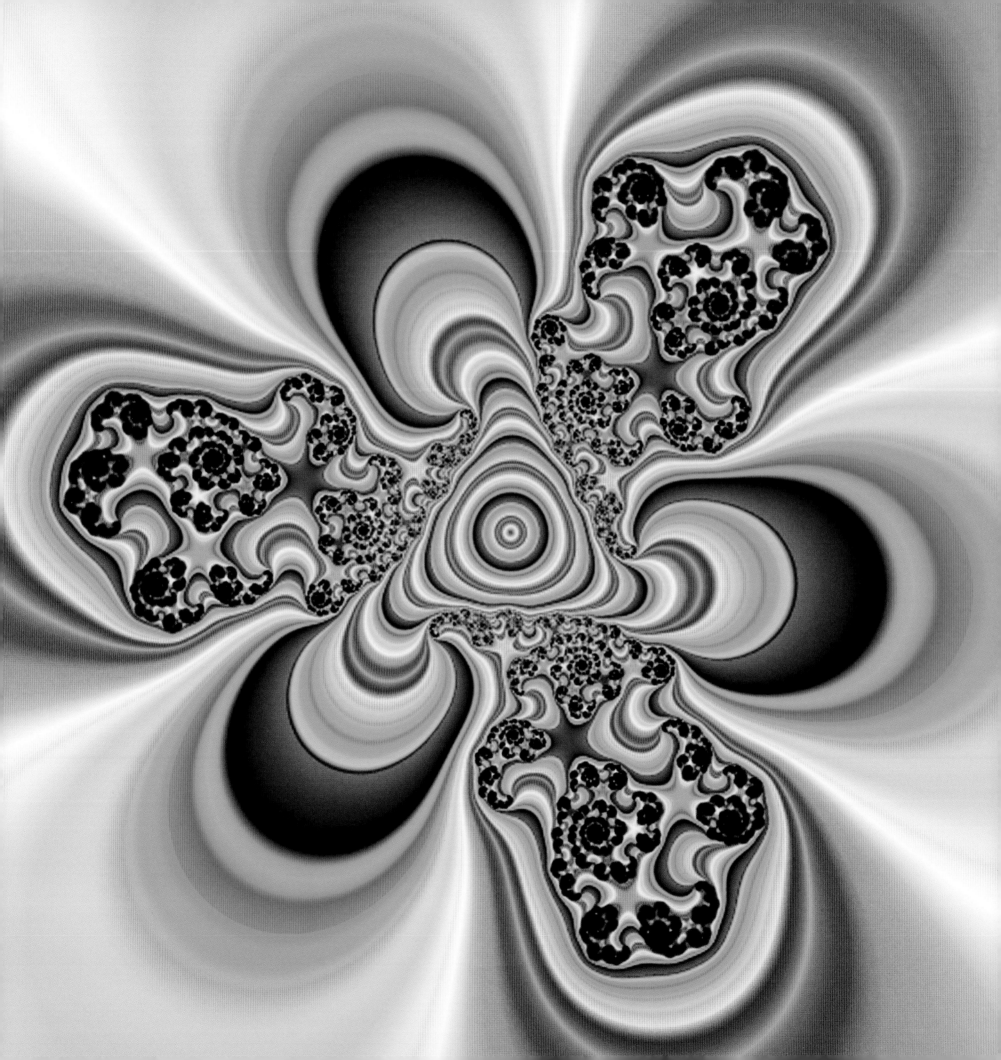

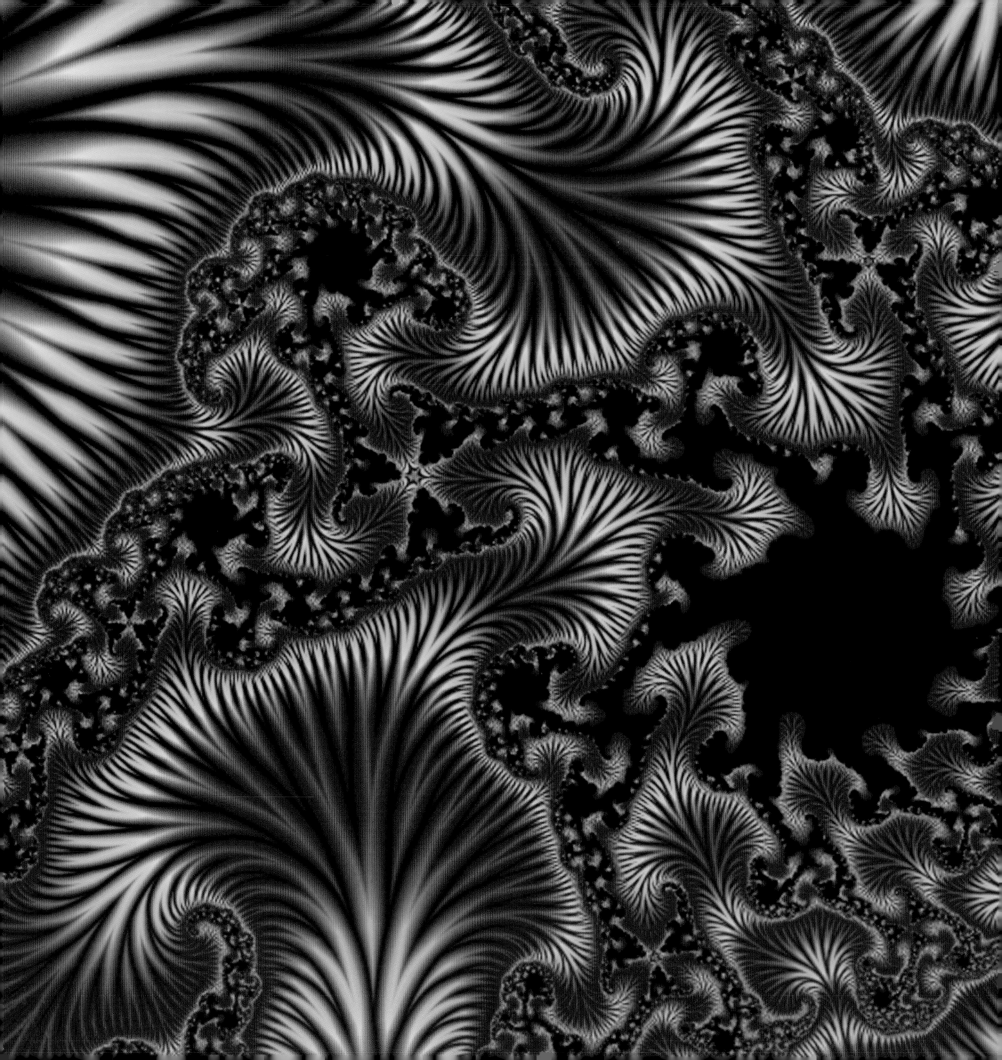

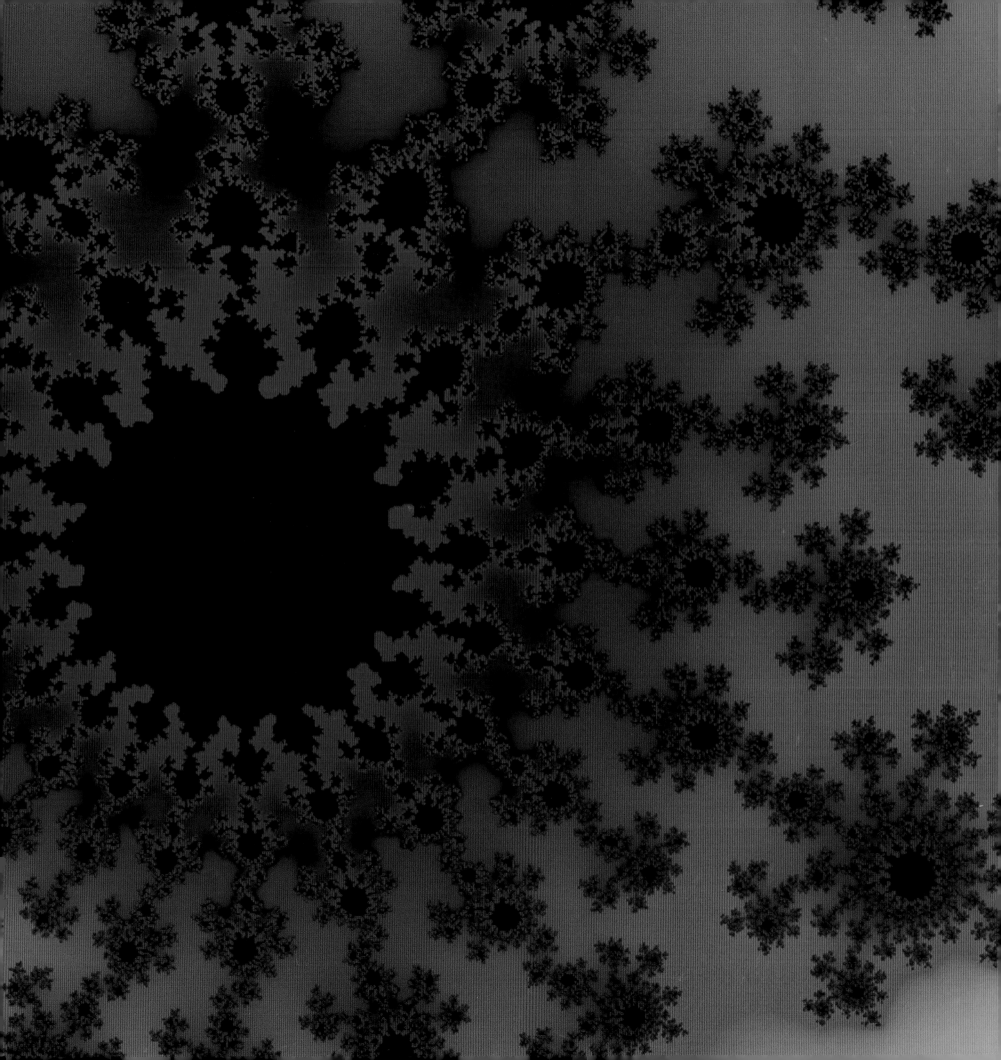

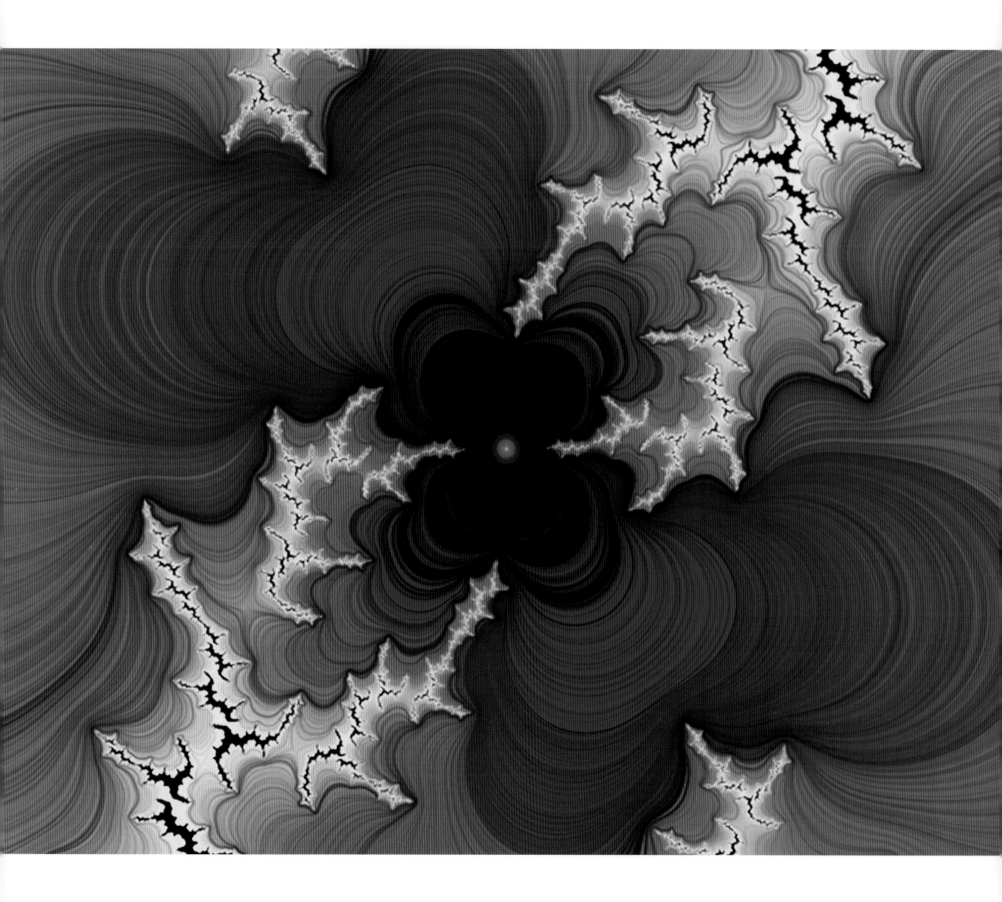

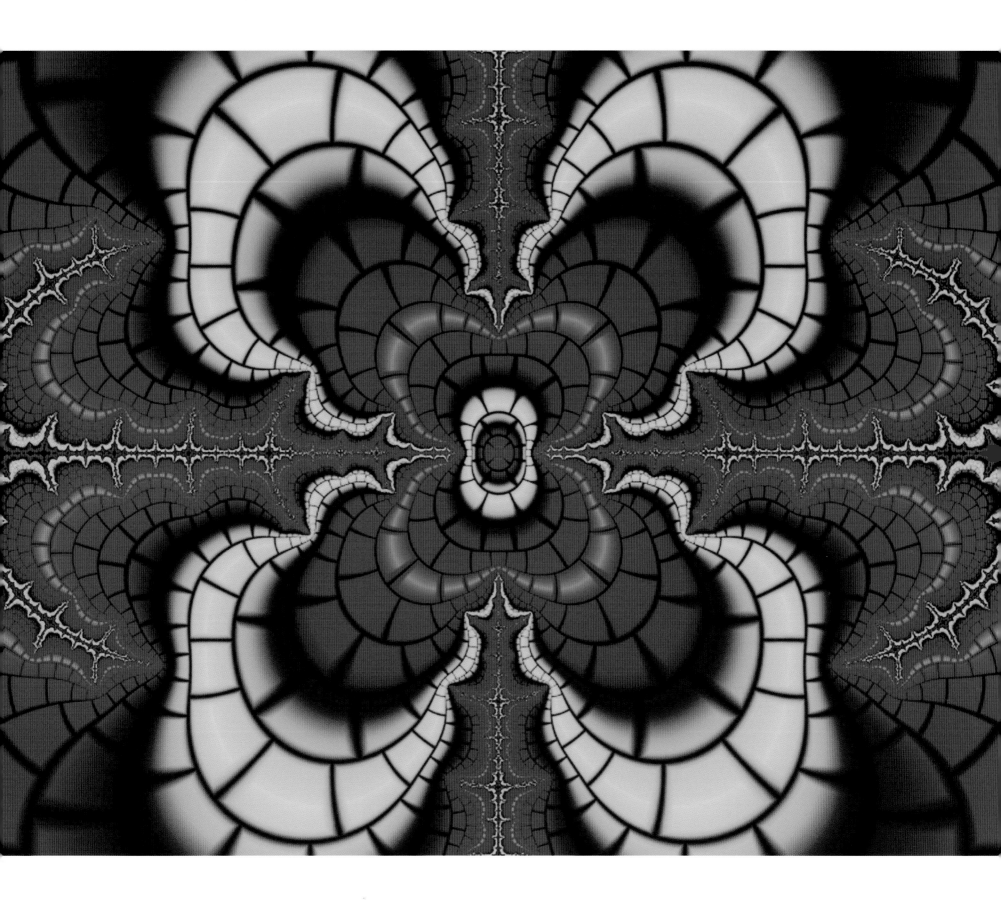

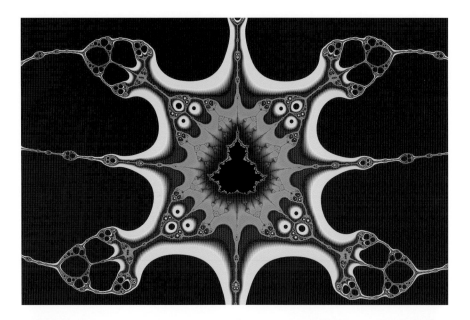

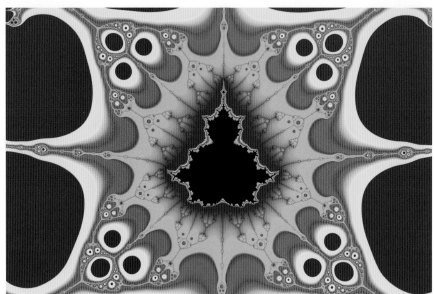

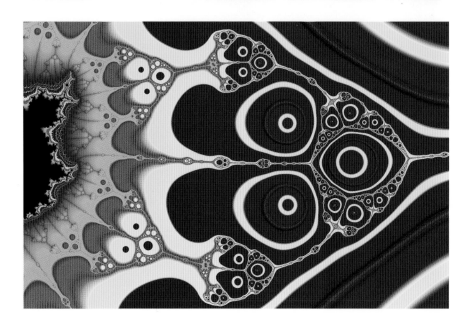

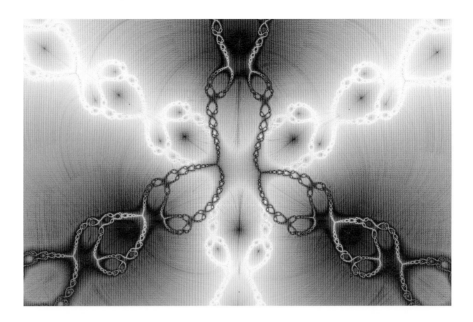

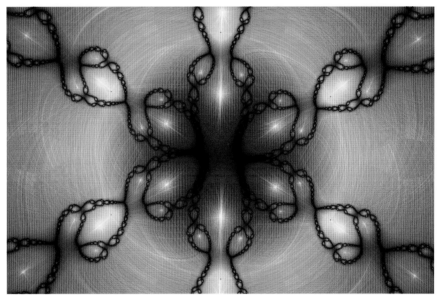

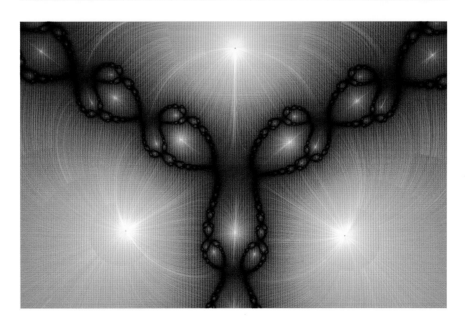

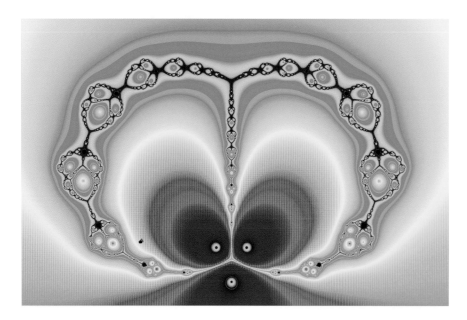

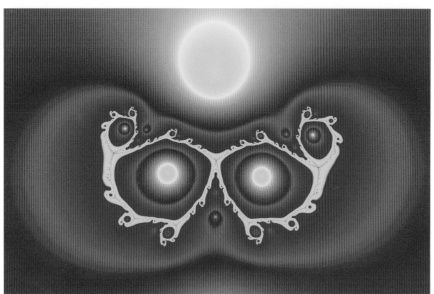

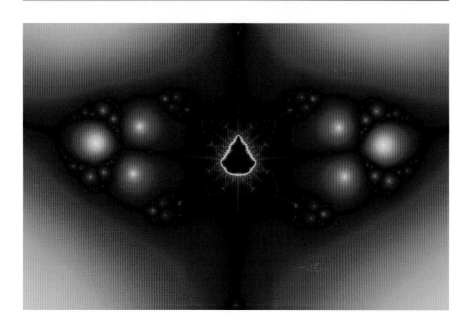

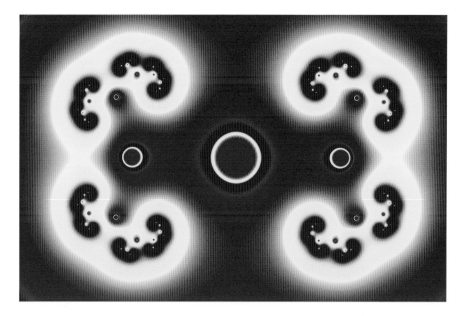

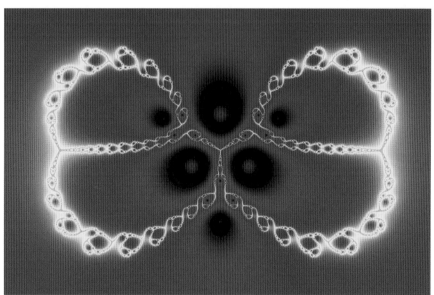

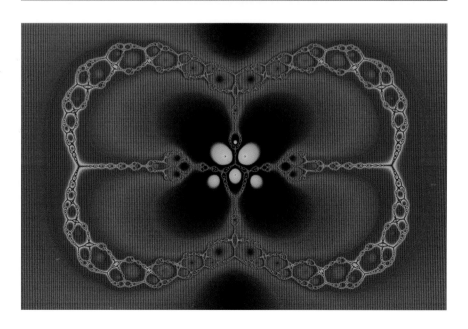

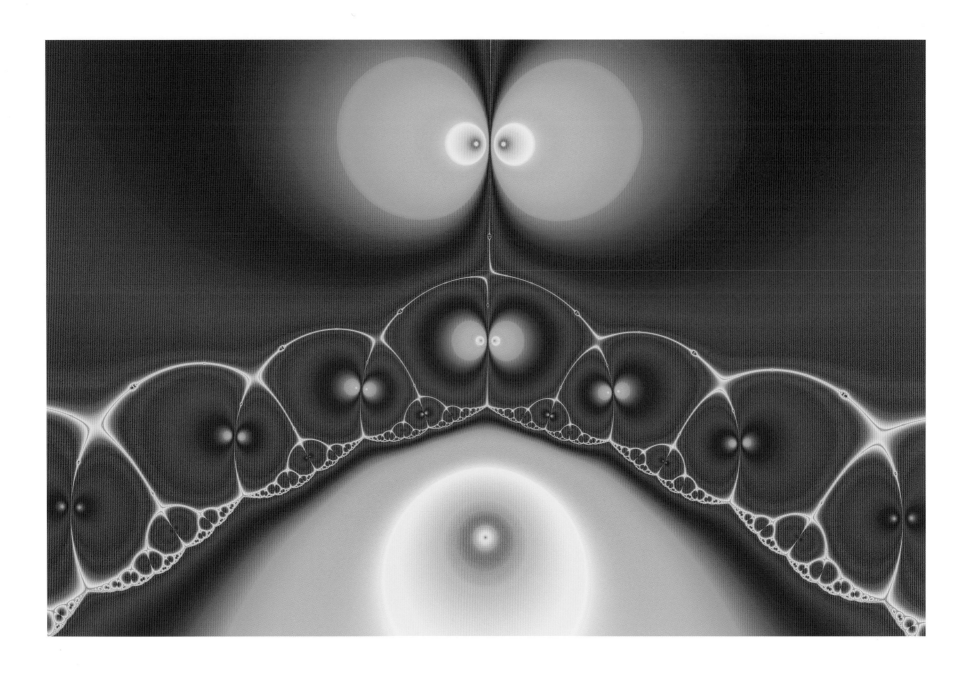

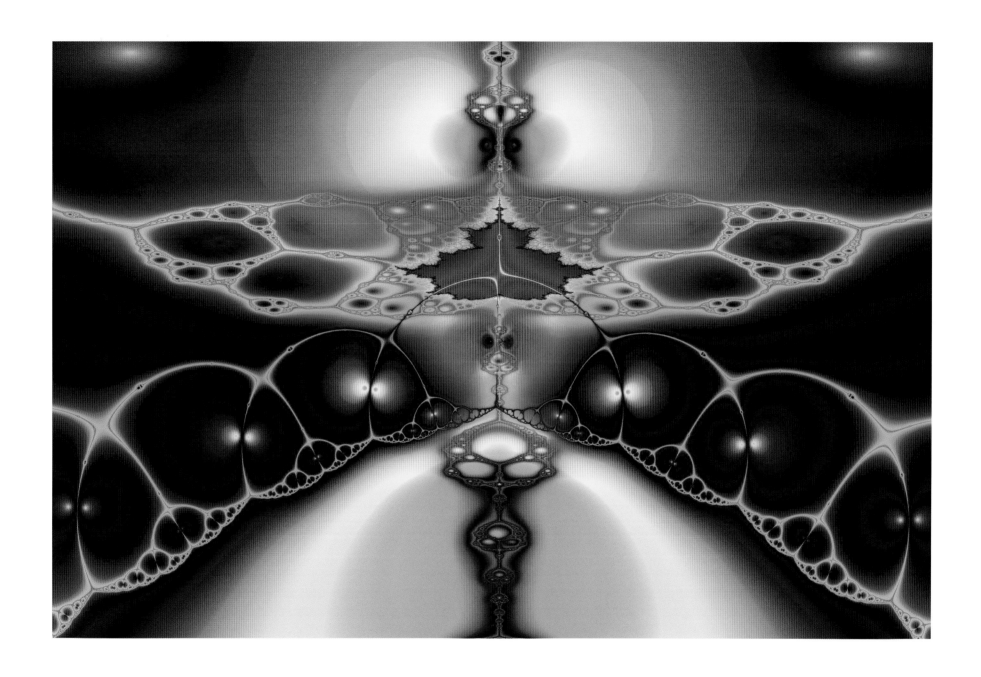

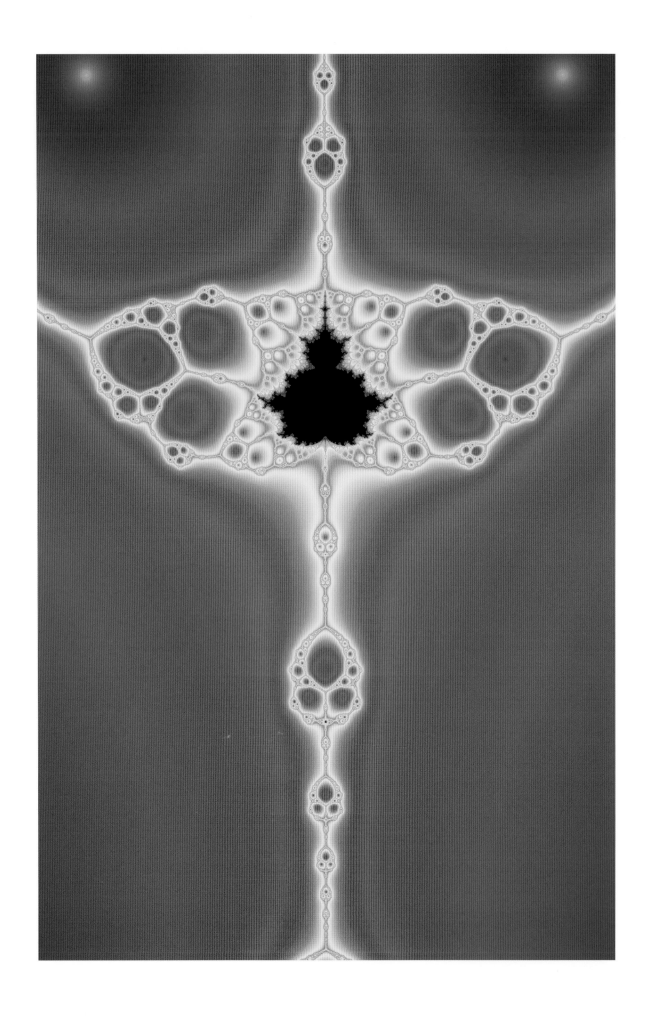

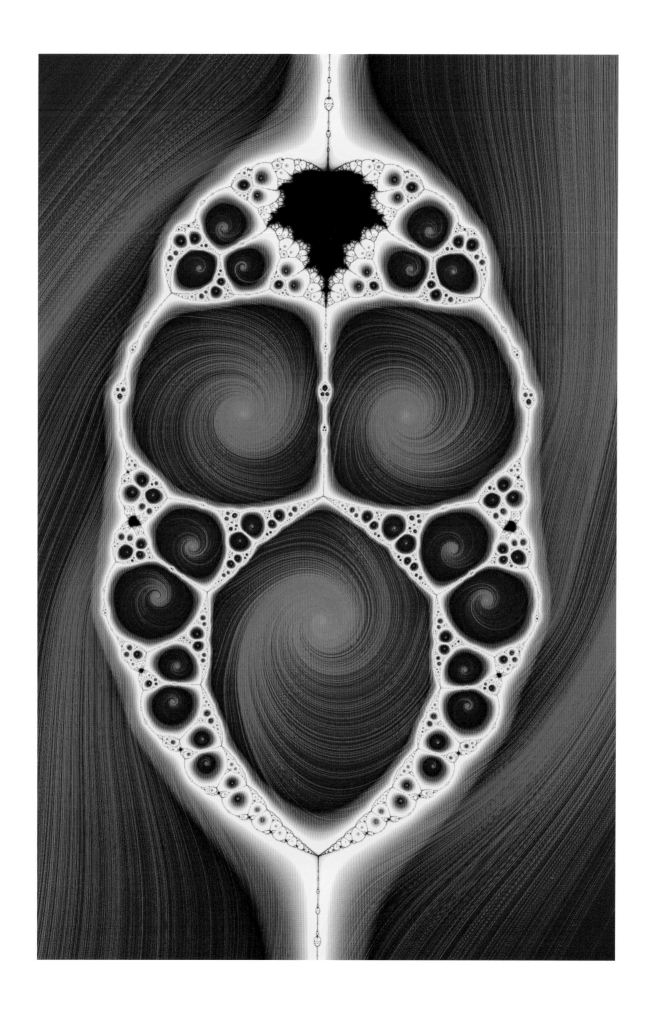

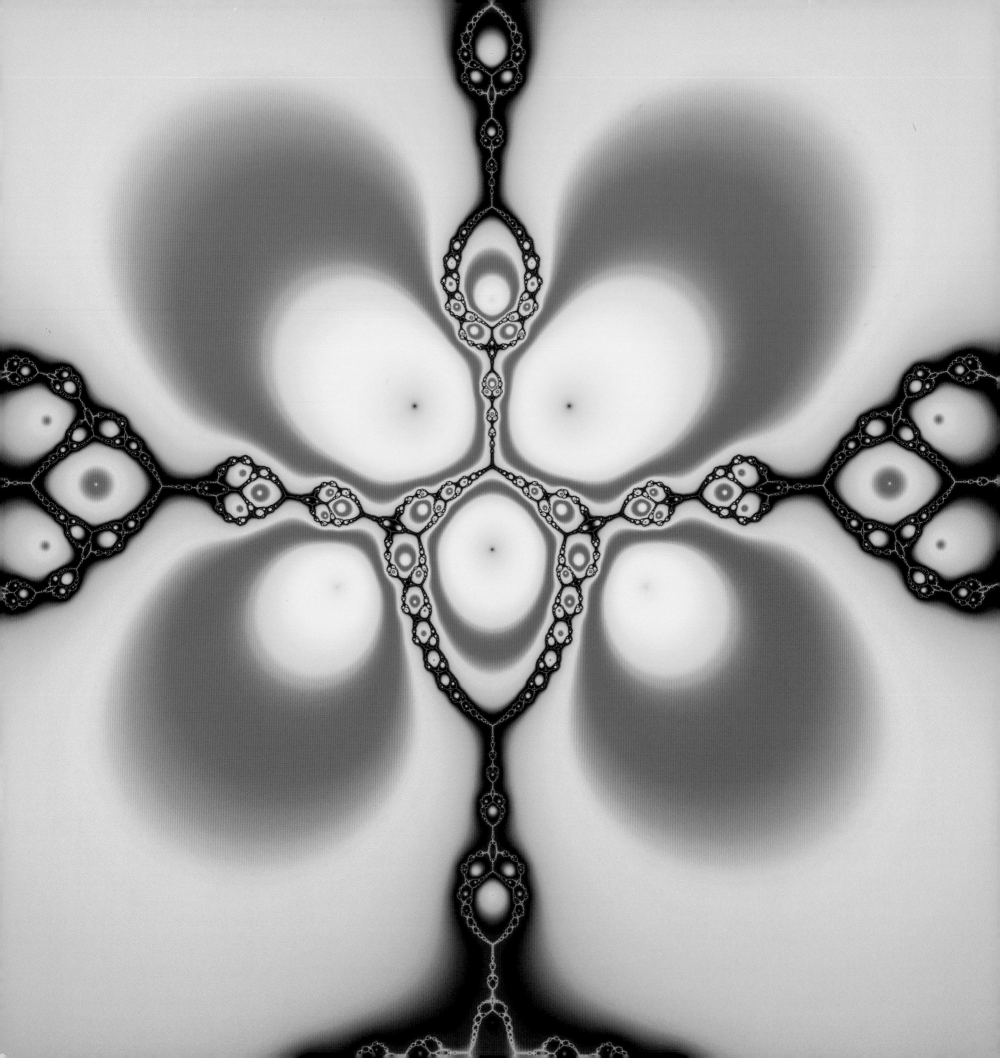

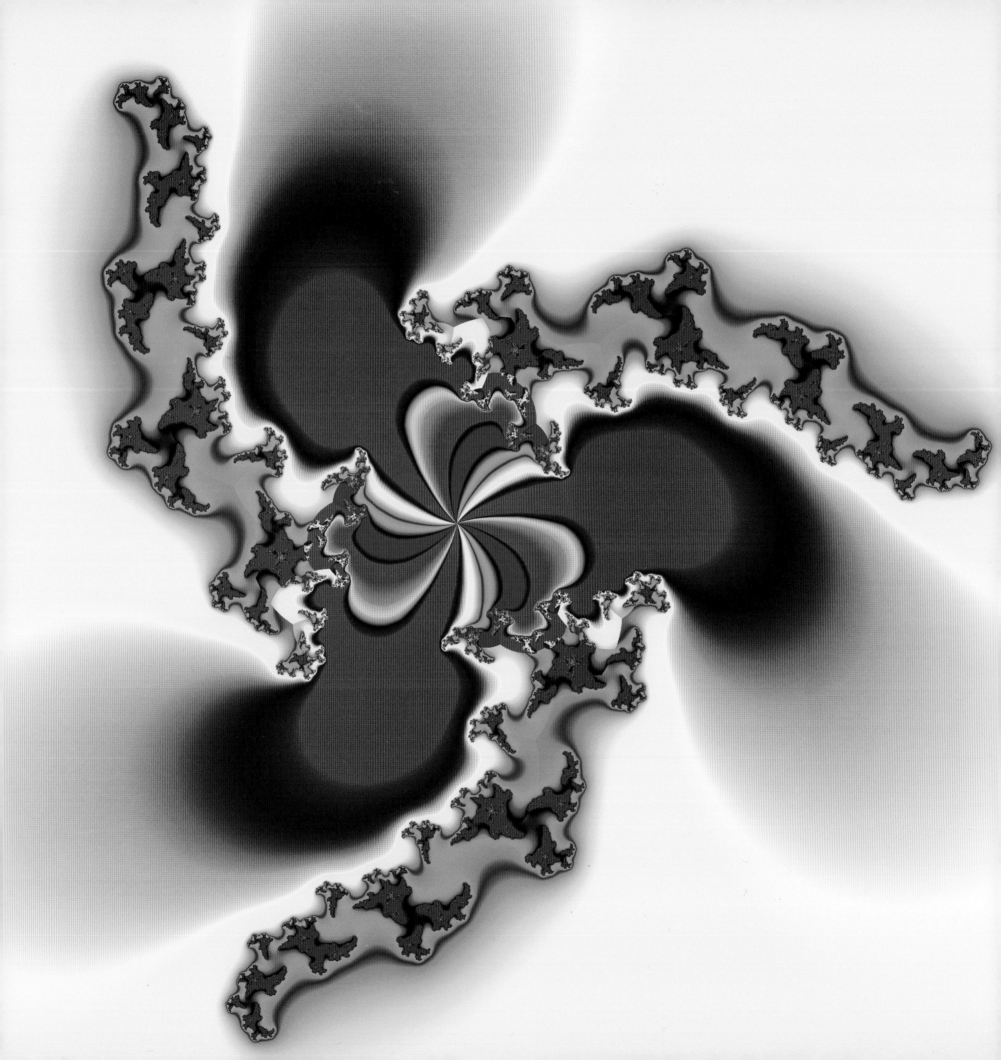

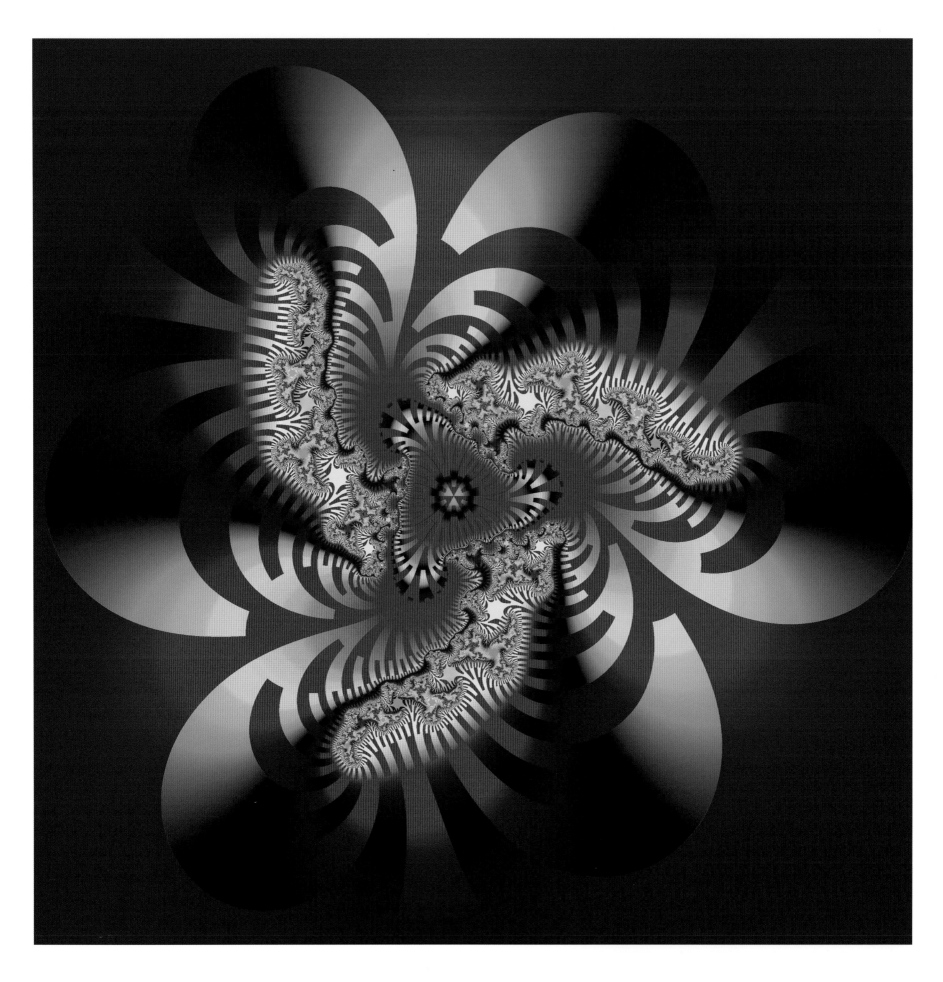

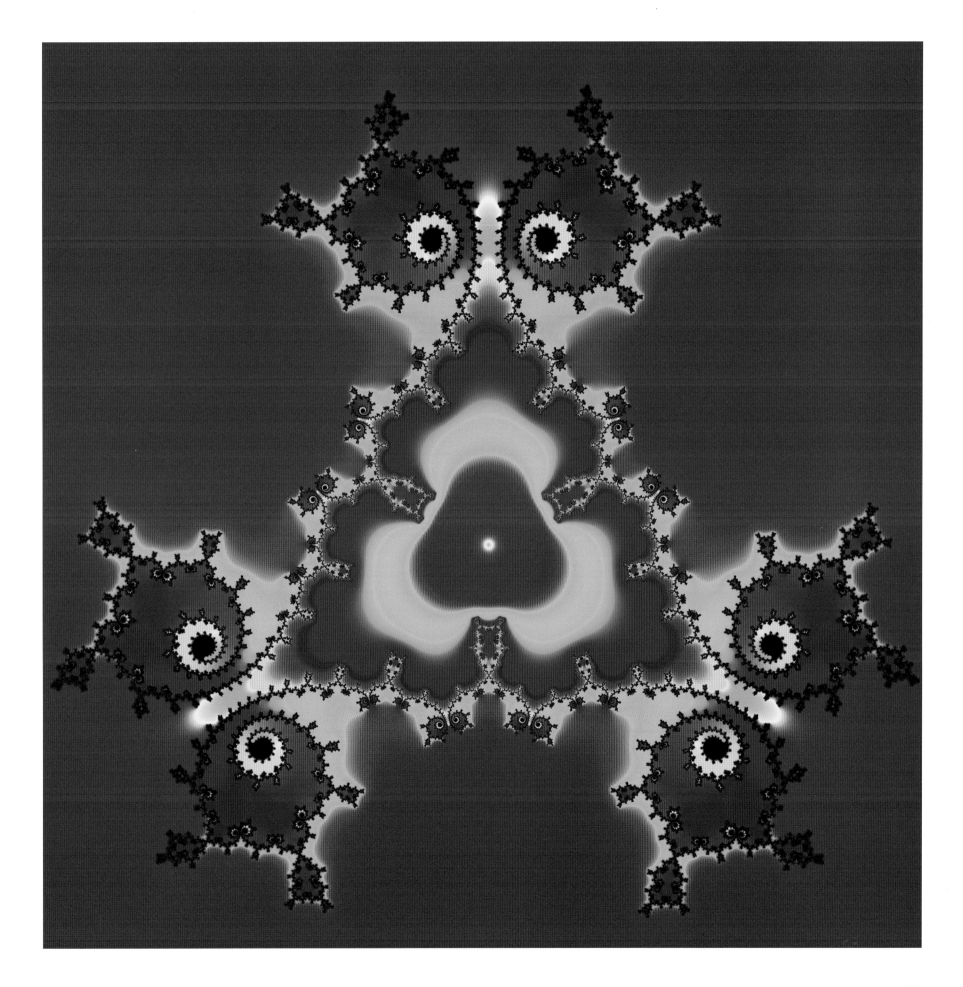

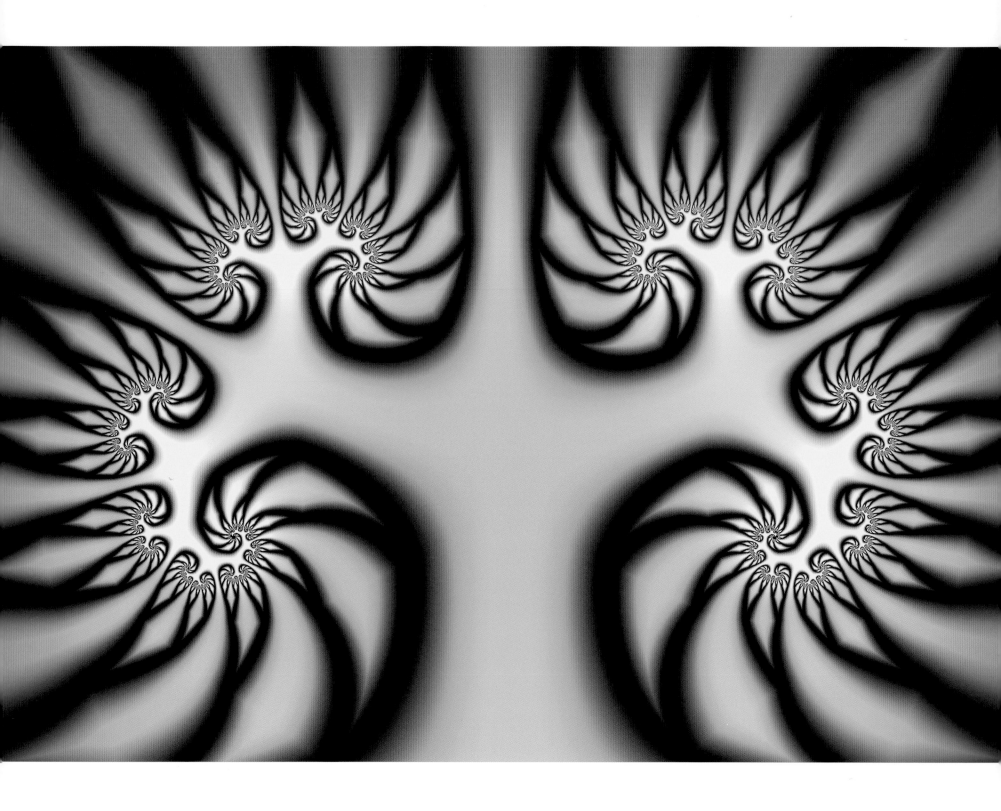

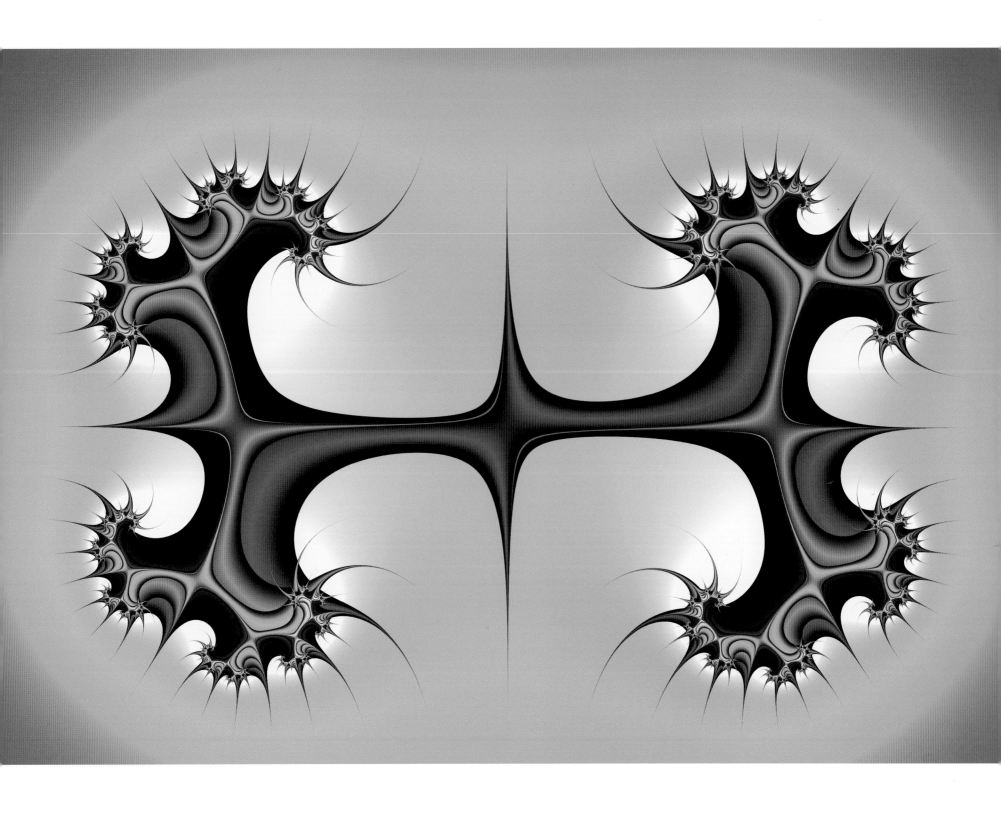

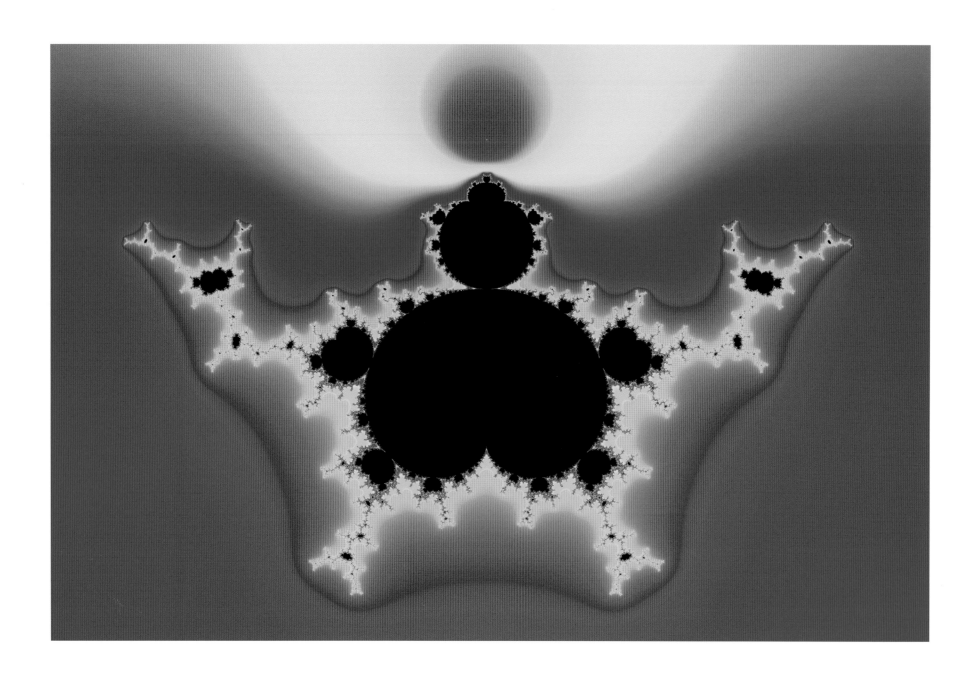

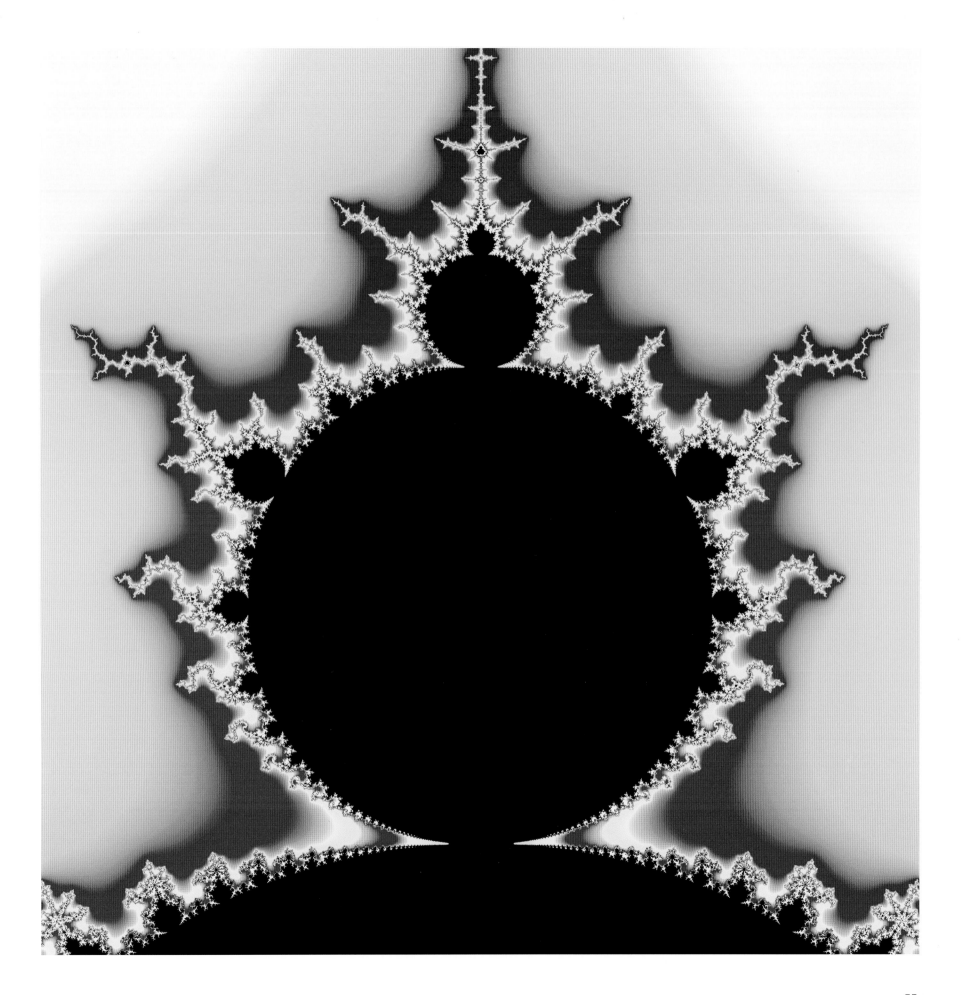

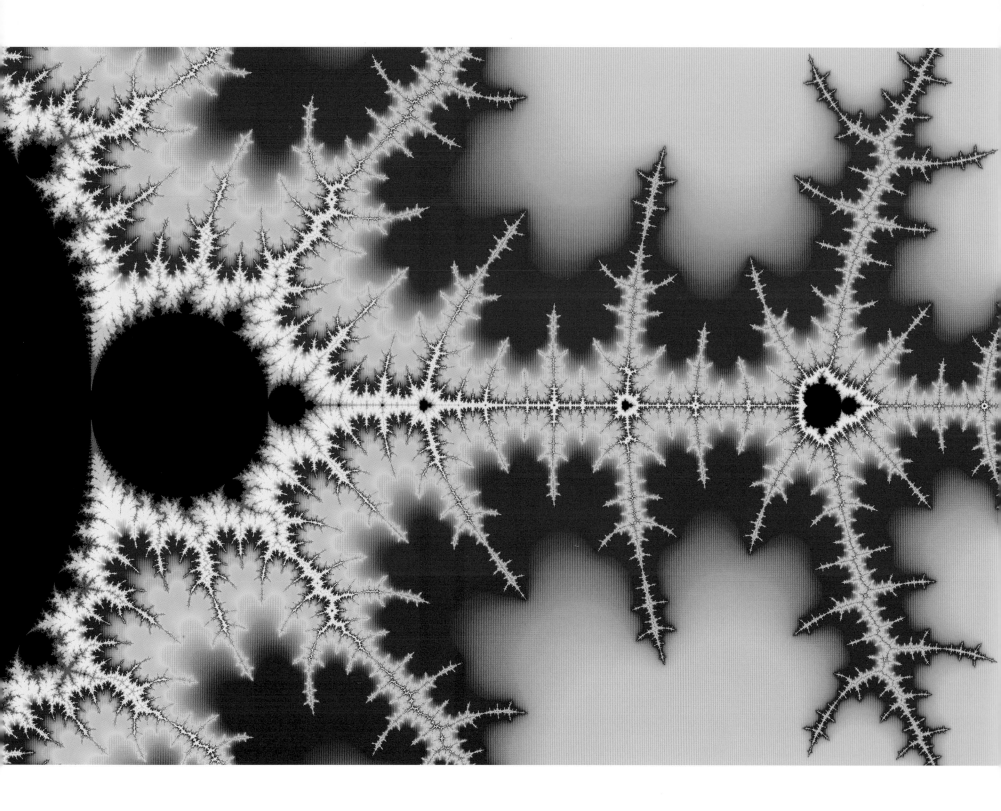

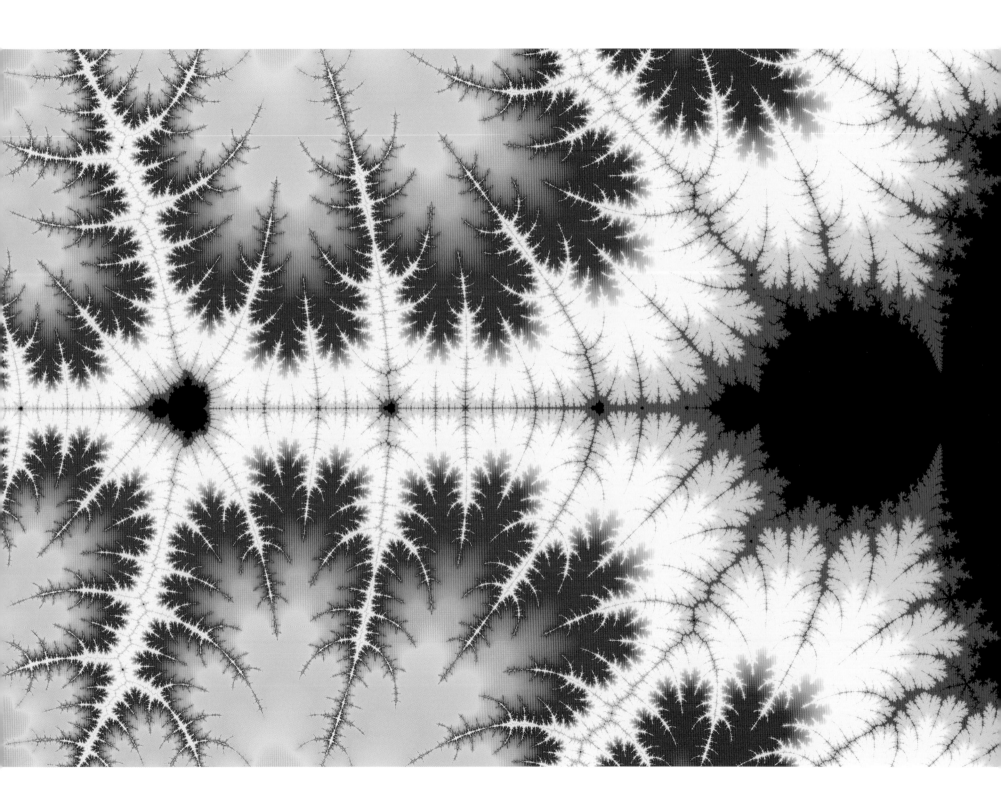

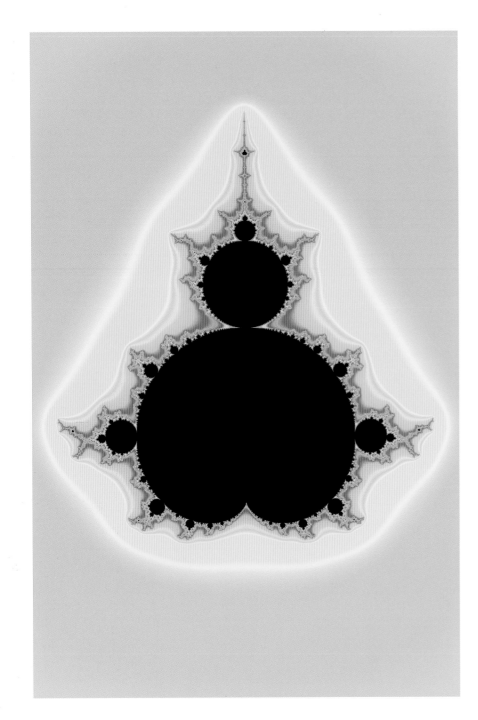

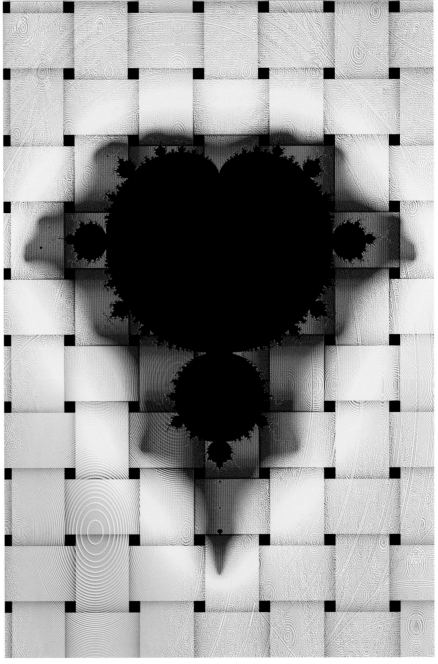

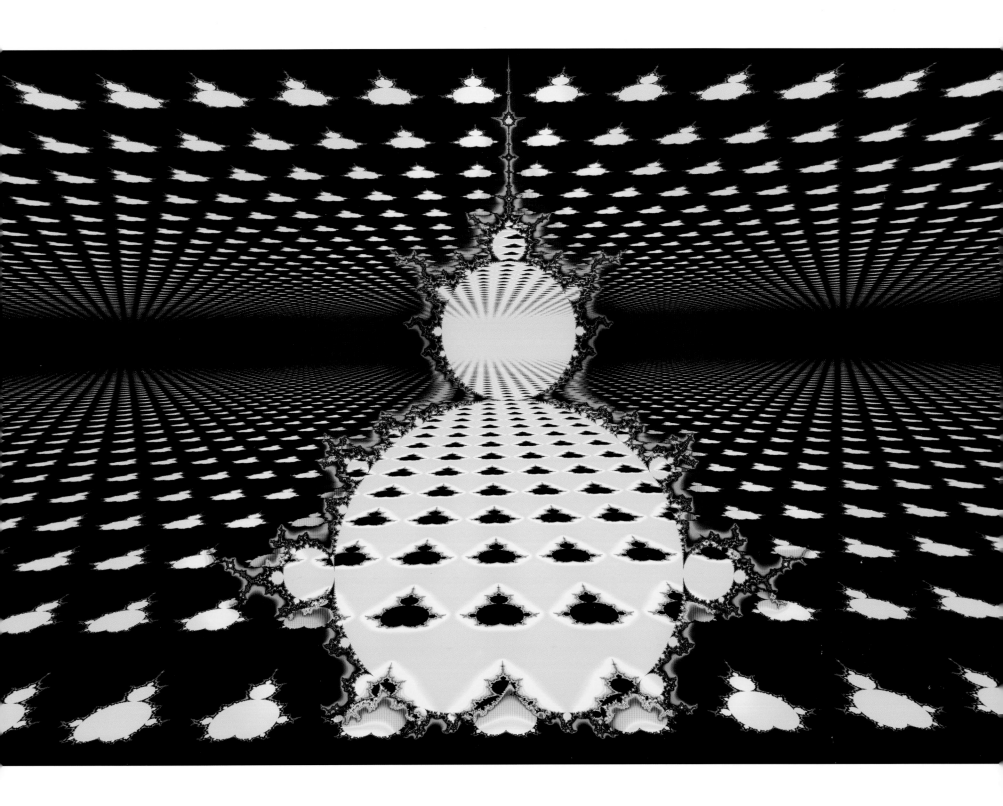

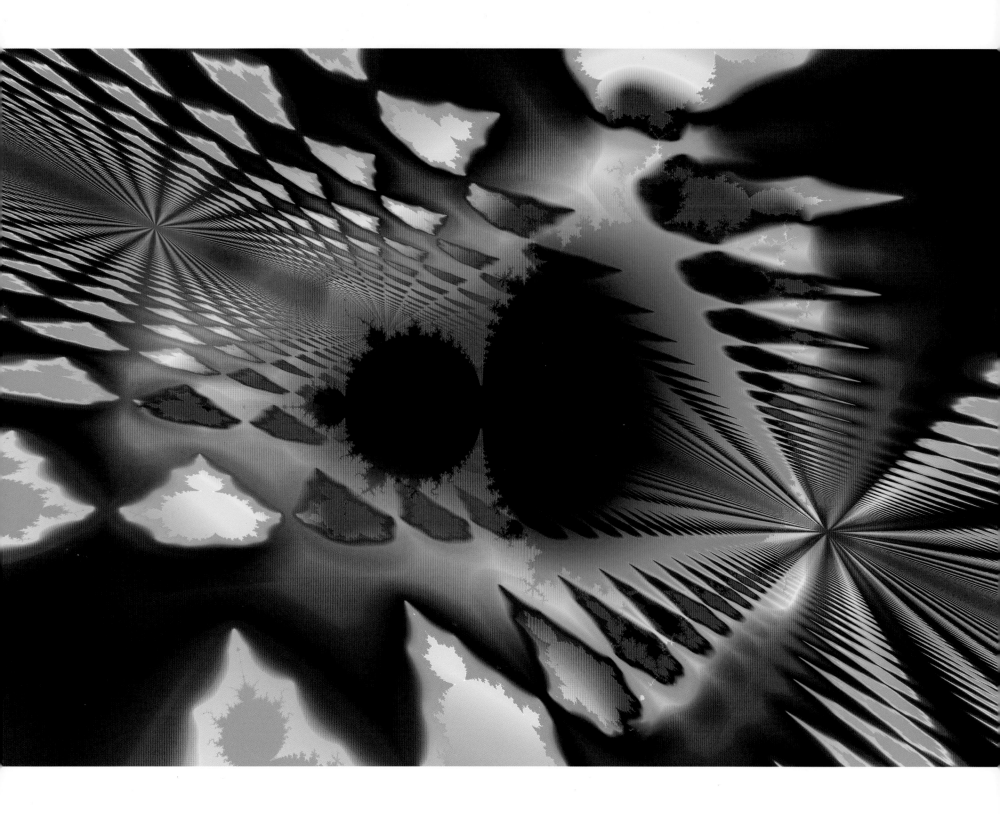

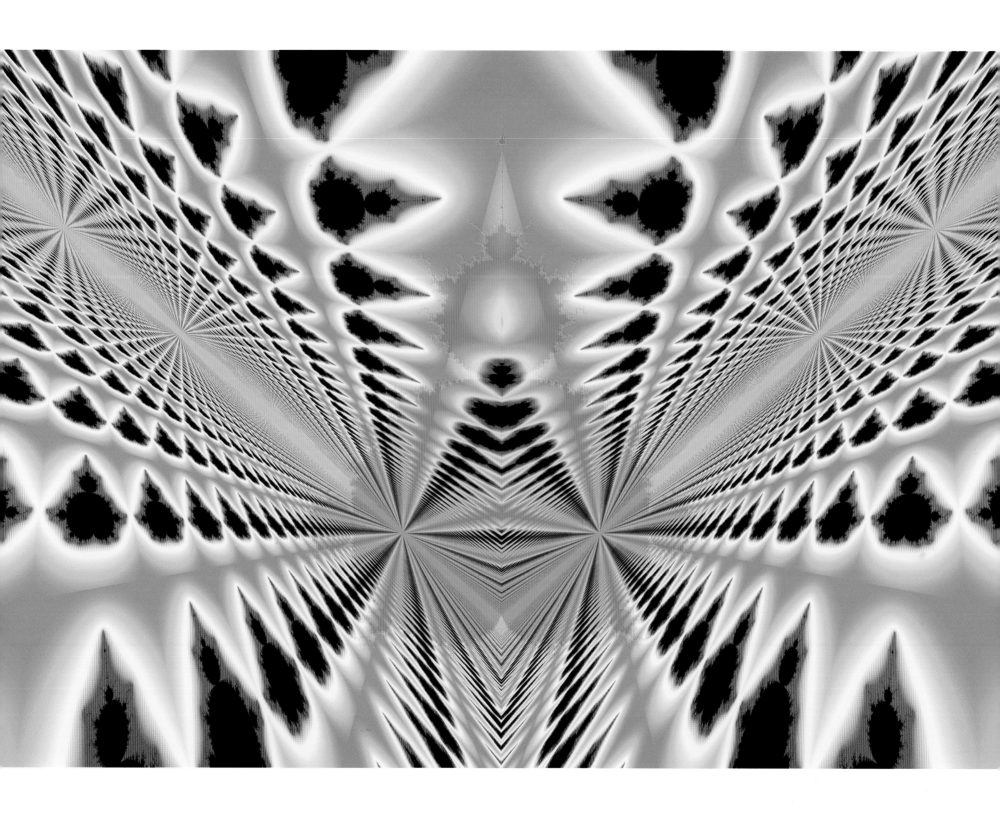

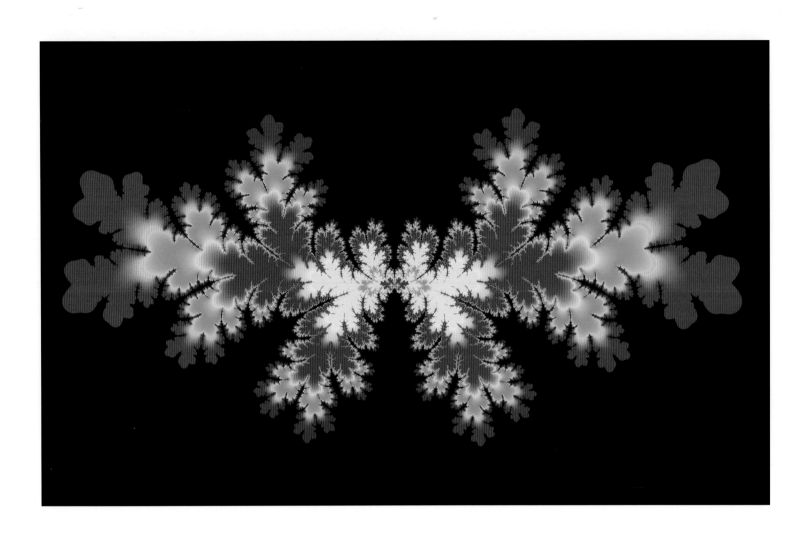

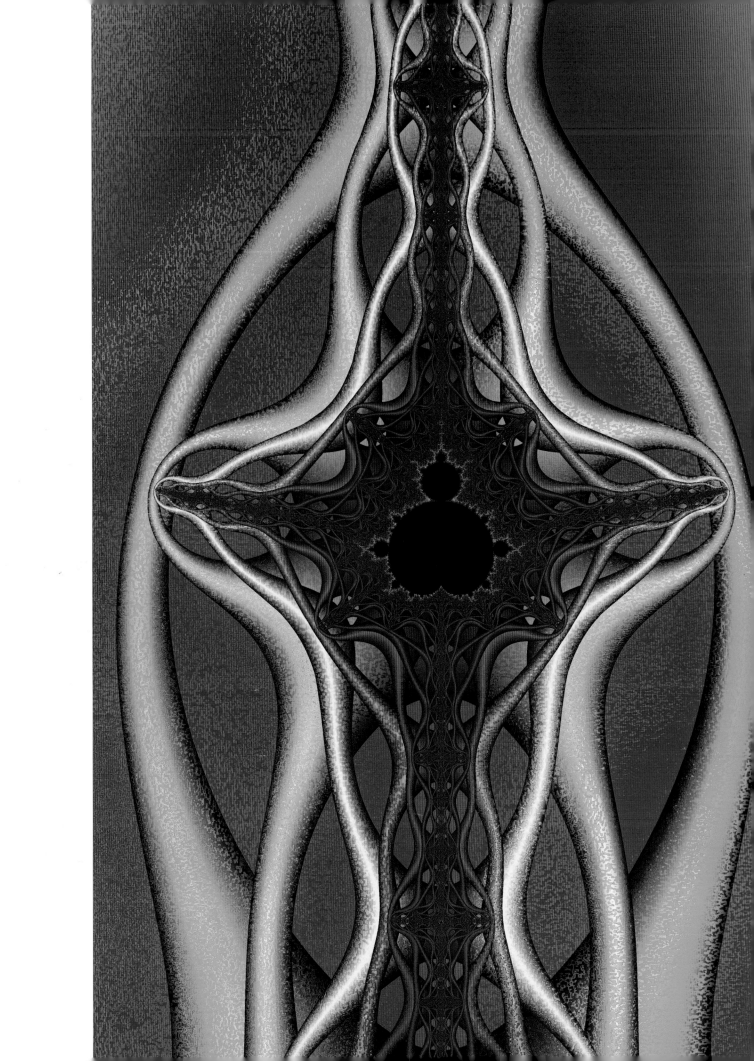

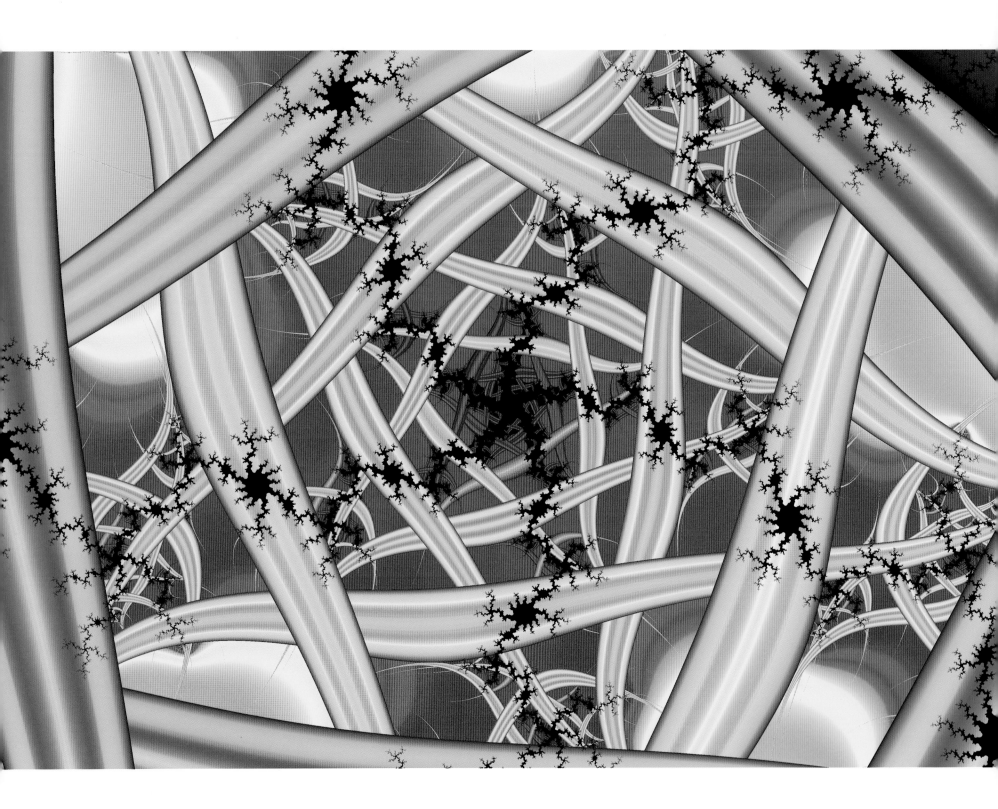

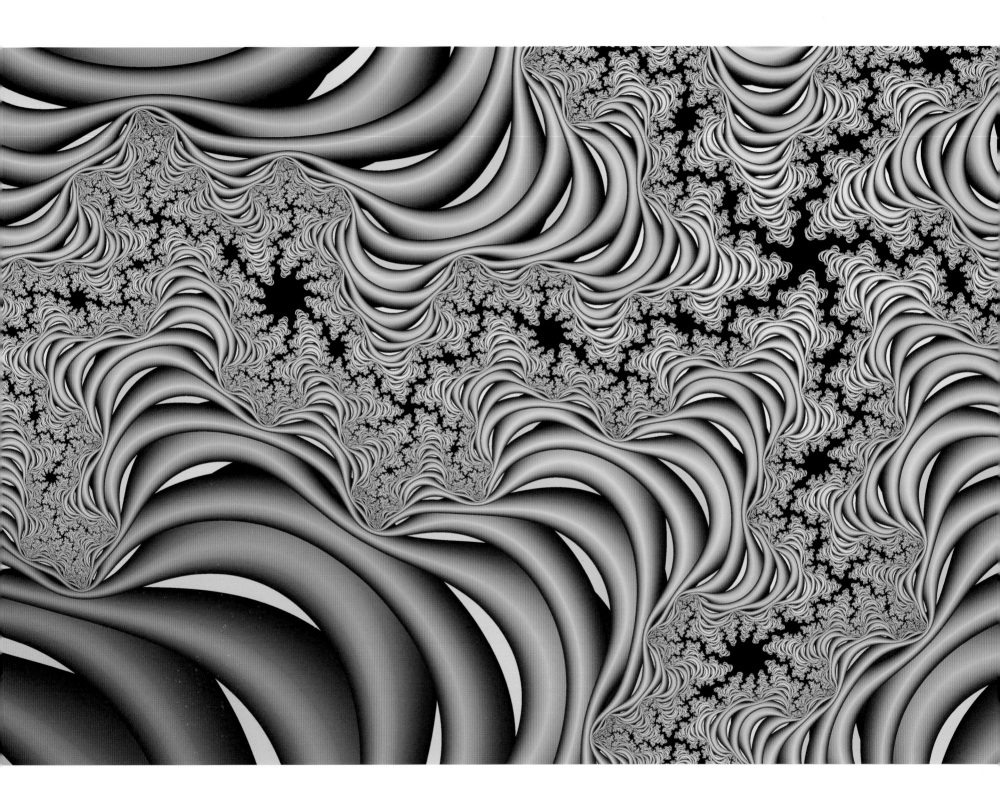

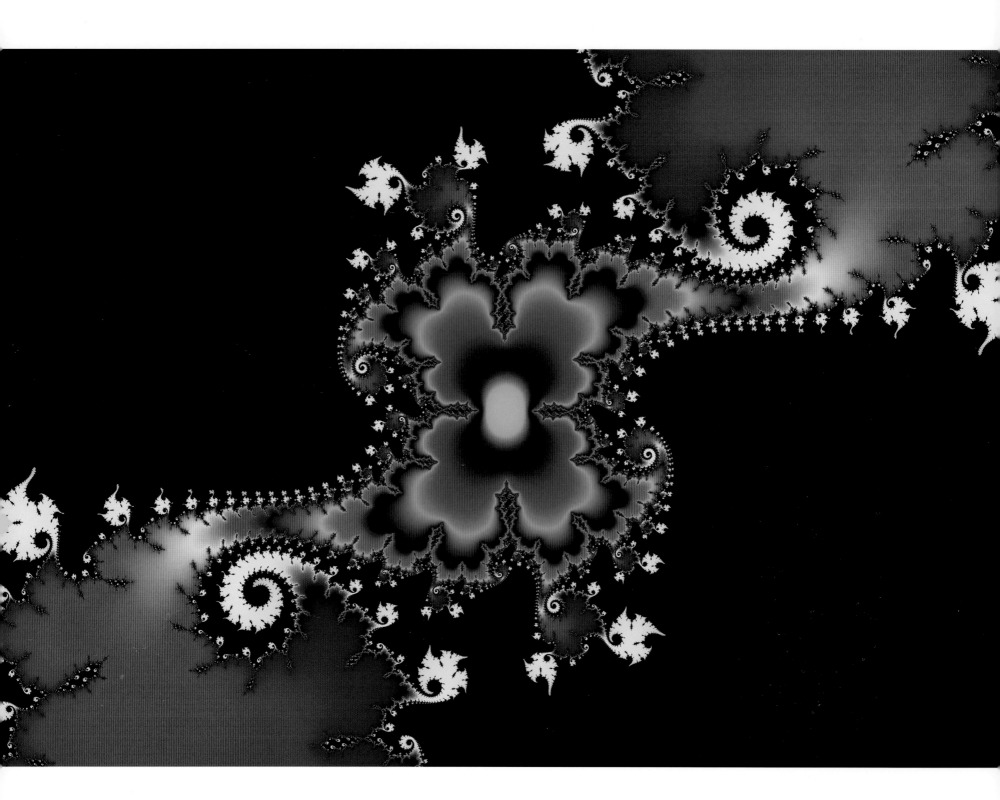

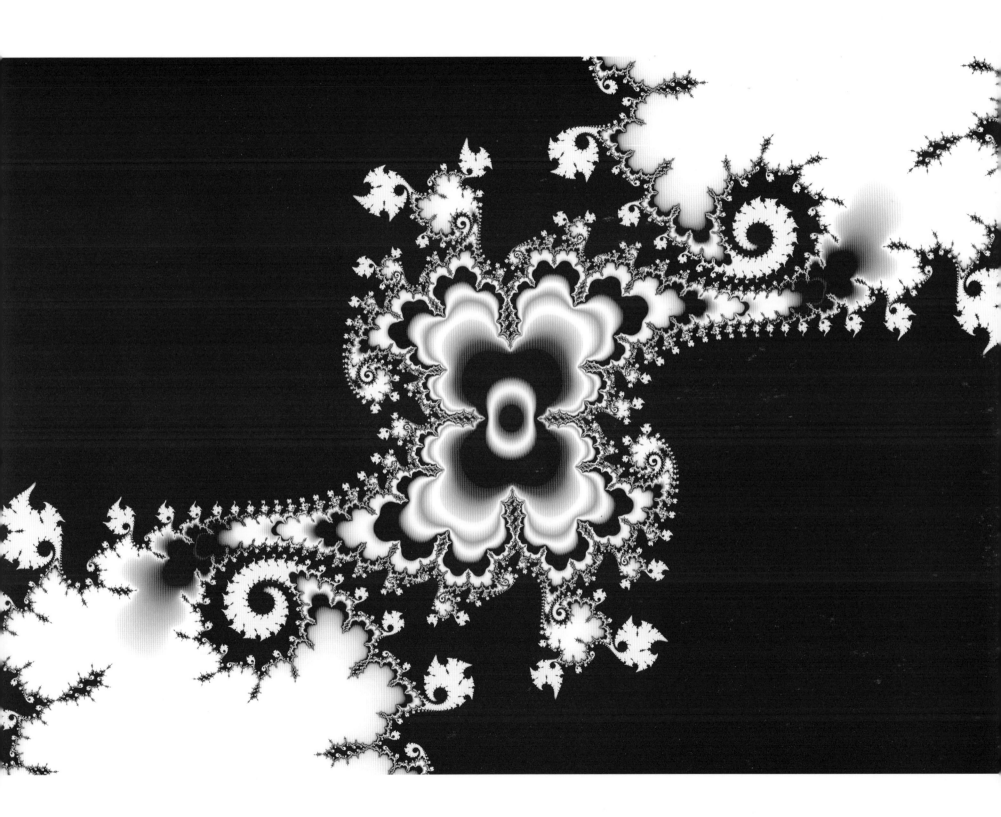

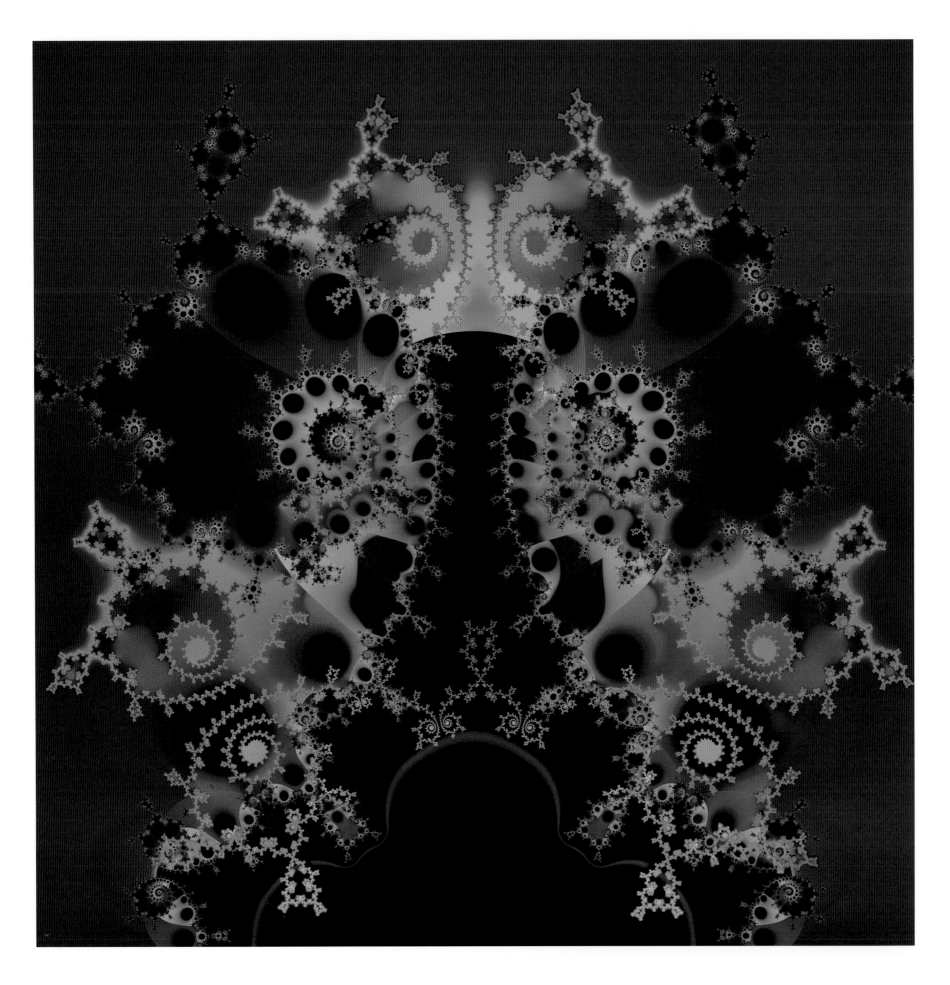

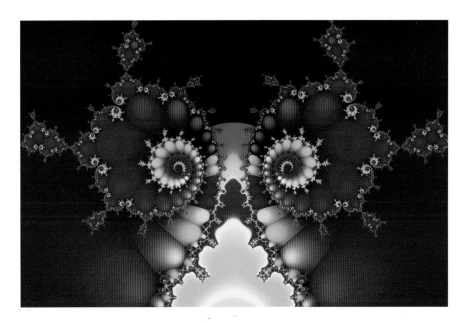

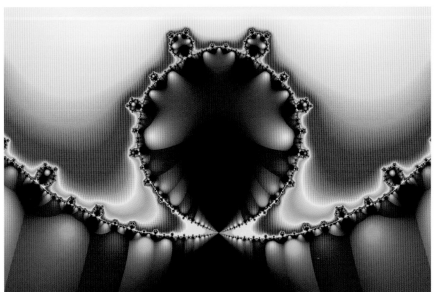

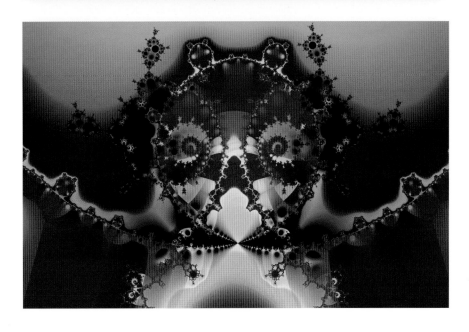

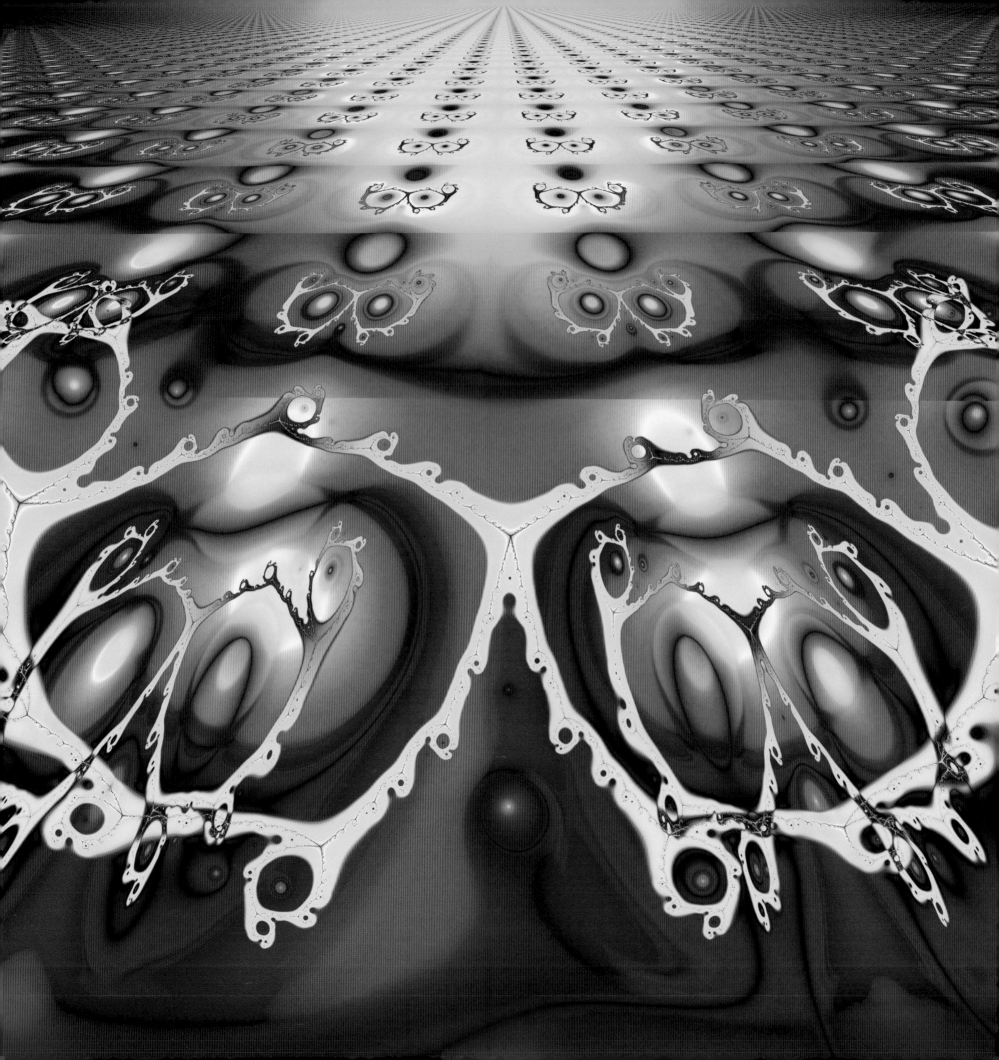

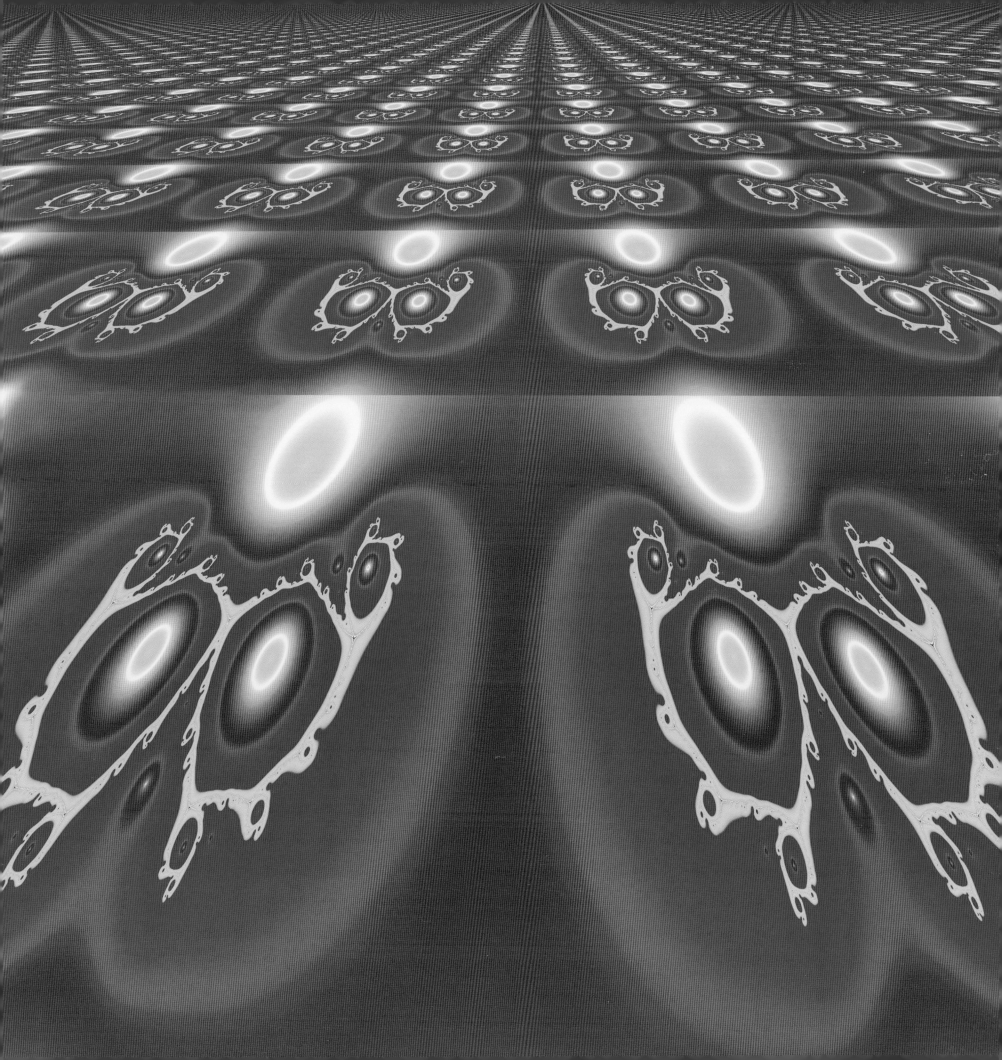

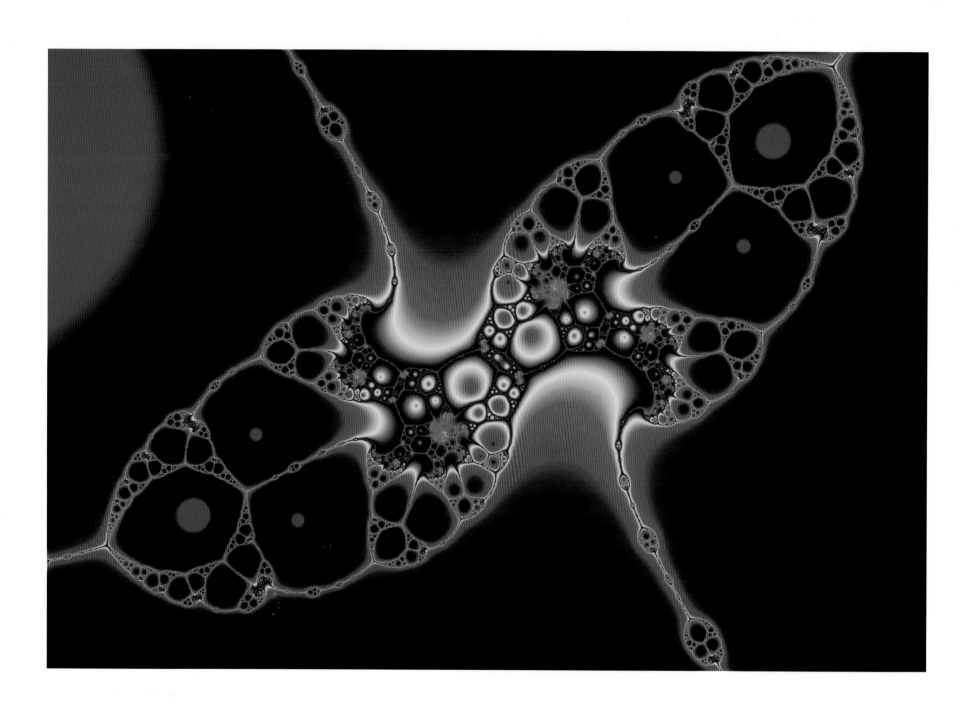

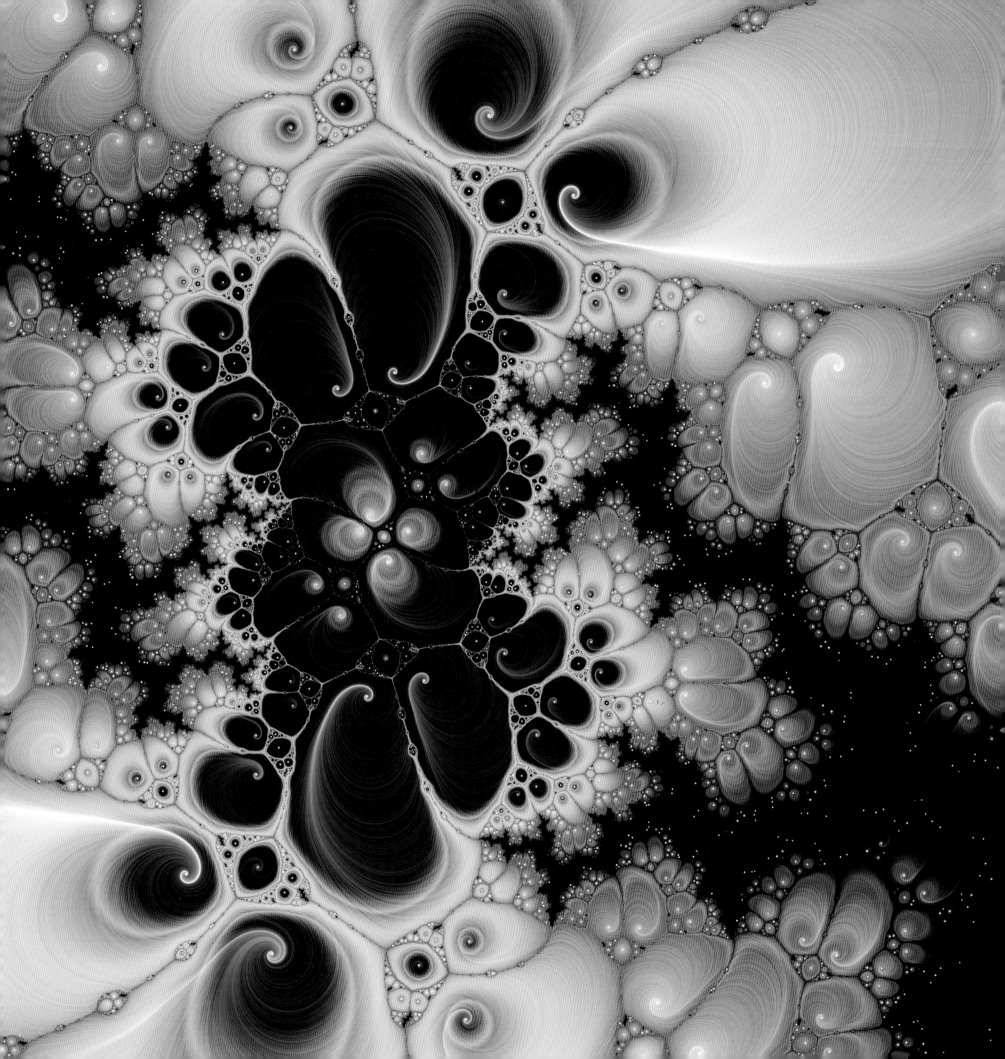

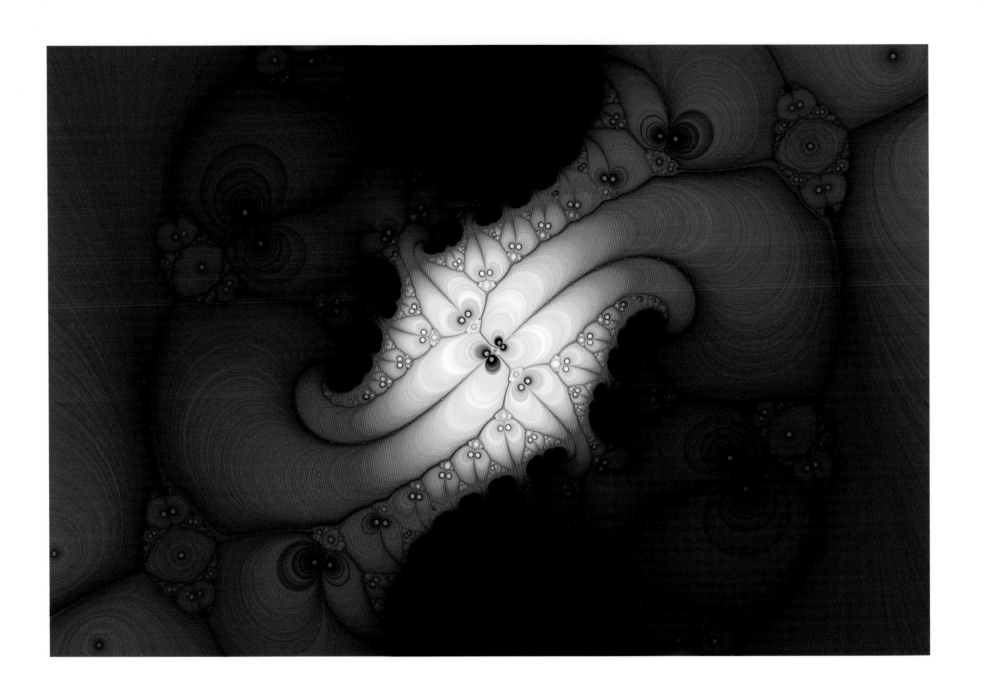

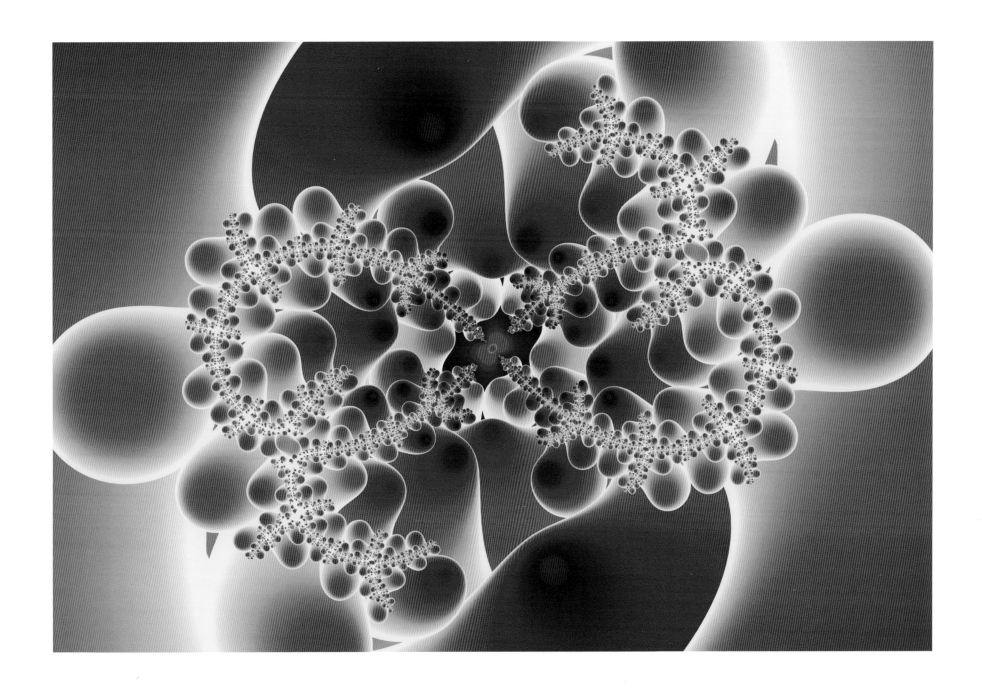

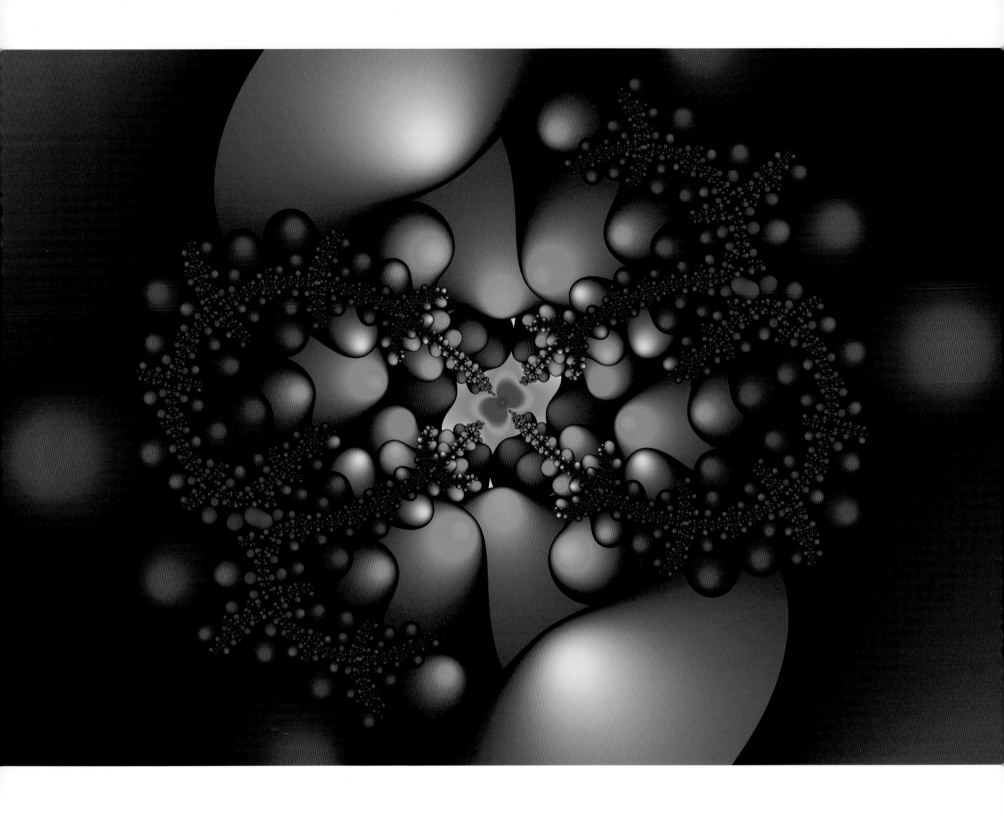

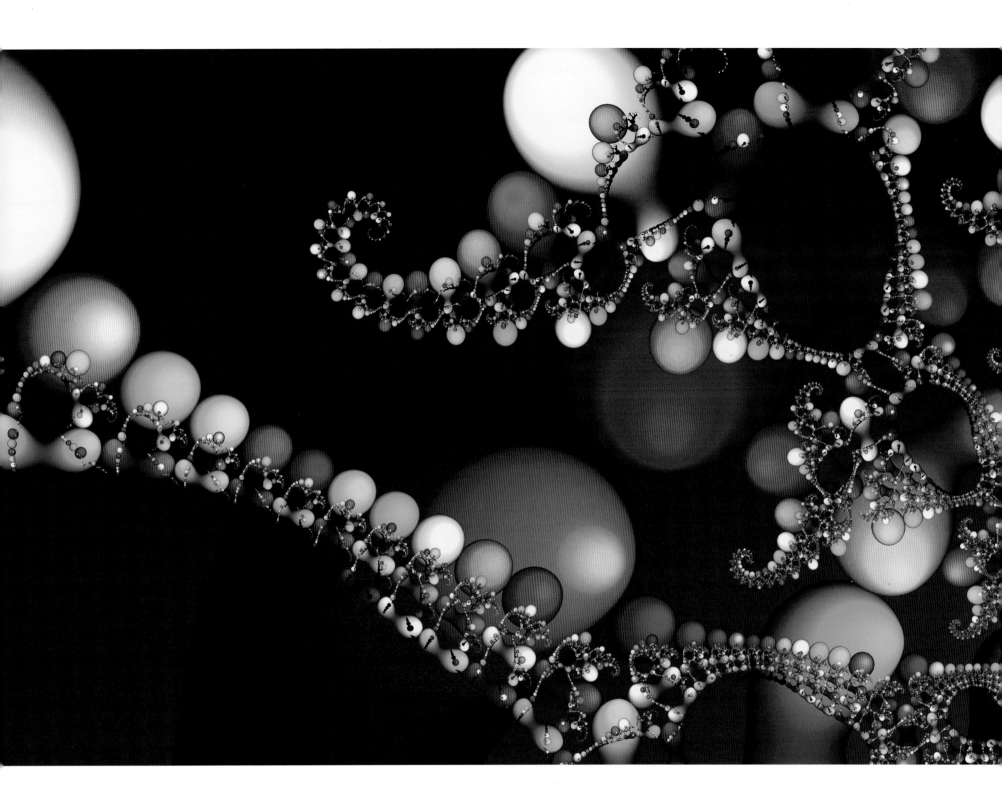

# CROP CIRCLES

CROP CIRCLES OU « CERCLES DE CULTURES »
**KORNKREISE**
LOS CÍRCULOS EN CAMPOS DE TRIGO
**CERCHI NEI CAMPI DI GRANO**
CÍRCULOS NAS PLANTAÇÕES
クロップサークル
麥田園

## Crop Circles

Crop circles are a phenomenon documented since the 16th century, in which designs have appeared overnight in crop fields all over the world. The stems of certain plants are bent just above the ground, but not broken, forming a binary pattern (standing plants, lying plants). The designs seem to follow the rules of ancient Egyptian sacred geometry determining the size, ratio and structure of the different elements in the pattern. Sizes vary between 100 and 400 meters in diameter.

There have been numerous scientific studies on crop circles, some funded by universities in England and Germany, to uncover and understand their origins, but no plausible answer or consistent theory has emerged. Some possible explanations and resulting questions are:

• It is a natural phenomenon caused by waves originating from below the surface of the earth. *But why has it not been possible to measure the radiation?*

• People are producing them (the 'Hoax Theory'). *But why would people secretly produce these designs without revealing themselves? And how could this practice continue for centuries in complete secrecy?* Furthermore, the footprints of the makers are easily detectable and seem to be present in only some fields where crop circles have been found.

• Aliens are creating them to communicate with us using advanced technology. *But why would these supposed aliens communicate with us yet not want to be seen? And if these signs contain a message, what would an appropriate reply be?*

## Kornkreise

Kornkreise sind ein seit dem 16. Jahrhundert dokumentiertes Phänomen, bei dem in aller Welt über Nacht Formen in Kornfeldern erscheinen. Die Halme gewisser Pflanzen sind kurz oberhalb des Erdbodens umgebogen – nicht geknickt – und bilden ein binäres Muster (stehende Pflanzen, umgelegte Pflanzen). Die Muster scheinen den Regeln antiker Ägyptischer Geometrie zu folgen, die Größe, Verhältnis und Struktur der einzelnen Elemente des Musters bestimmt. Die Durchmesser variieren zwischen 100 und 400 Meter. In einer großen Anzahl wissenschaftlicher Studien, die zum Teil auch von englischen und deutschen Universitäten durchgeführt worden sind, wurde bereits versucht, die Ursachen hinter den Kornkreisen zu erkennen und zu erklären. Dennoch konnte bis heute keine plausible Antwort oder stichhaltige Erklärung gefunden werden. Einige denkbare Erklärungen und damit zusammenhängende Fragen sind:

• Es ist ein natürliches Phänomen, das durch Wellen unterhalb der Erdoberfläche hervorgerufen wird. *Weshalb war es dann bisher nicht möglich, diese Strahlung zu messen?*

• Menschen haben die Kornkreise geschaffen (die ‚Hoax-Theorie'). *Weshalb aber sollten Menschen heimlich diese Formen erzeugen, ohne sich zu erkennen zu geben? Und wie kann dieses Vorgehen Jahrhunderte lang ganz im Geheimen andauern?* Außerdem würden sich Fußabdrücke dieser „Täter" leicht feststellen lassen, und dies war bisher nur bei einigen wenigen Kornkreisfeldern der Fall.

• Außerirdische Wesen legen sie an, um mit uns zu kommunizieren, wobei sie sich einer fortschrittlichen Technologie bedienen. *Aber weshalb sollten diese vermutlichen Außerirdischen mit uns kommunizieren, aber nicht gesehen werden wollen? Und falls diese Zeichen eine Botschaft enthalten, wie sollte dann angemessen darauf reagiert werden?*

## Crop Circles

Les crop circles ou « cercles de cultures » sont un phénomène attesté depuis le XVIe siècle et caractérisé par l'apparition de dessins dans les champs du monde entier : les tiges de certains plants sont courbées, sans être brisées, juste au-dessus du sol de manière à former un motif binaire (plants dressés, plants couchés) dont la conception semble suivre les règles d'une sorte de géométrie sacrée qui déterminerait la taille, la structure et les rapports de proportion des différents éléments du motif. Les tailles varient entre 100 et 400 mètres de diamètre.

De multiples études scientifiques, dont certaines financées par des universités anglaises ou allemandes, ont tenté de trouver et de comprendre l'origine des crop circles, mais sans qu'aucune réponse plausible ni aucune théorie cohérente n'émerge. Parmi les explications possibles, et les questions qui en découlent, figurent les suivantes :

• Il s'agit d'un phénomène naturel causé par des ondes émises sous la surface du sol. *Mais alors, pourquoi n'a-t-on jamais pu en mesurer la radiation ?*

• Ce sont des réalisations humaines (la « théorie du canular »). *Mais pour quelle raison quelqu'un créerait-il ces motifs en secret sans se faire connaître ? Et comment une telle pratique pourrait-elle se poursuivre pendant des siècles dans le plus grand secret ?* Par ailleurs, les traces de pas des auteurs sont faciles à détecter et ne semblent présentes que dans certains des champs où des crop circles sont retrouvés.

• Des extra-terrestres tracent ces dessins, au moyen d'une technologie très avancée, pour communiquer avec nous. *Mais pourquoi ces supposés extra-terrestres voudraient-ils communiquer avec nous sans être vus ?*

*Et si ces signes sont porteurs d'un message, quelle réponse conviendrait-il de leur apporter ?*

## Los círculos en campos de trigo

Este fenómeno, documentado desde el siglo XVI, consiste en la aparición de dibujos en los campos de trigo y se ha observado en lugares de todo el mundo. Los tallos de algunas plantas aparecen doblados a ras de suelo –sin llegar a estar rotos– formando un esquema binario (plantas derechas, plantas dobladas). Los diseños parecen seguir las reglas de una geometría sagrada que determina el tamaño, la proporción y la estructura de todos los elementos del dibujo. El tamaño de los círculos varía entre los 100 y los 400 metros de diámetro.

Numerosos estudios científicos, algunos financiados por universidades de Inglaterra y Alemania, han tratado de esclarecer y comprender los orígenes de este fenómeno. Aunque hasta la fecha no hay explicaciones plausibles o teorías unánimes, a continuación se exponen algunas de las hipótesis y las preguntas que éstas, a su vez, plantean:

• Se trata de un fenómeno natural provocado por ondas que se originan a nivel subterráneo. Pero, *¿por qué no se han podido medir las radiaciones?*

• Son obra del hombre (la «teoría de la conspiración»). Si así fuera, *¿por qué alguien crearía estos dibujos sin darse a conocer? ¿Cómo se explica que una práctica así se haya mantenido en el más absoluto secreto durante siglos?* Además, aunque es fácil detectar las huellas de los autores, sólo se han encontrado en algunos de los campos en los que han aparecido círculos.

• Los extraterrestres, utilizando su avanzada tecnología, los crean para comunicarse con nosotros. *¿Pero por qué querrían comunicarse con nosotros sin ser vistos? Por otro lado, si estos signos escondieran un mensaje, ¿cuál sería la respuesta adecuada?*

# Cerchi nei campi di grano

Si tratta di un fenomeno documentato sin dal XVI secolo, caratterizzato dalla comparsa, di notte, di forme circolari nei campi di grano di tutto il mondo. I gambi di alcune piante sono piegati, e non spezzati, appena al di sopra del suolo, in modo da formare un modello binario (piante dritte, piante distese). I disegni sembrano seguire le regole di qualche geometria sacra che determina la dimensione, il rapporto e la struttura dei diversi elementi del modello. La dimensione varia tra i 100 e 400 metri di diametro.

Sono stati eseguiti molti studi scientifici, alcuni finanziati da università inglesi e tedesche, volti a scoprire e capire l'origine dei cerchi, ma non è stata trovata una risposta plausibile o teoria con fondamento. Di seguito, sono esposte alcune delle possibili spiegazioni e relative domande sorte a proposito di questo fenomeno:

• È un fenomeno naturale causato da onde che hanno origine sotto la superficie terrestre. *Ma allora perché non è stato possibile misurare il livello di radiazione?*

• Sono opere create dall'uomo (la teoria dello scherzo). *Ma perché qualcuno sarebbe interessato a creare questi disegni di nascosto senza volersene attribuire il merito? E poi, com'è possibile che questa pratica sia stata portata avanti per secoli in completa segretezza?* Inoltre, le orme di piedi sono visibili unicamente in alcuni campi in cui sono presenti i cerchi nel grano.

• Sono stati gli alieni ad averli creati per comunicare con noi utilizzando una tecnologia avanzata. *Ma perché questi presunti alieni dovrebbero volere comunicare con noi senza essere visti? E se questi segni contengono davvero un messaggio, quale potrebbe essere la risposta corretta?*

# クロップサークル

一夜にして穀物畑にパターンが出現するクロップサークルについては、世界各地ですでに16世紀から報告があります。植物の茎が地面から直ぐ上の部分で折れることなく曲がり、（立っている茎、折れている茎という）2つの要素によってパターンが描かれます。このデザインは、様々なパターンの要素とその構造の比率を定める聖なる幾何学の法則に従っているように見えます。クロップパターナの規模は直径100mから400mまで色々です。この現象の起源についてはイギリスやドイツの大学による研究を含め、数多くの研究報告が行われていますが、信憑性の高い回答や一貫性のある理論はまだ出ていません。クロップサークルをめぐる憶測とそこに潜む疑問点には、次のようなものがあります：

これは地表下で発生する波動によって引き起こされる自然現象である。*しかし、そうすると、その波動はなぜ測定することができないのか？*

パターンは人間によって人為的に作られている（Hoax理論）。*ならば、人々はなぜ他人に知られずにこっそりとパターンを作ろうとするのか？さらに、どのようにして何世紀にもわたり完全な秘密を保ちつつパターン作りを継承することができたのか？さらに、人が作ったのなら足跡が残るのですぐ分かるはずだが、人の足跡は一部のクロップサークルでしか見つかっていないようだ。*

宇宙人が私たち人類とコミュニケーションを図るため最先端技術を用いてパターンを作っている。*だとすれば、その宇宙人は人類とのコミュニケーションを求めているのに、なぜ姿を現そうとしないのか？また、かりにこのシンボルが何らかのメッセージを含んでいるのだとすれば、それに対する適切な回答は何なのか？*

# Círculos nas plantações

Os círculos nas plantações são um fenómeno documentado desde o século XVI, segundo o qual desenhos têm aparecido durante a noite em campos de cultivo de todo o mundo. Os caules de certas plantas são dobrados um pouco acima do solo, mas não são partidos, formando um padrão binário (plantas de pé, plantas deitadas). Os desenhos parecem seguir as regras de uma geometria sagrada que define o tamanho, a proporção e a estrutura dos diferentes elementos do padrão. Os tamanhos variam entre os 100 e os 400 metros de diâmetro.

Têm sido realizados inúmeros estudos científicos sobre os círculos nas plantações, alguns deles subvencionados por universidades da Inglaterra e Alemanha, com o objectivo de descobrir e entender as suas origens, mas ainda não surgiu nenhuma resposta plausível ou teoria coerente sobre o assunto. Eis algumas explicações possíveis e perguntas relacionadas:

• É um fenómeno natural provocado por ondas com origem abaixo da superfície da Terra. *Mas porque não foi possível medir a radiação?*

• Há pessoas que fazem estes círculos (a «Teoria da troça»). *Mas por que motivo haviam as pessoas de produzir secretamente estes desenhos sem revelar sua autoria? E como é possível que essa prática se prolongue durante séculos no mais completo segredo?* Além disso, as pegadas dos autores podem ser facilmente detectadas e parecem estar presentes apenas em alguns campos onde se encontraram círculos nas plantações.

• Os extraterrestres estão a criar os círculos para comunicarem connosco usando uma tecnologia avançada. *Mas por que razão haviam esses supostos extraterrestres de comunicar connosco se não querem ser vistos? E, se esses sinais contêm uma mensagem, qual seria a resposta mais adequada?*

# 麥田園

自16世紀以來就有有關麥田園之文獻記錄：世界各地的莊稼地裡一夜之間出現了各種圖案。某些植物地表之上的莖出現了彎曲而非折斷，從而形成了一種兩位元圖案（直立植物、倒地植物）。這些圖案在樣式及結構上的各種要素之尺寸比例似乎符合某些宗教幾何的規則。其直徑介於100至400米之間。

為了發現並掌握麥田園之起源，全世界進行了無數次的科學研究（其中部份得到了英國及德國大學之資助），但至今仍未找到令人信服的答案或前後一致的假設。部份可能的解釋及隨之而來的問題包括：

這是植物表層以下的波動所造成的一種自然現象。*但為什麼始終無法測量這種輻射呢？*

這是一種人為現象（'惡作劇理論'）*但人們為什麼要秘密地製造出這些圖案，而不願為人所知？並且，如何能夠在幾個世紀的時間裡、在完全保密的情況下持續這一做法？此外，製造者的足跡只在部份麥田園裡可明顯地探測到或存在。*

外星人製造了這些圖案，透過一種先進的技術與我們溝通。*但是，這些假想中的外星人如果想要與我們溝通，為什麼又不願讓人看見呢？如果這些符號中包含了一種資訊，我們又該如何作答呢？*

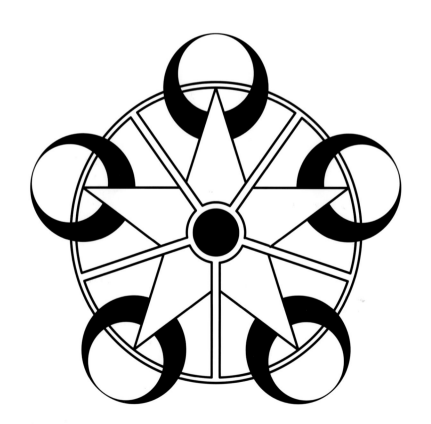

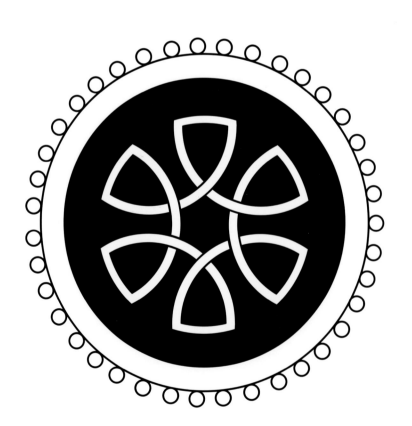

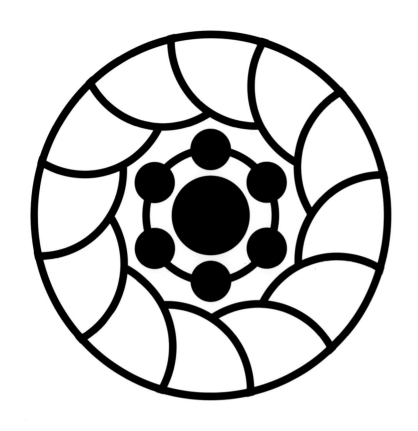

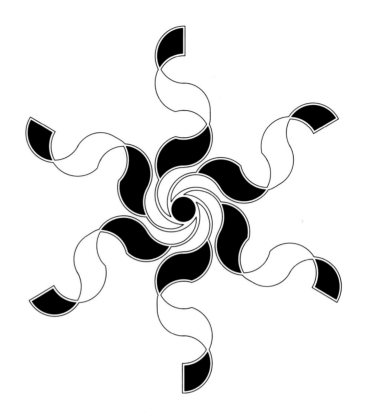

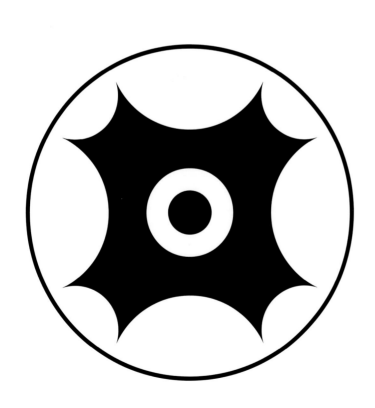

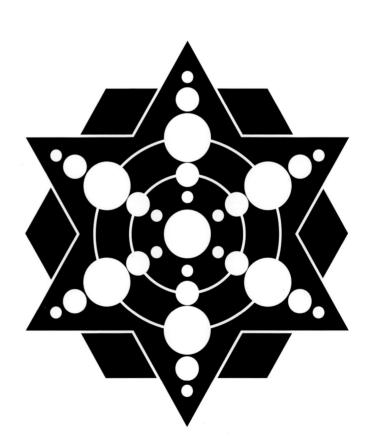

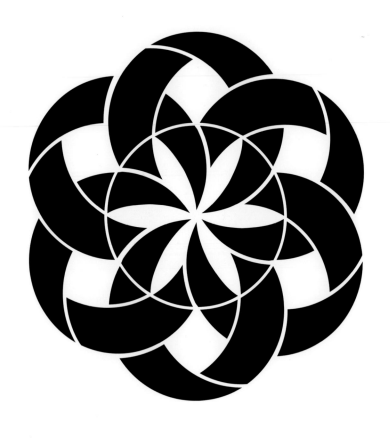

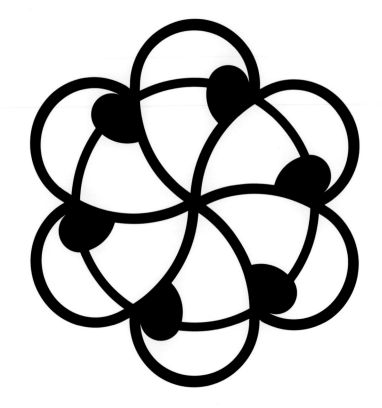

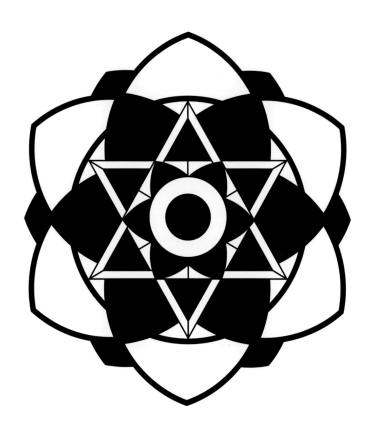

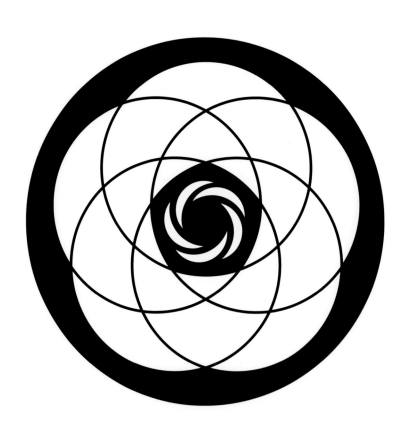

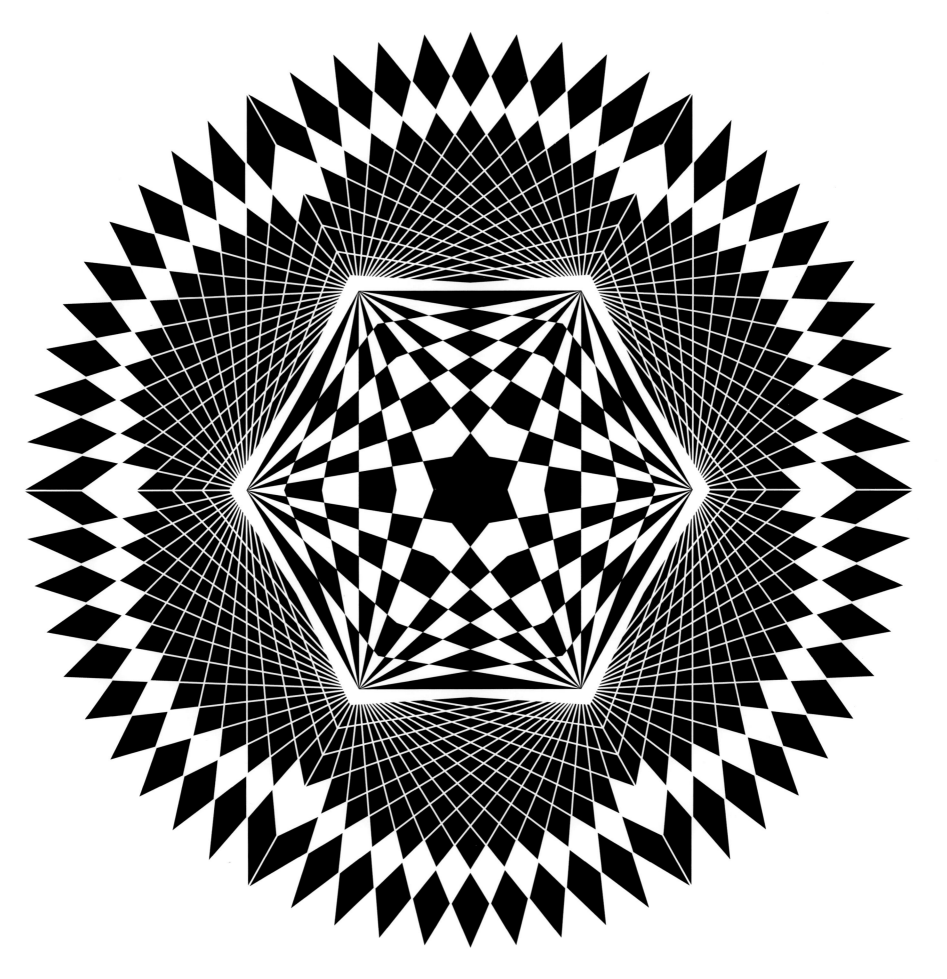

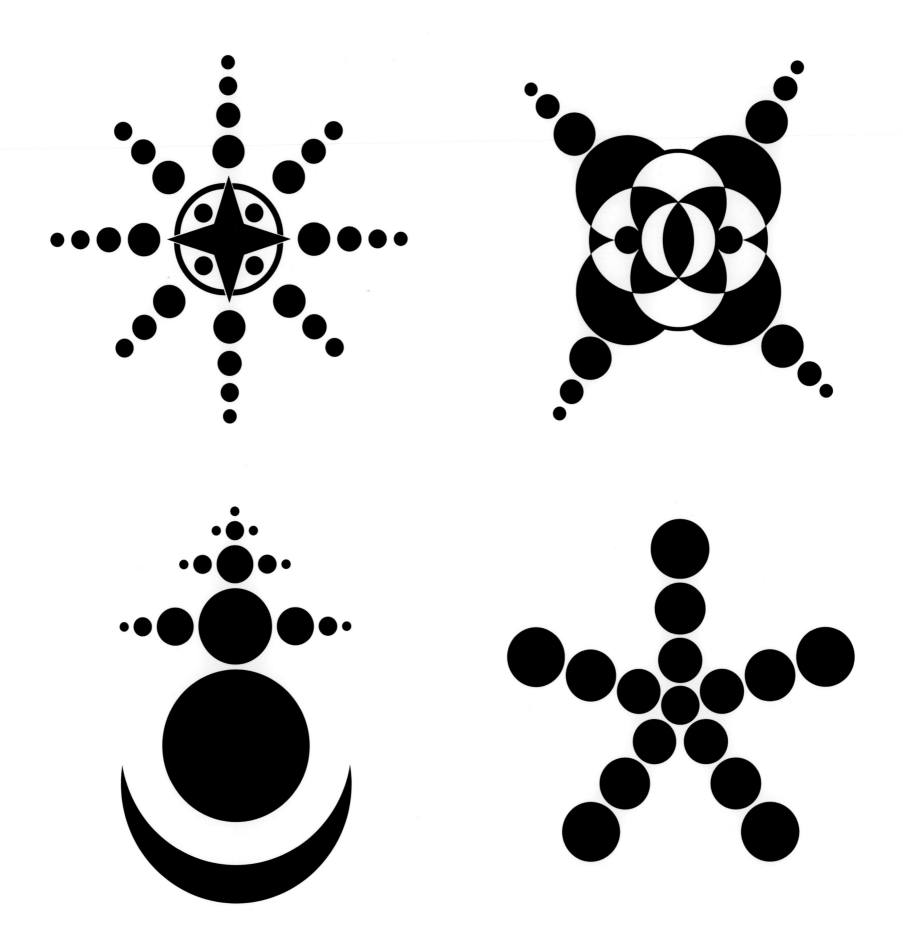

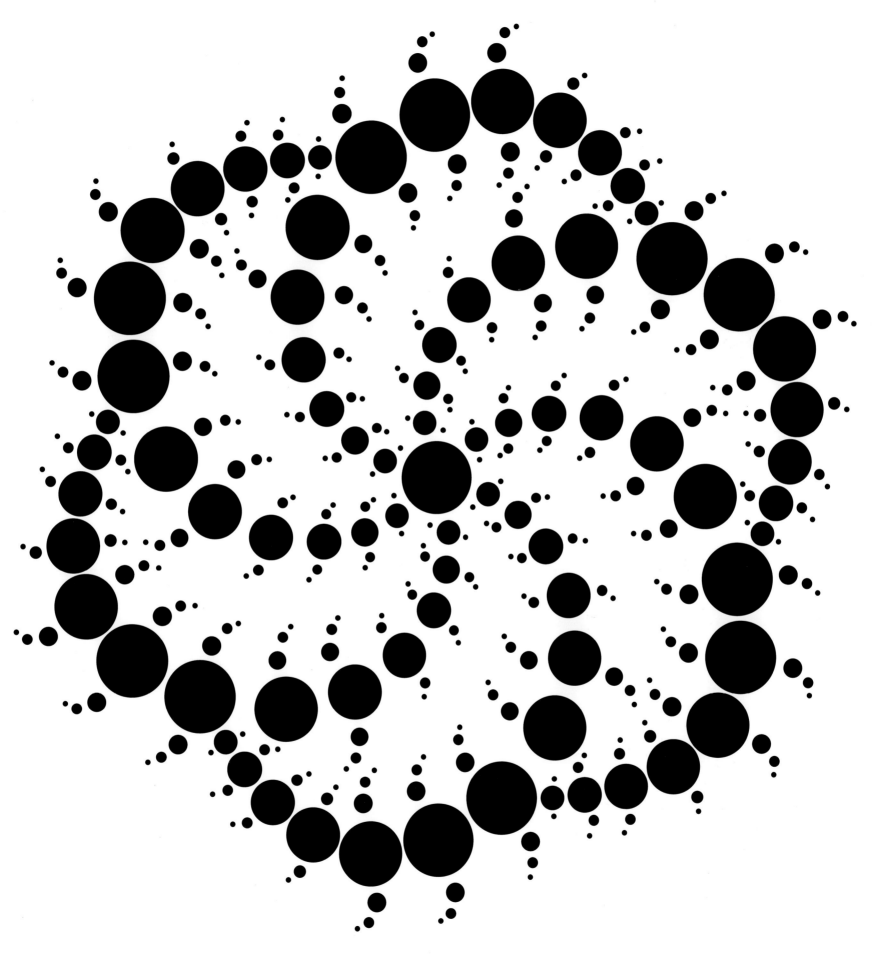

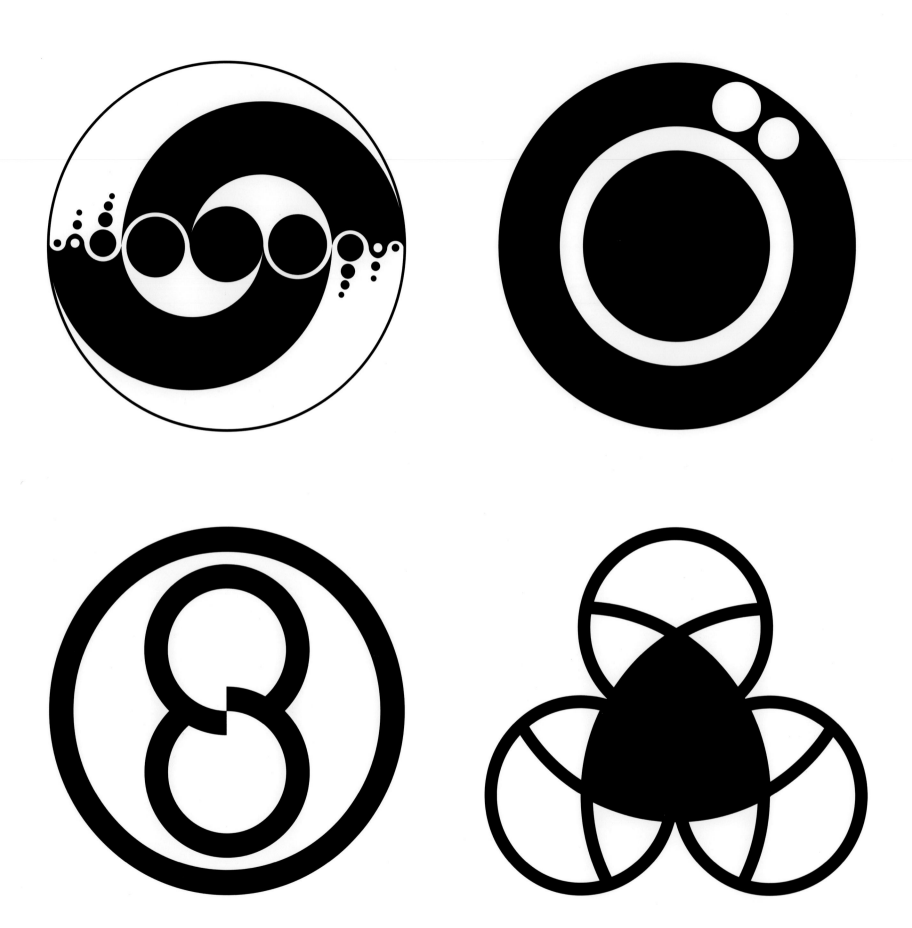

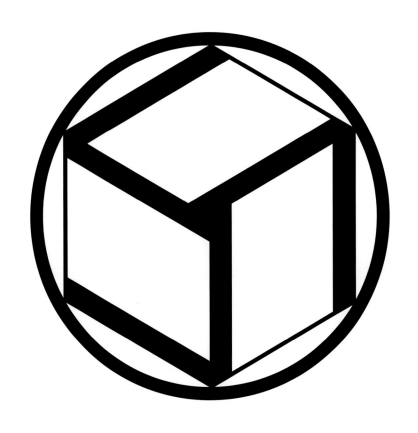
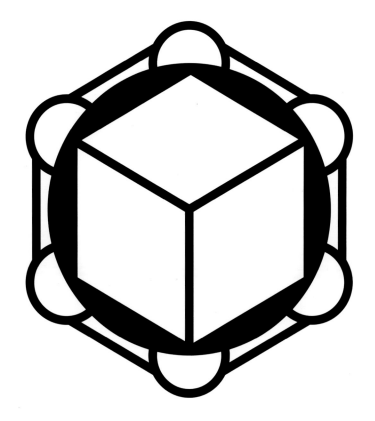
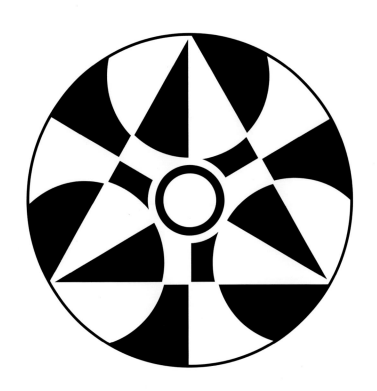
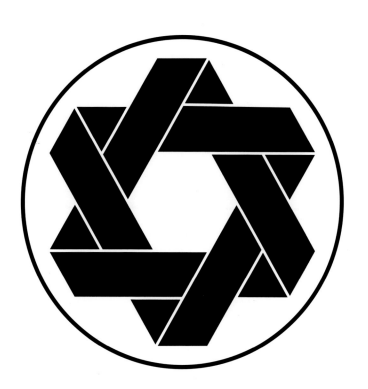

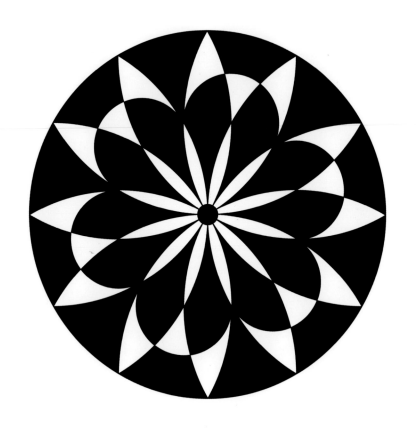
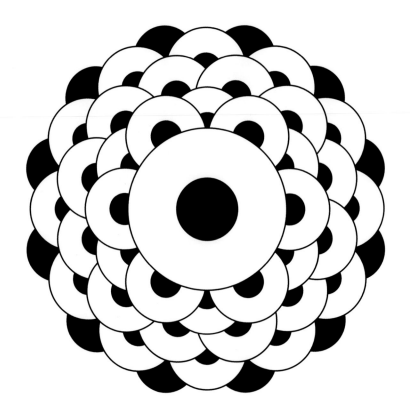
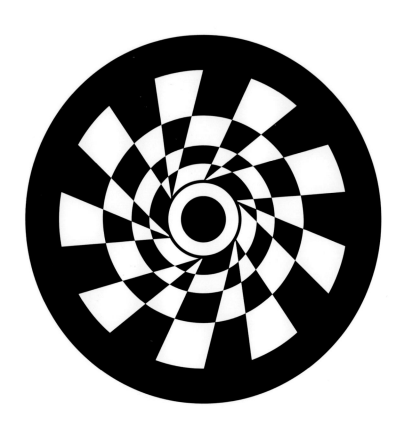

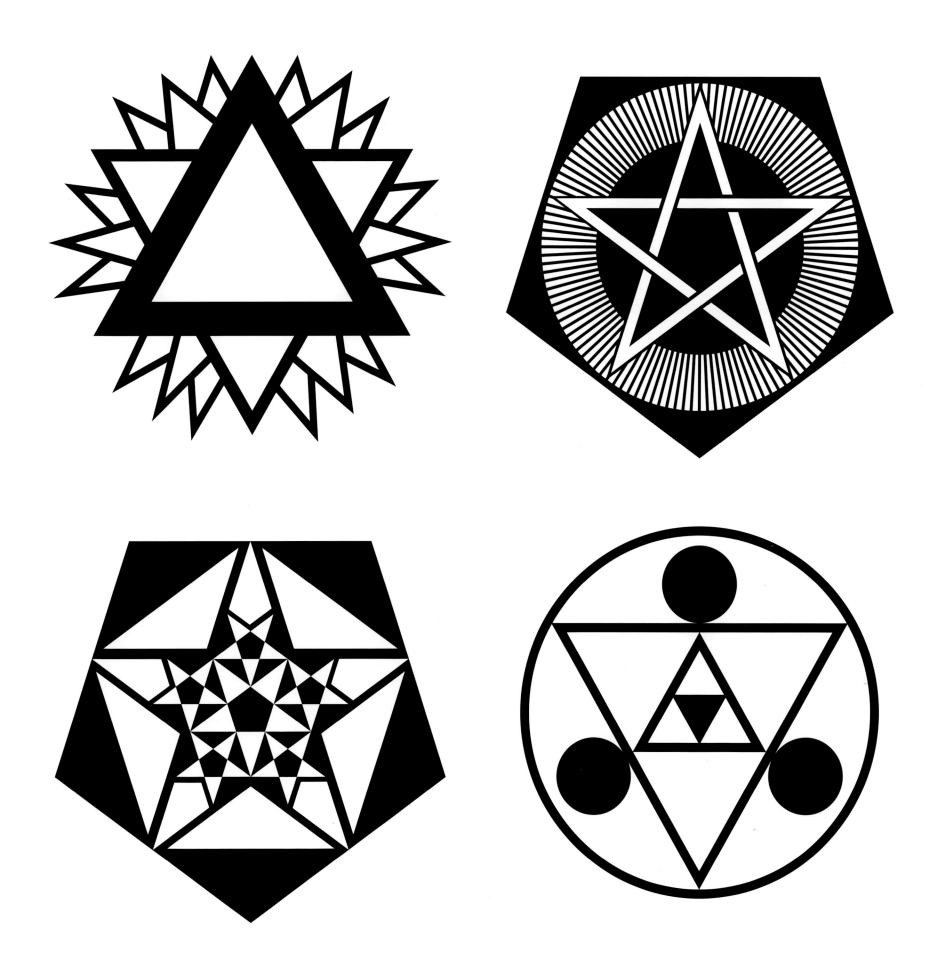

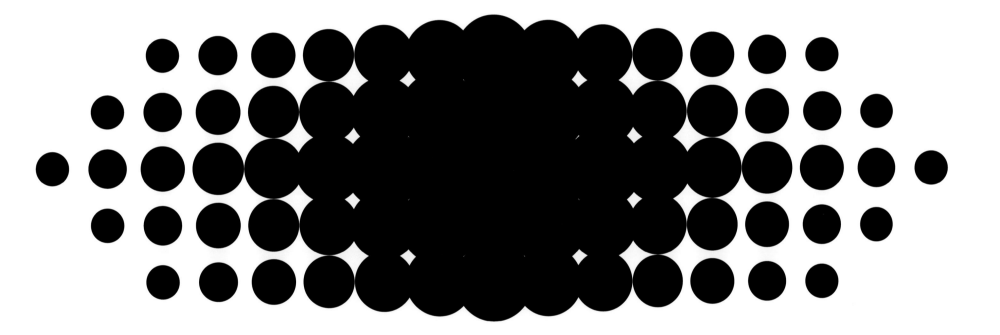

# COMPUTER SOFTWARE AS A TOOL FOR ART

L'INFORMATIQUE, UN OUTIL AU SERVICE DE L'ART
**COMPUTERSOFTWARE ALS WERKZEUG FÜR DIE KUNST**
EL SOFTWARE COMO HERRAMIENTA DE CREACIÓN ARTÍSTICA
**IL SOFTWARE COME STRUMENTO D'ARTE**
O SOFTWARE COMO FERRAMENTA ARTÍSTICA
芸術手段としてのコンピュータソフト
電腦軟體: 藝術的工具

## Computer software as a tool for art

Modern software, such as graphic design programs, offer new ways of generating patterns. The development of decoration and pattern evolves with time, and the end results are often an imprint of the process, similar to a photograph taken at a specific moment during an ongoing movement.

If one were to create the kind of patterns found in this chapter in conventional ways (drawing or painting), the process would involve first conceiving the basic form and then repeating it to get an impression of its effect.

Using graphic programs allows for a different approach, as the design process becomes much more direct. The method is comparable to modeling a piece of clay: while working on the pattern, the direct implications are immediately visible and this facilitates the decision on when the development process is finished.

## Computersoftware als Werkzeug für die Kunst

Moderne Software, wie Programme für grafisches Design, bietet neue Möglichkeiten zur Gestaltung von Mustern. Die Entwicklung von Ornamentierungen und Mustern bildet sich mit der Zeit heraus, und als Endergebnis erhält man häufig einen Abdruck des Vorgangs, der einer fotografischen Aufnahme in einem spezifischen Augenblick einer stattfindenden Bewegung ähnelt.

Würde man den Typ von Mustern in diesem Kapitel nach konventionellen Methoden gestalten wollen, müsste man zuerst die Grundform konzipieren und diese dann wiederholen, um den Eindruck ihrer Wirkung zu erhalten.

Die Verwendung grafischer Programme ermöglicht einen andersartigen Ansatz, denn der Gestaltungsprozess läuft entschieden direkter ab. Die Vorgehensweise kann mit dem Modellieren eines Tonklumpens verglichen werden: schon während man das Muster herausbildet, sind die Wirkungen direkt sichtbar, und dadurch vereinfacht sich die Entscheidung darüber, wann der Entwicklungsprozess abgeschlossen ist.

## L'informatique, un outil au service de l'art

Les logiciels modernes, tels les programmes de conception graphique, ouvrent de nouvelles possibilités pour la réalisation de motifs. En effet, les styles de décoration et de motifs évoluent avec le temps de sorte que les résultats finals sont souvent l'empreinte laissée par un procédé, semblable à la photographie qu'on prendrait d'un moment spécifique d'un mouvement en cours.

Pour créer les types de motifs présentés dans ce chapitre avec des moyens conventionnels (dessin ou peinture), la méthode consisterait à concevoir d'abord la forme de base puis à la reproduire pour obtenir l'impression de l'effet voulu.

Les programmes graphiques permettent une approche différente car la méthode de conception est beaucoup plus directe – comparable au modelage d'un morceau d'argile : les conséquences directes sont visibles immédiatement lors du travail sur le motif et la décision s'en trouve facilitée lorsque le développement est achevé.

## El software como herramienta de creación artística

Hoy en día existen programas informáticos, como los de diseño gráfico, que abren nuevas vías de creación. El desarrollo del diseño y la decoración evoluciona con el tiempo y, en muchos casos, el resultado final es una imagen de ese proceso, como una instantánea de un momento específico durante un movimiento.

Si se quisiera crear el tipo de diseños que aparecen en este capítulo usando métodos convencionales (dibujo o pintura), en primer lugar sería necesario crear la forma básica y, a continuación, repetirla hasta poder obtener la impresión del efecto.

El uso de software gráfico proporciona aquí un nuevo enfoque, ya que el proceso de diseño es mucho más directo. El método es comparable al modelado de un trozo de arcilla: al tiempo que se trabaja la forma se va visualizando directamente lo que implica, lo cual permite determinar más fácilmente cuándo acaba el proceso de creación.

## Il software come strumento d'arte

Il software più moderno, come ad esempio i programmi per il disegno grafico, offre nuove modalità di creazione dei modelli. Lo sviluppo di decorazione e modelli evolve con il tempo e i risultati finali sono spesso un'impronta del processo, simile ad una fotografia presa in un momento specifico durante un movimento.

Se si dovessero creare i modelli presentati in questo capitolo usando le modalità convenzionali (disegno o pittura), il processo richiederebbe prima la creazione della forma di base  e quindi la sua ripetizione fino ad ottenere l'effetto richiesto.

L'utilizzo di programmi di grafica ci consente un approccio diverso, poiché il processo di design diventa molto più diretto. Il metodo è paragonabile alla modellazione di un pezzo di argilla: mentre si lavora sul modello, sono immediatamente visibili le conseguenze delle nostre azioni. Ciò facilita la decisione rispetto a quando considerare terminato il processo di sviluppo.

## 芸術手段としてのコンピュータソフト

グラフィックデザイン・プログラムのような最新ソフトを利用すれば、新たな方法によるパターン製作が可能です。通常、装飾やパターンの作成には時間がかかりますが、最終的にできる図形は、連続する運動のある瞬間を捉えた写真に似た、プロセスの軌跡となる場合がよくあります。

（図や絵を描く際に）この章に掲載されている様なパターンを簡単な方法で作成するには、まず基本となるフォルムを考え、それを一定の視覚的効果が得られるまで反復するのです。

グラフィックプログラムを使用すればこのデザインプロセスをより直接的に進められるので、様々なアプローチが可能です。この方法は粘土を使って形を作るのに似ています。あるパターンを作る過程でその直接的結果がすぐに目に見える形となって現れるので、いつ反復プロセスを完了すべきかが容易に決定できるのです。

## O software como ferramenta artística

O software moderno, tal como os programas de design gráfico, proporciona novas formas de gerar padrões gráficos. O desenvolvimento da decoração e dos padrões gráficos evolui com o tempo, sendo os resultados finais uma marca do processo de evolução, semelhante a uma fotografia tirada num momento específico de um movimento.

Se alguém quisesse criar o tipo de padrões gráficos presentes neste capítulo por meios convencionais (desenho ou pintura), o processo envolveria, em primeiro lugar, a concepção da forma básica e, depois, a repetição dessa forma para se obter uma impressão do seu efeito.

O uso de programas gráficos permite uma abordagem diferente, porque o processo de desenho se torna muito mais directo. O método pode ser comparado à modelagem de uma peça de barro: ao trabalhar no padrão gráfico, as implicações directas são imediatamente visíveis e isso facilita a decisão sobre quando o processo de desenvolvimento é finalizado.

## 電腦軟體: 藝術的工具

裝幀設計程式等現代化軟體提供了全新的圖案製作方式。隨著時間的推移，裝飾及圖案的開發得到了發展，其最終結果常常具有與拍攝運動中的某一特定時刻畫面相類似的過程。

以傳統方式（製圖或繪畫）製作本章中的各種圖案時，可能首先需要對基本形狀進行構思，然後透過不斷重複以獲得對其效果之印象。

裝幀程式則採用了一種不同的方法，使得設計過程變得更加直接。該方法就像是用粘土進行造型：在製作圖案的同時，其直接的含義也將立刻一目了然，這將有助於製作者判斷開發過程之結束時間。

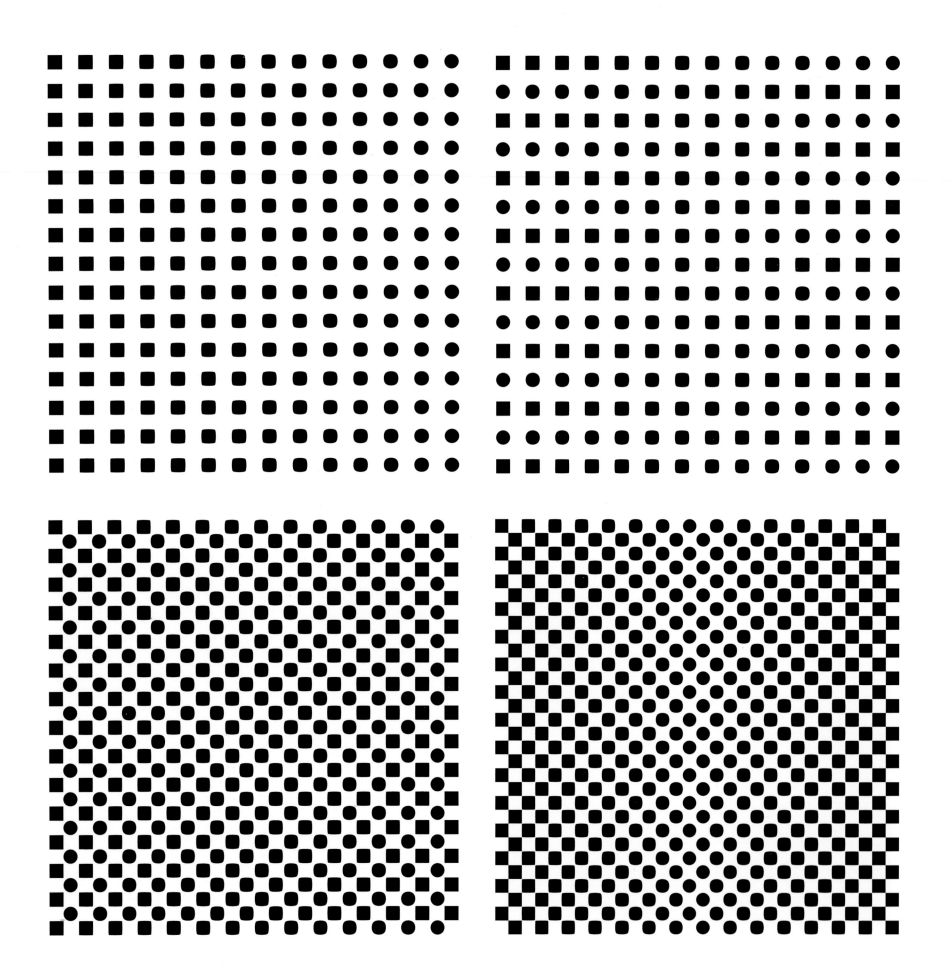

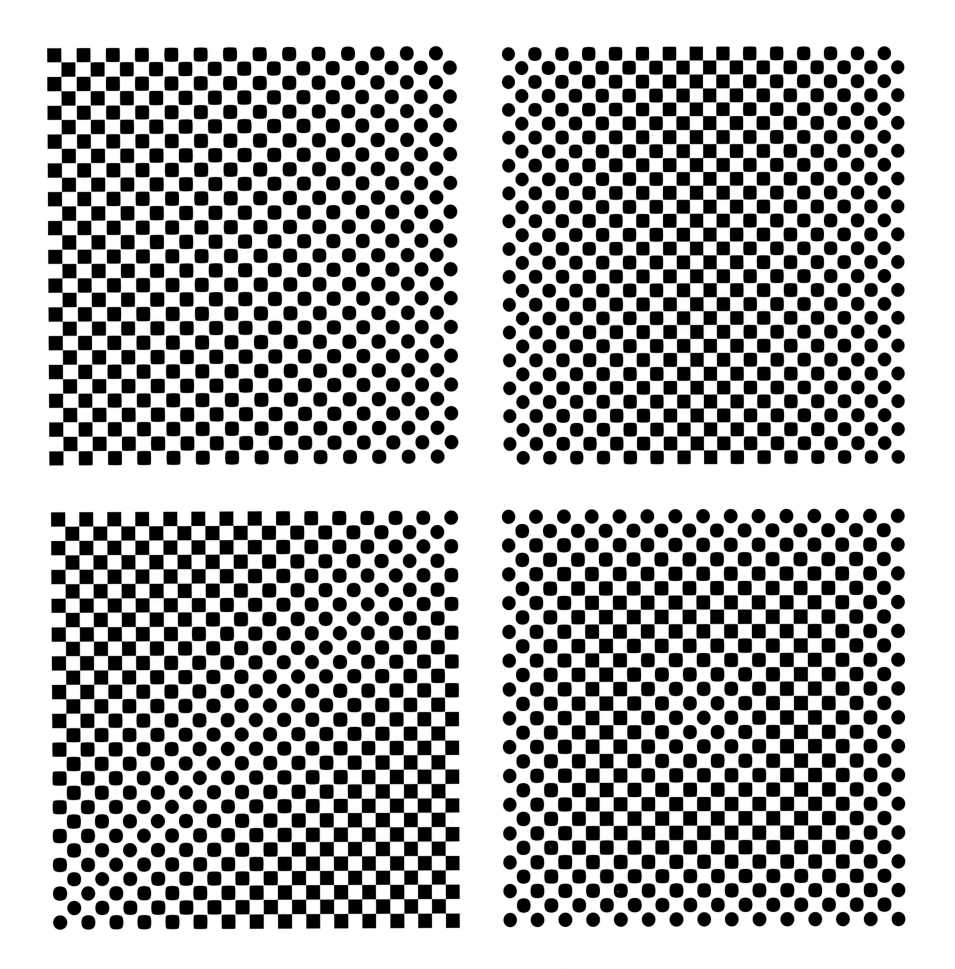

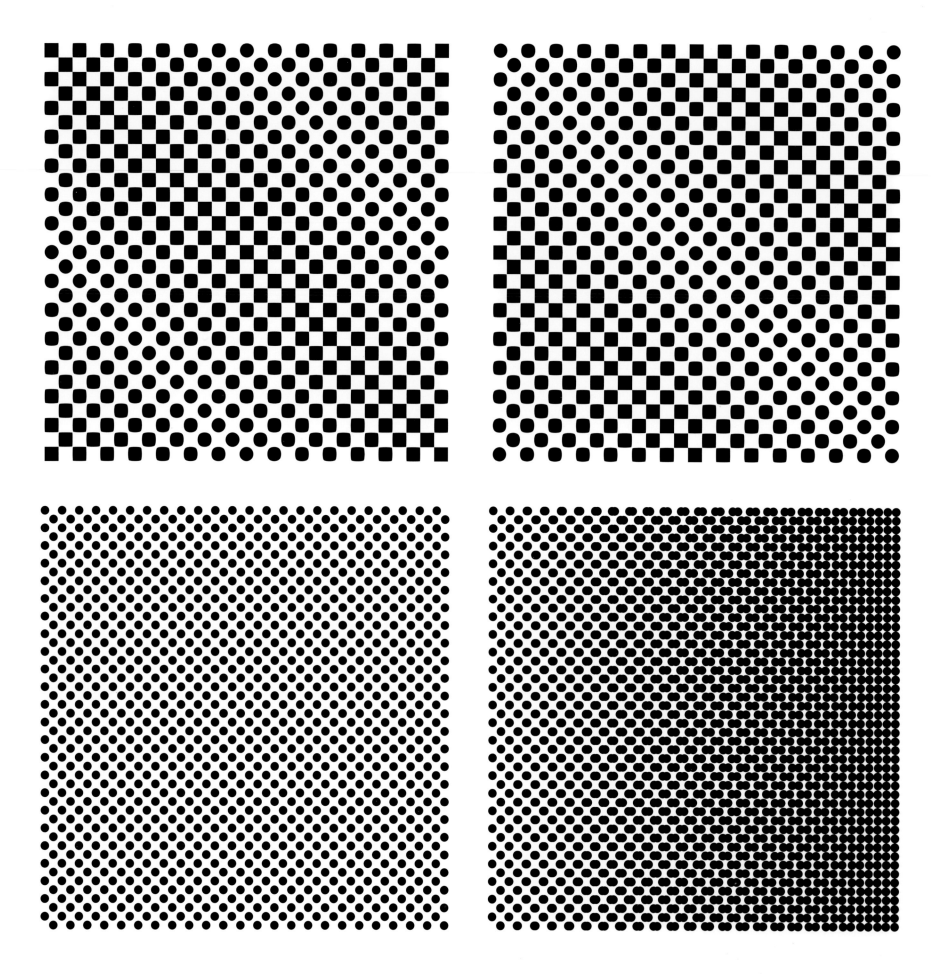

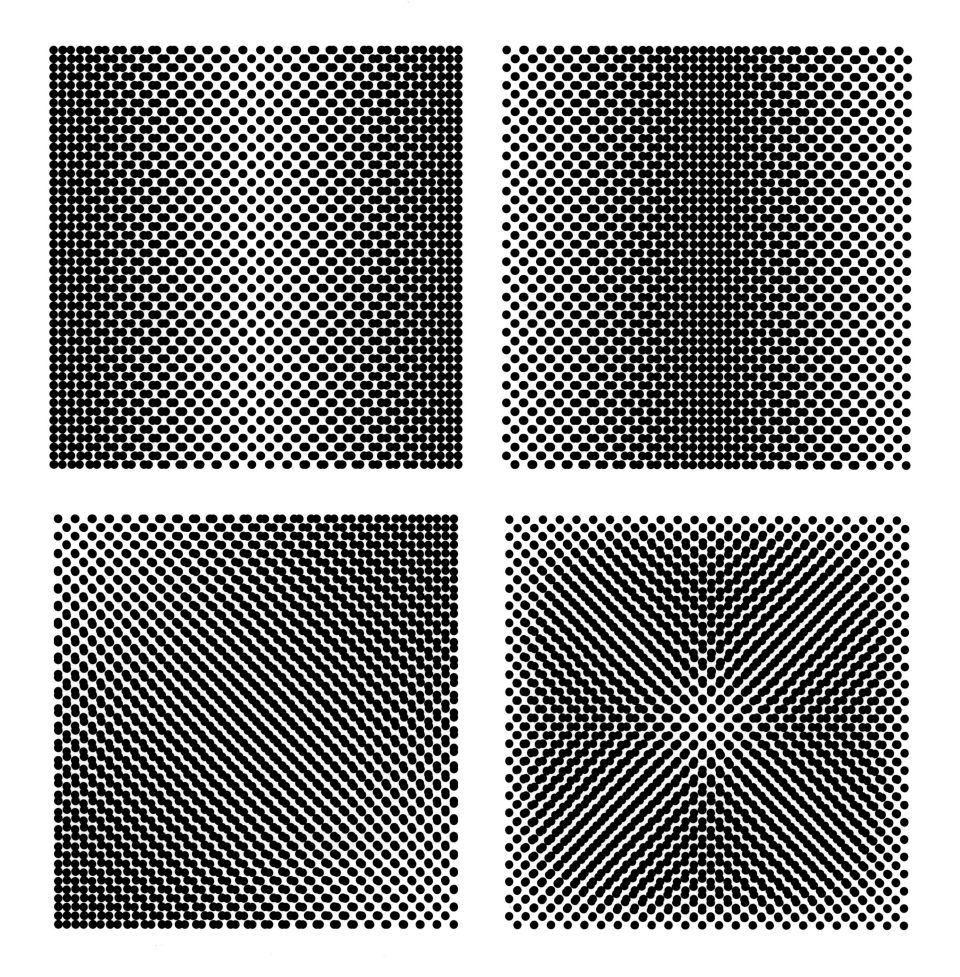

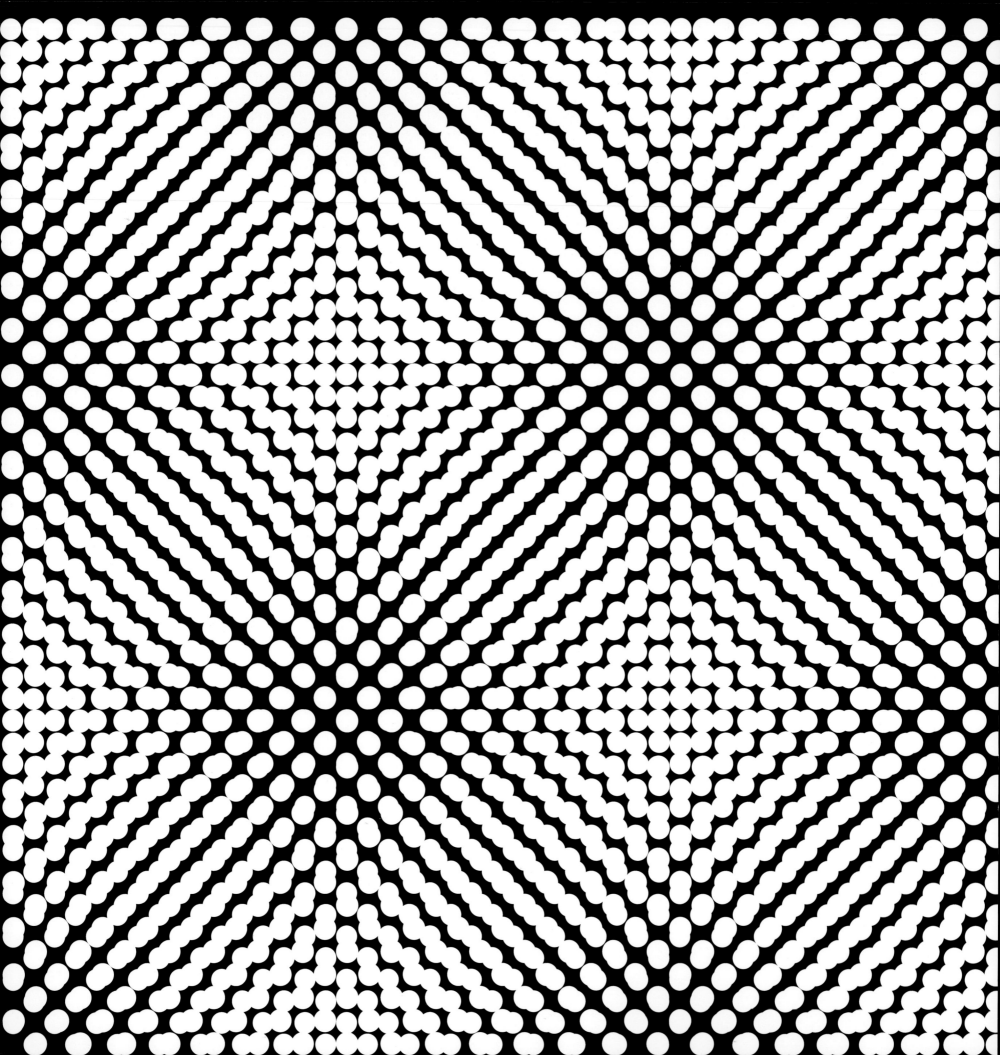

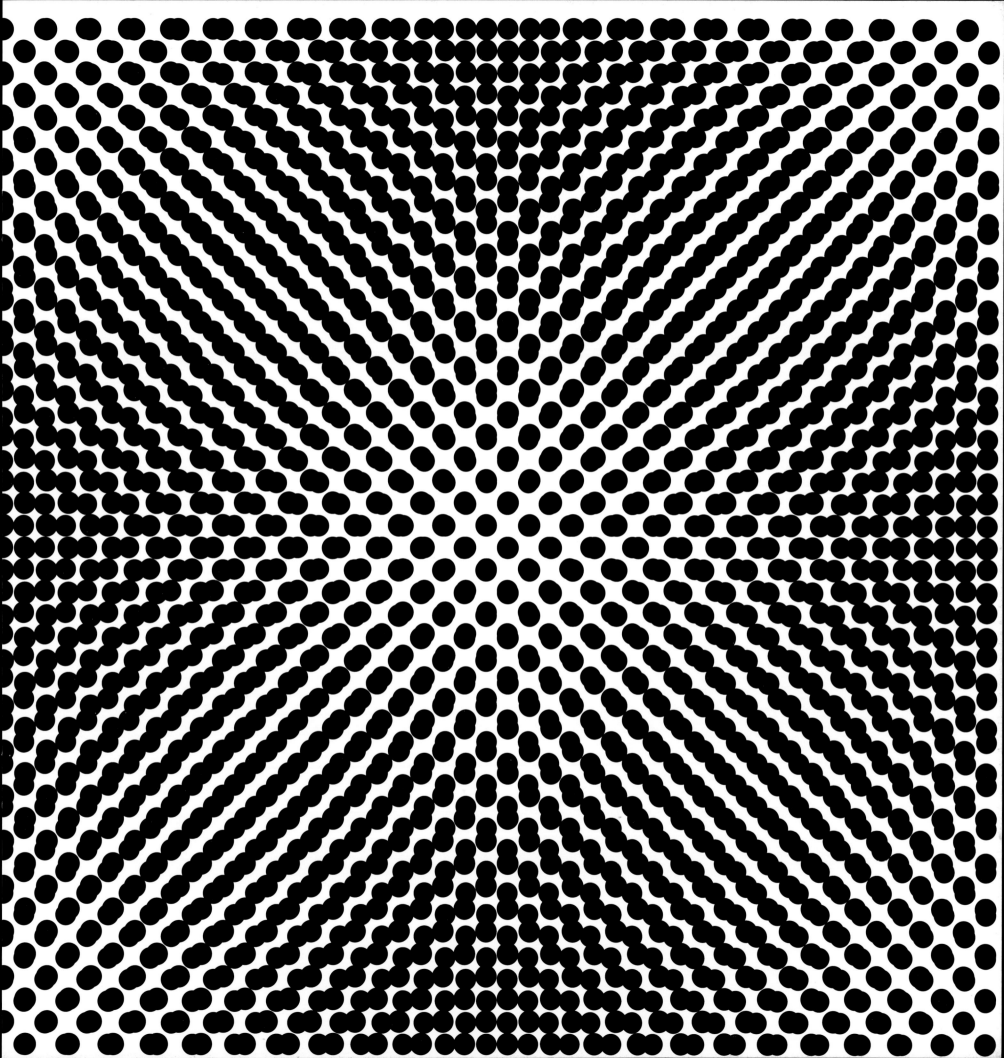

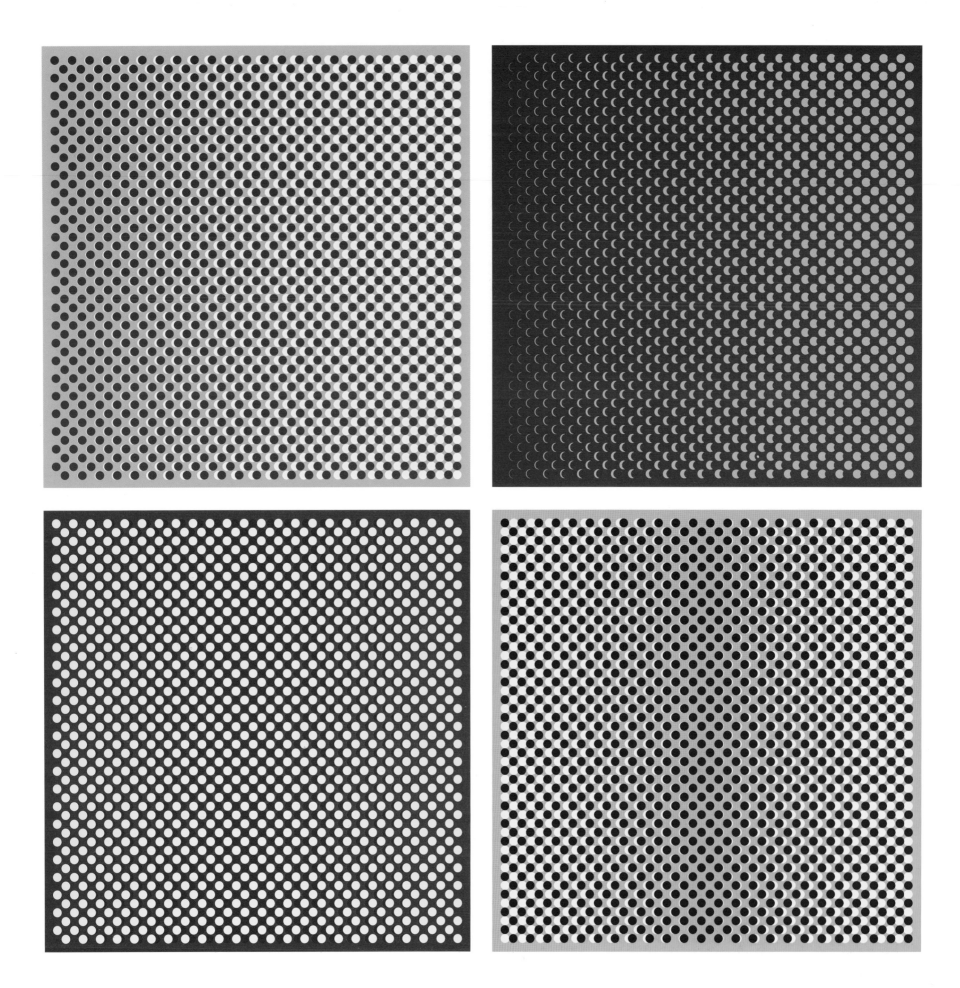

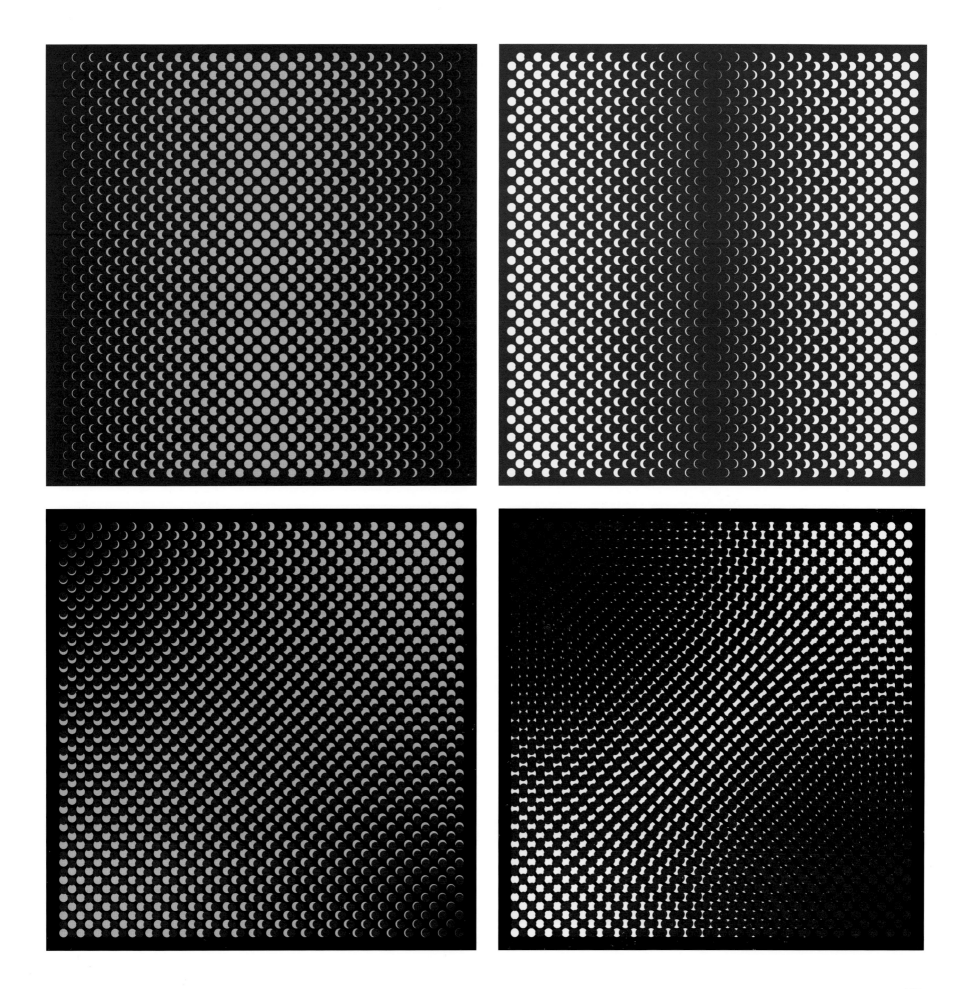

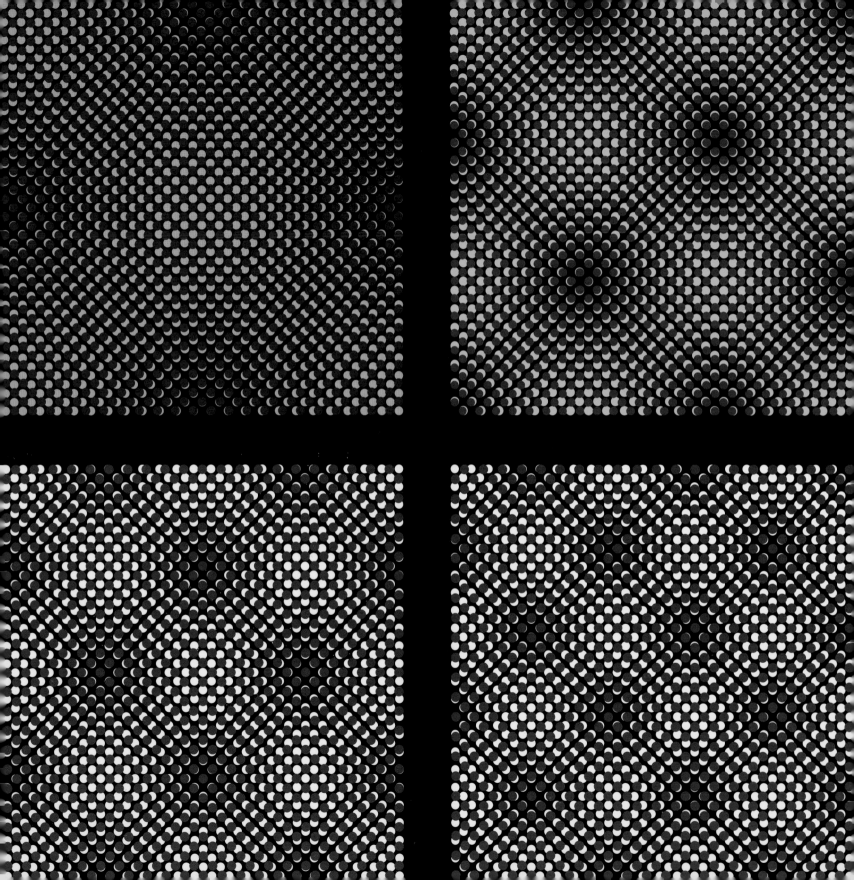

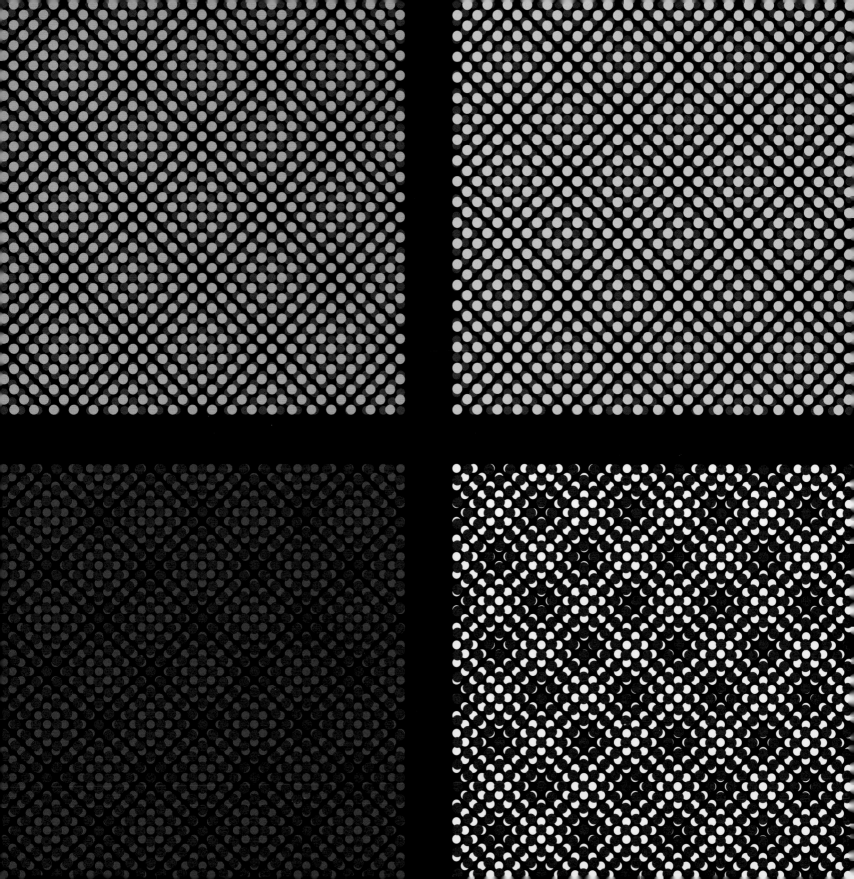

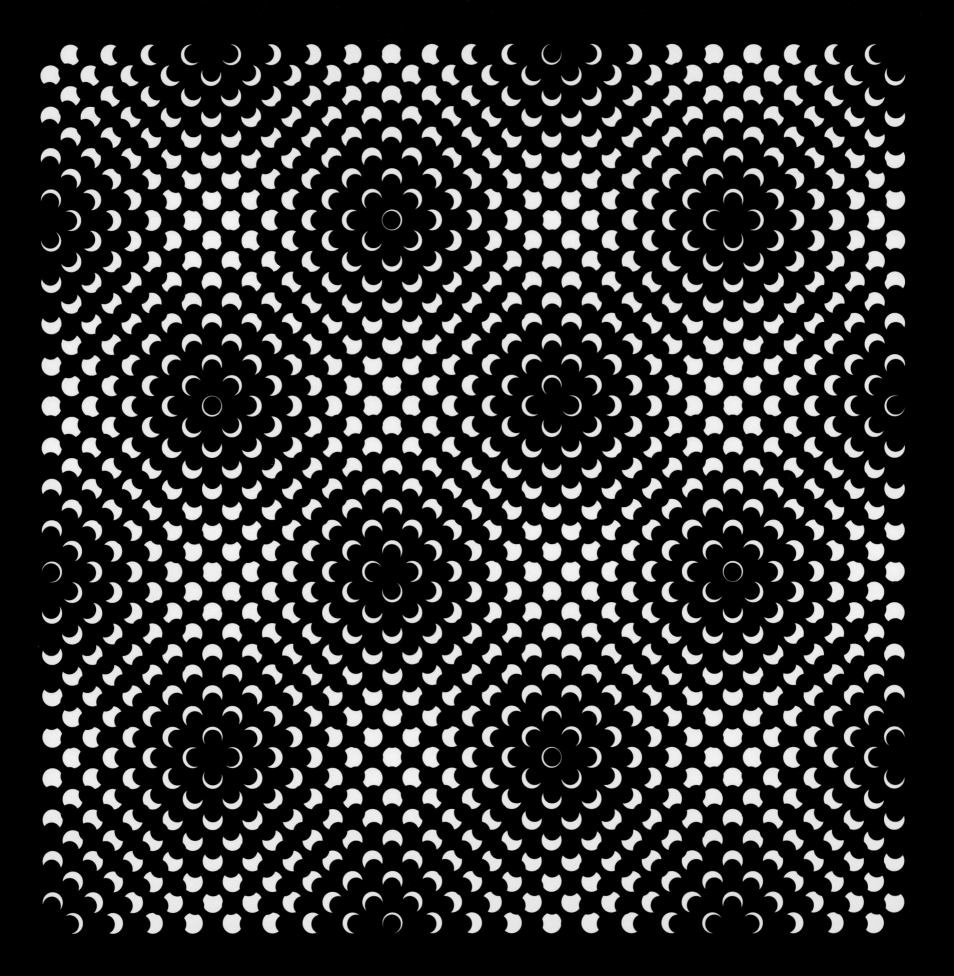

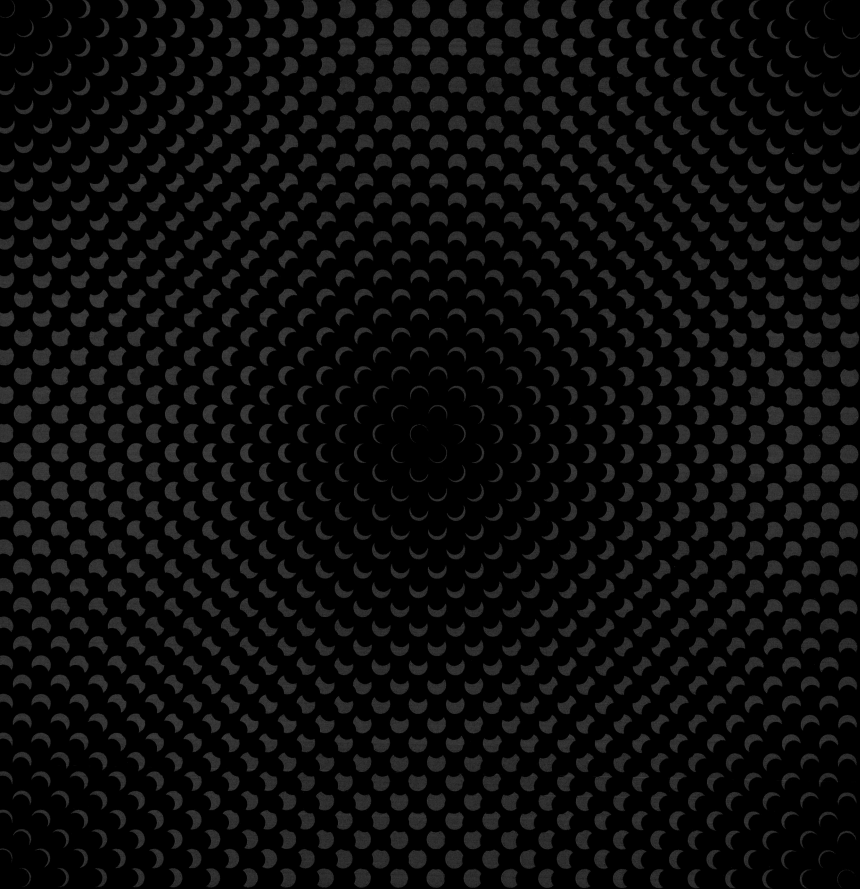

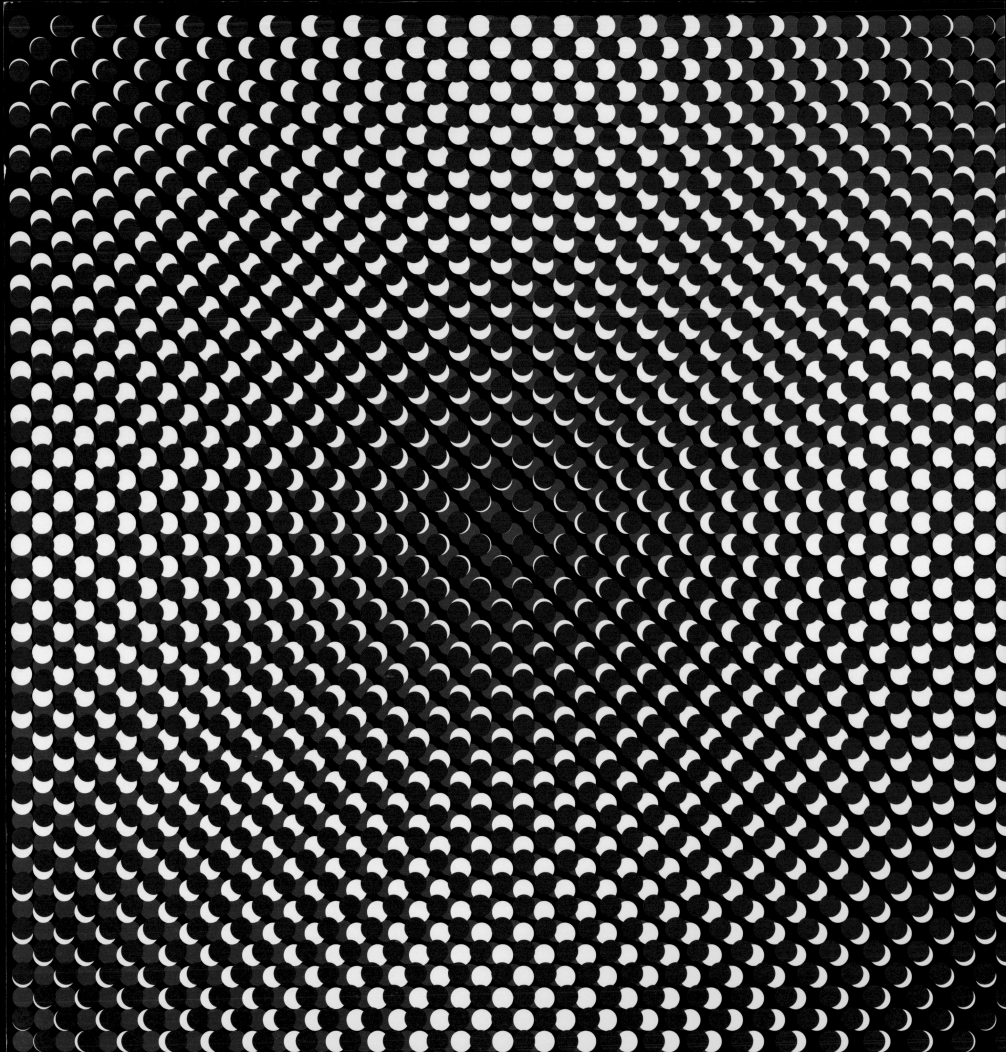

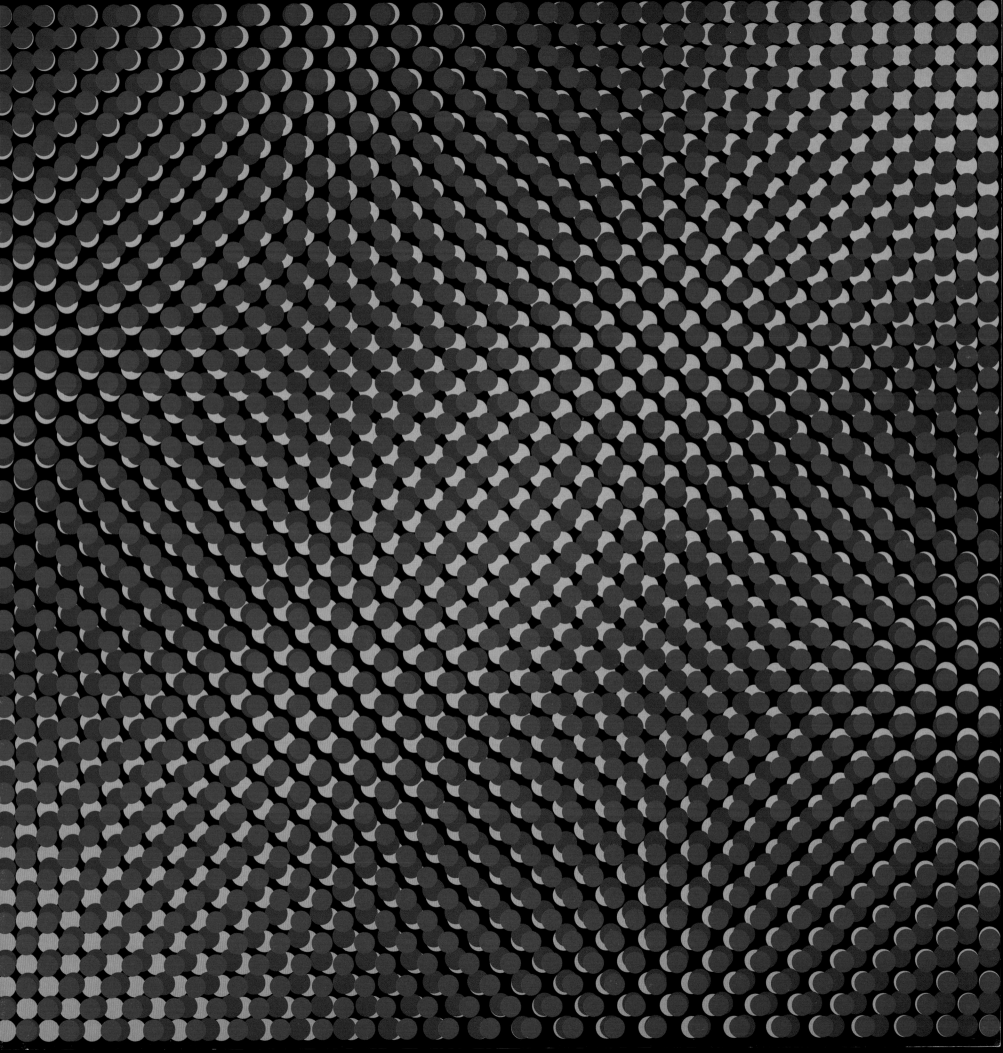

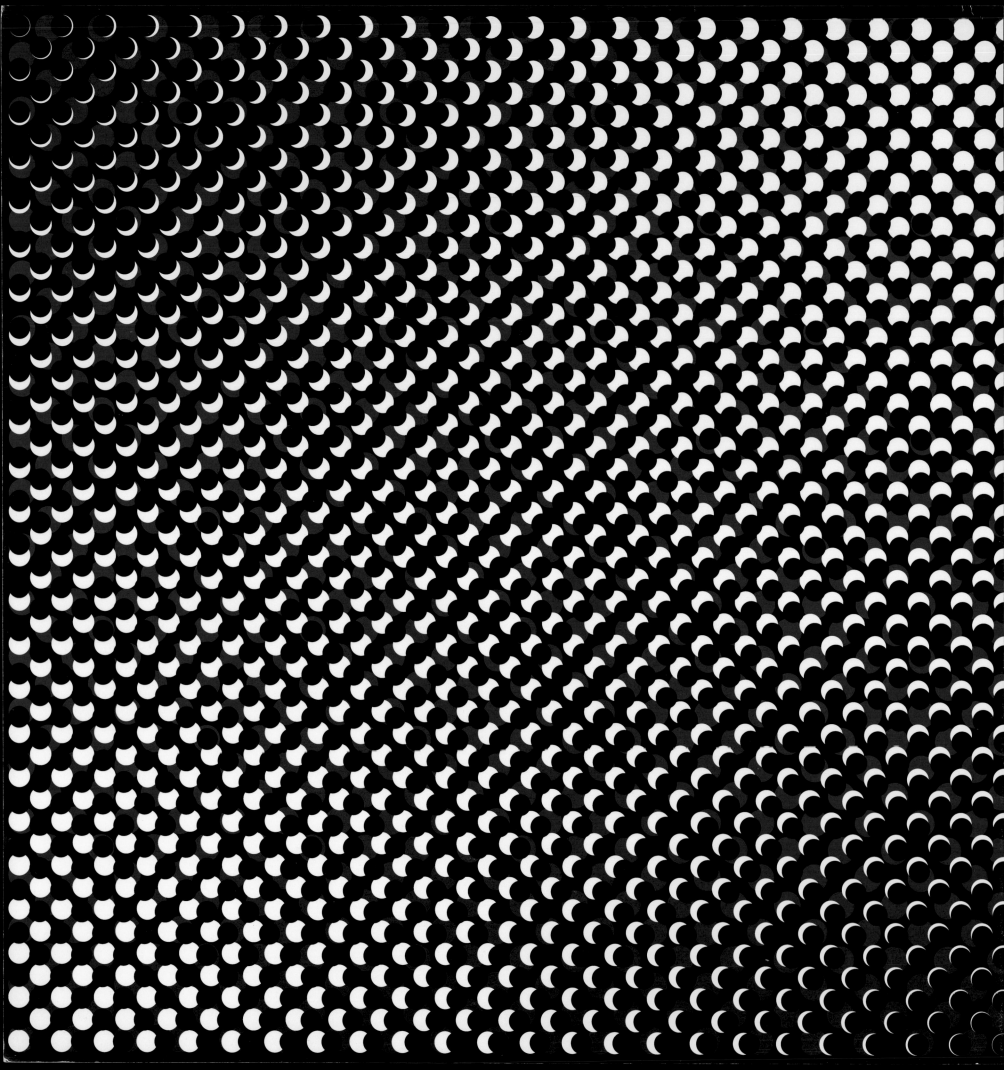

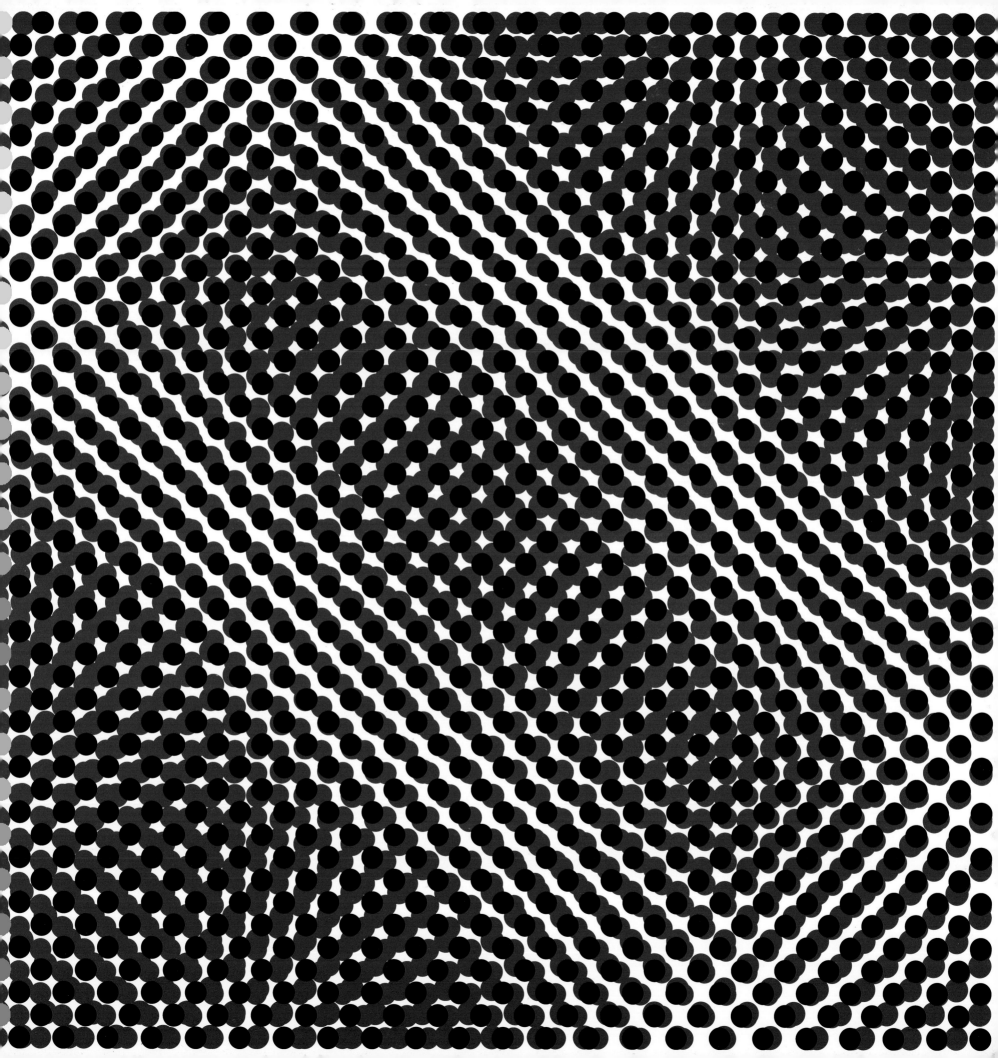

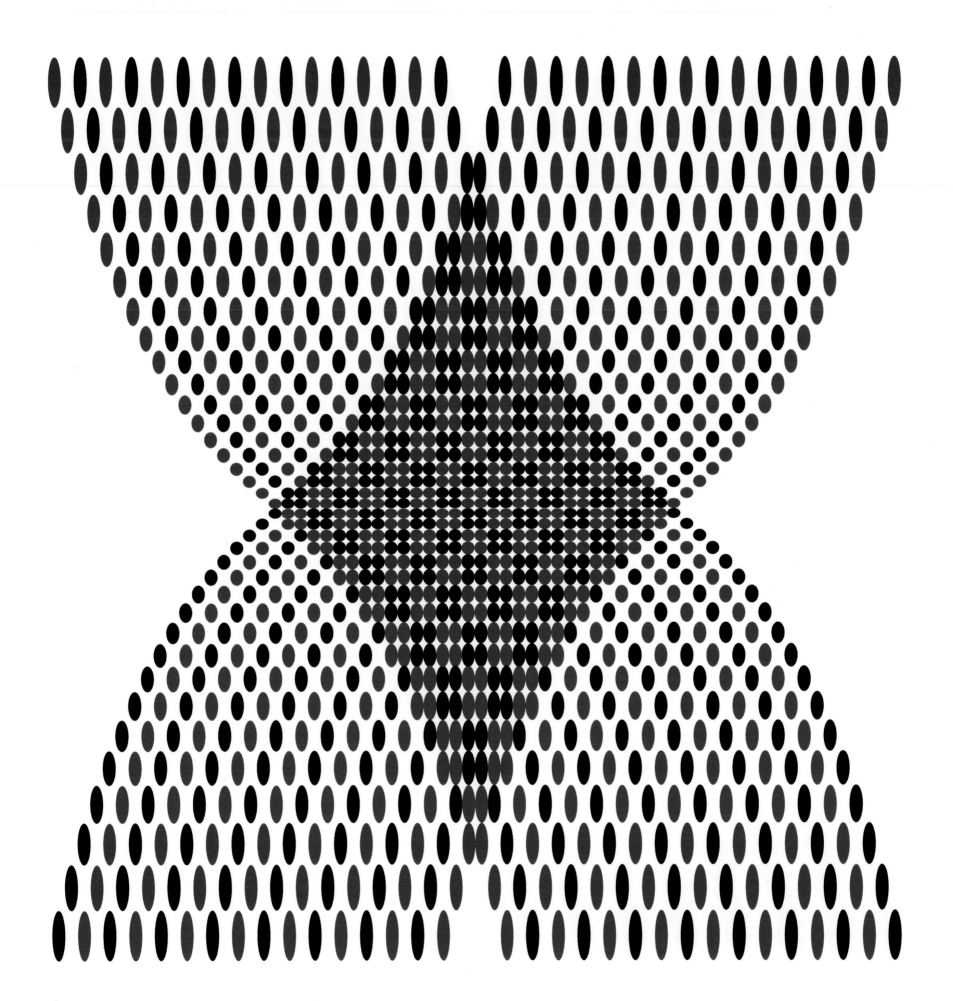

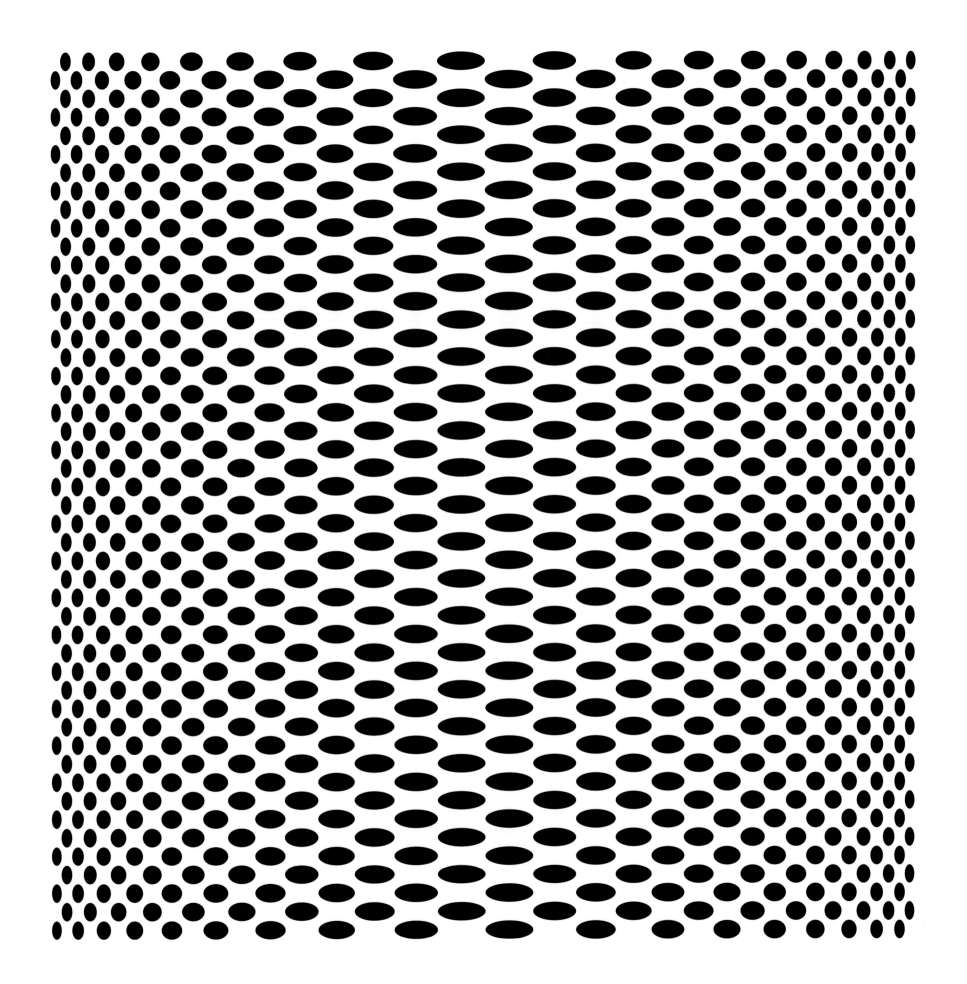

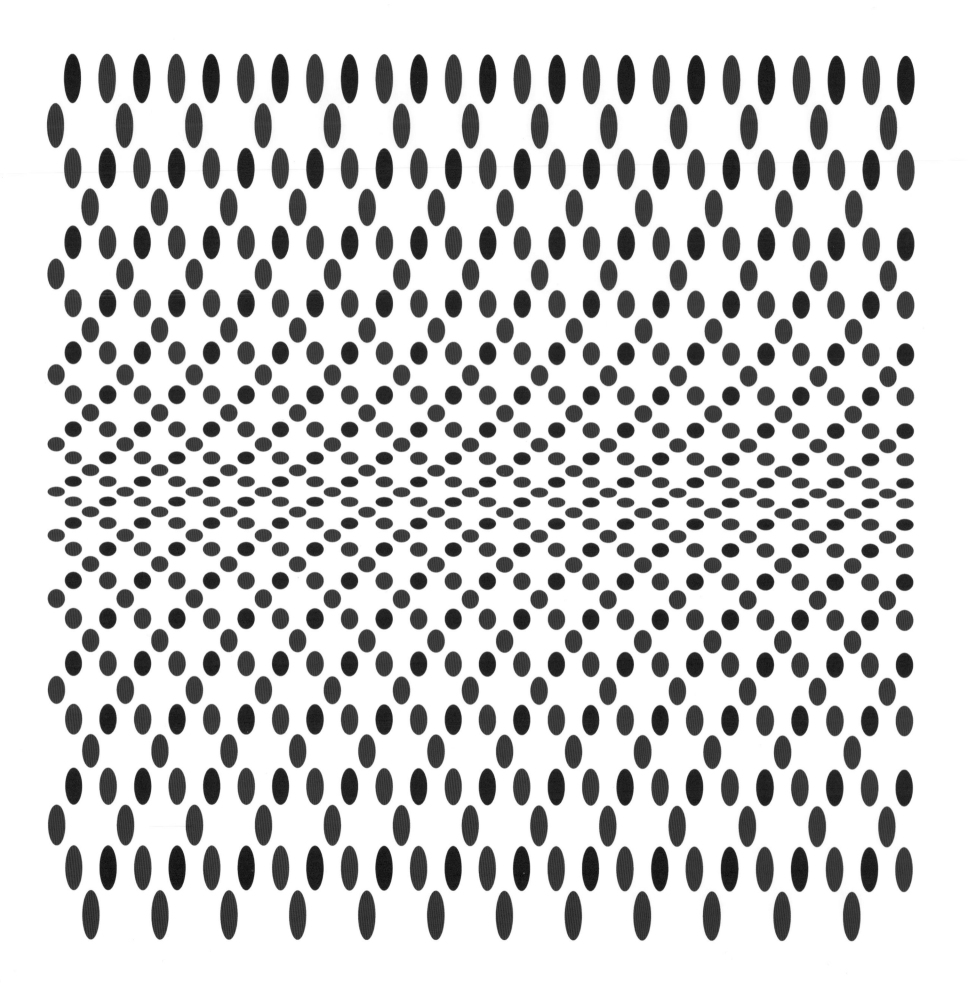

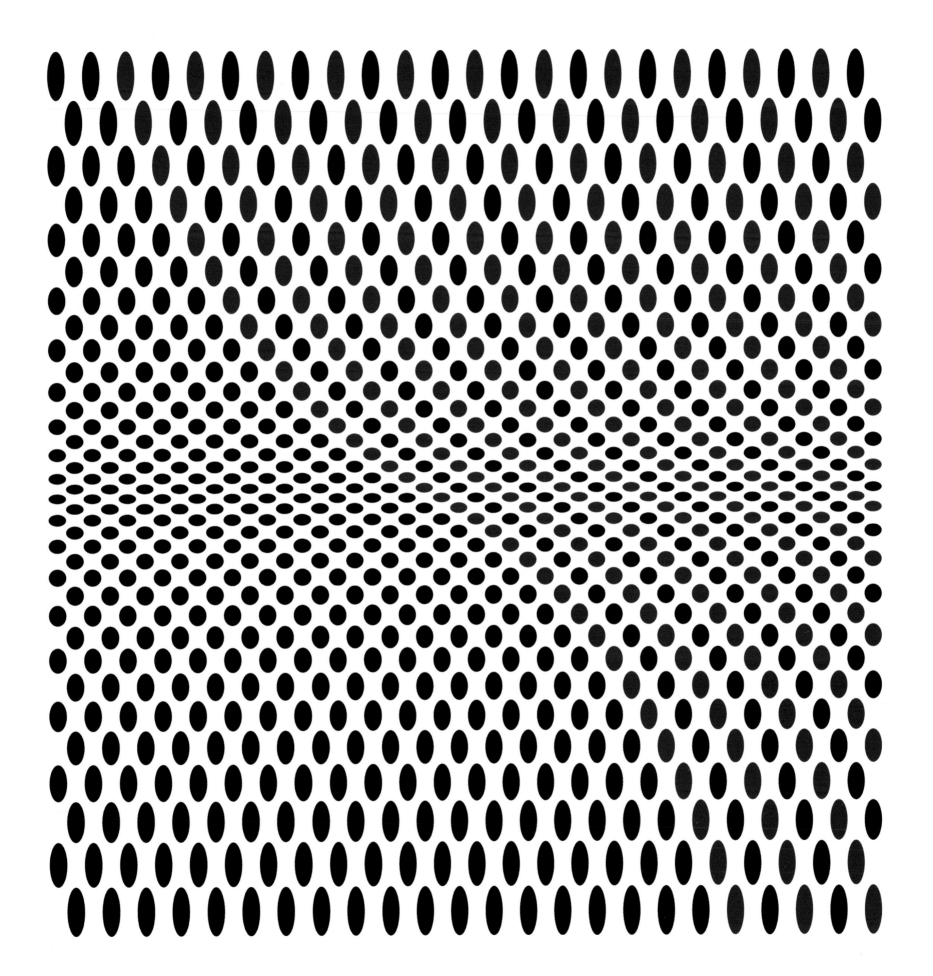

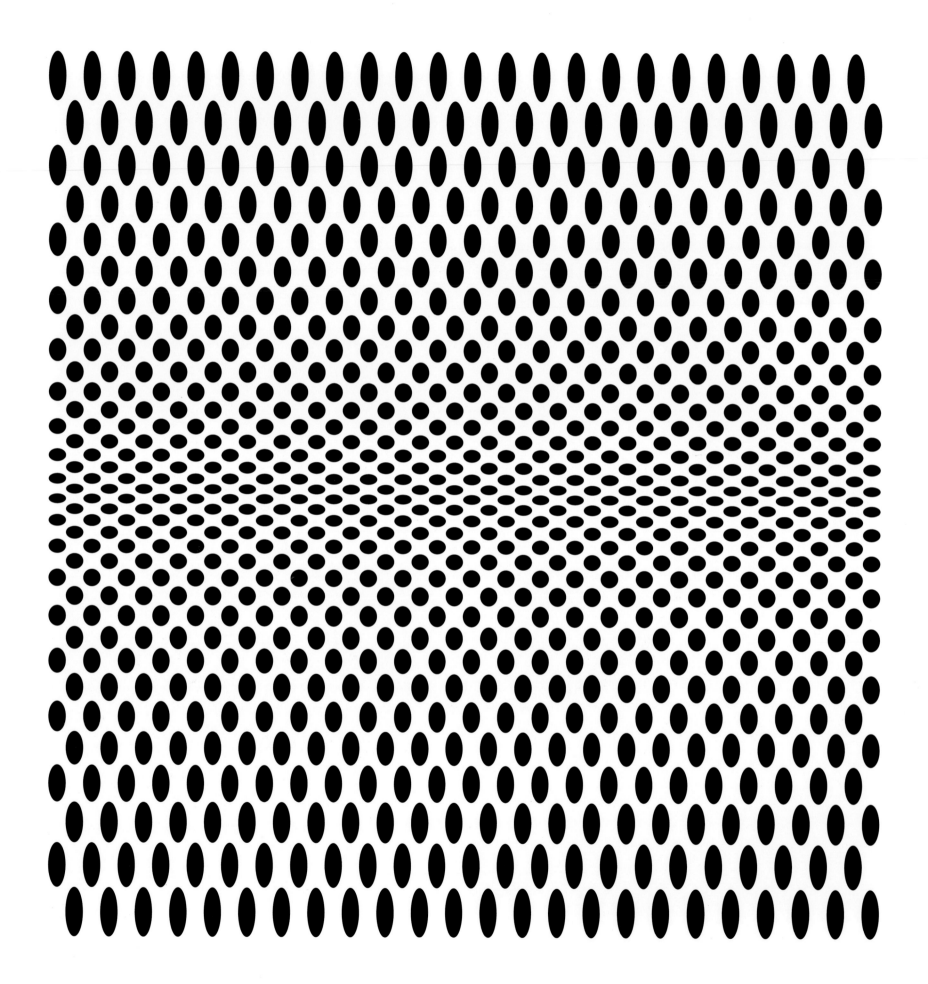

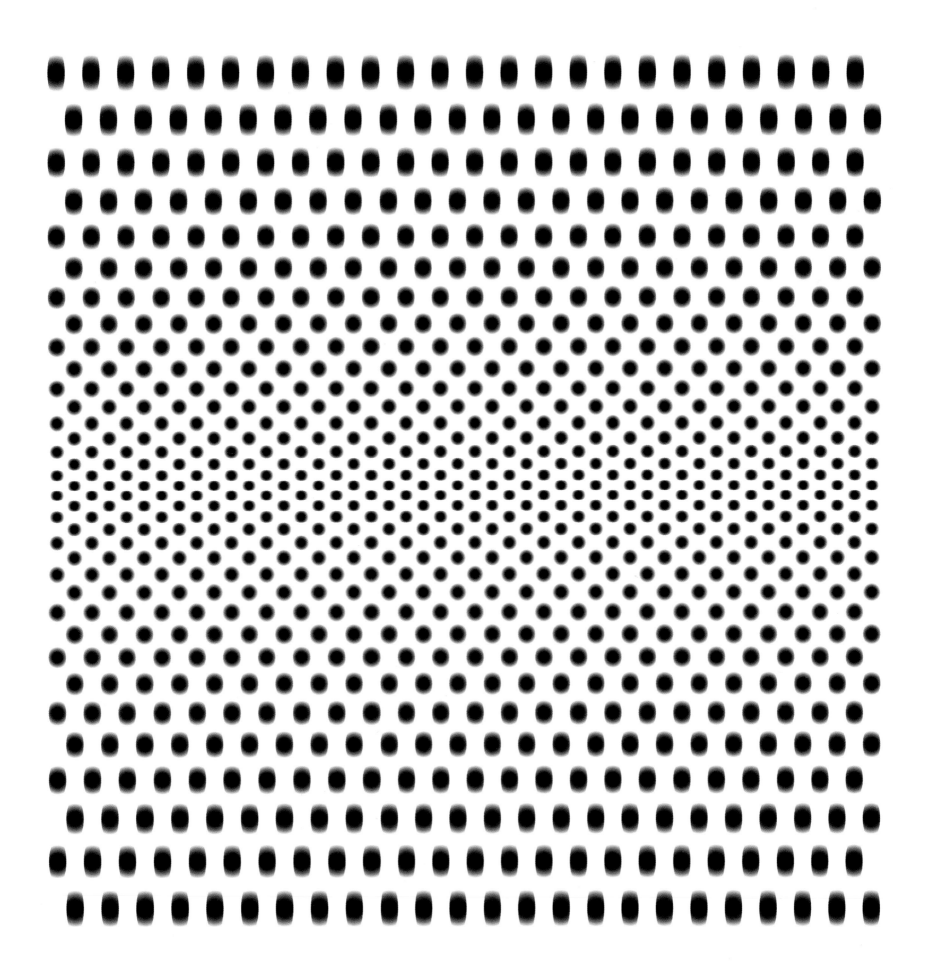

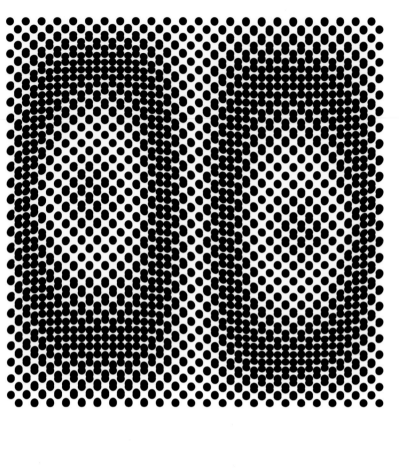
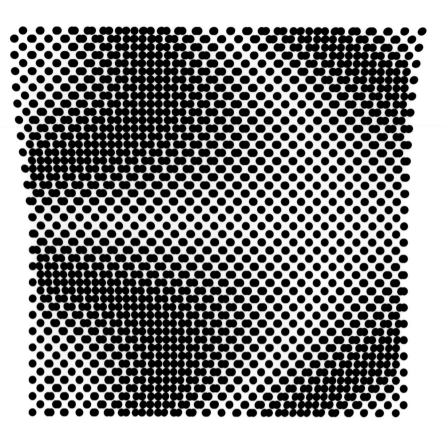
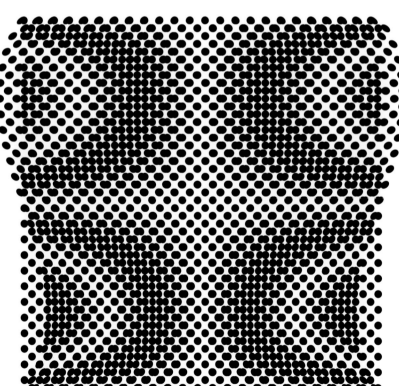
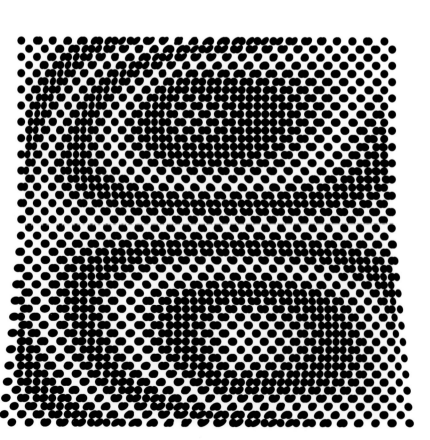

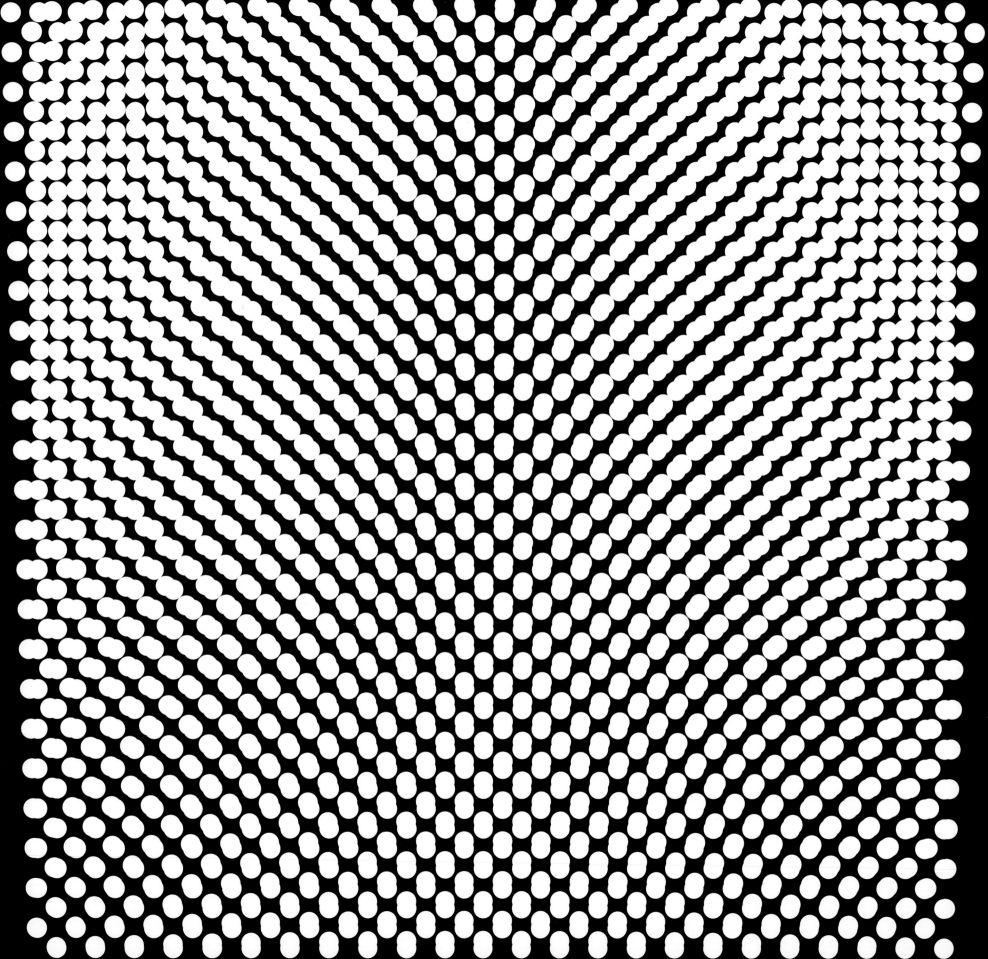

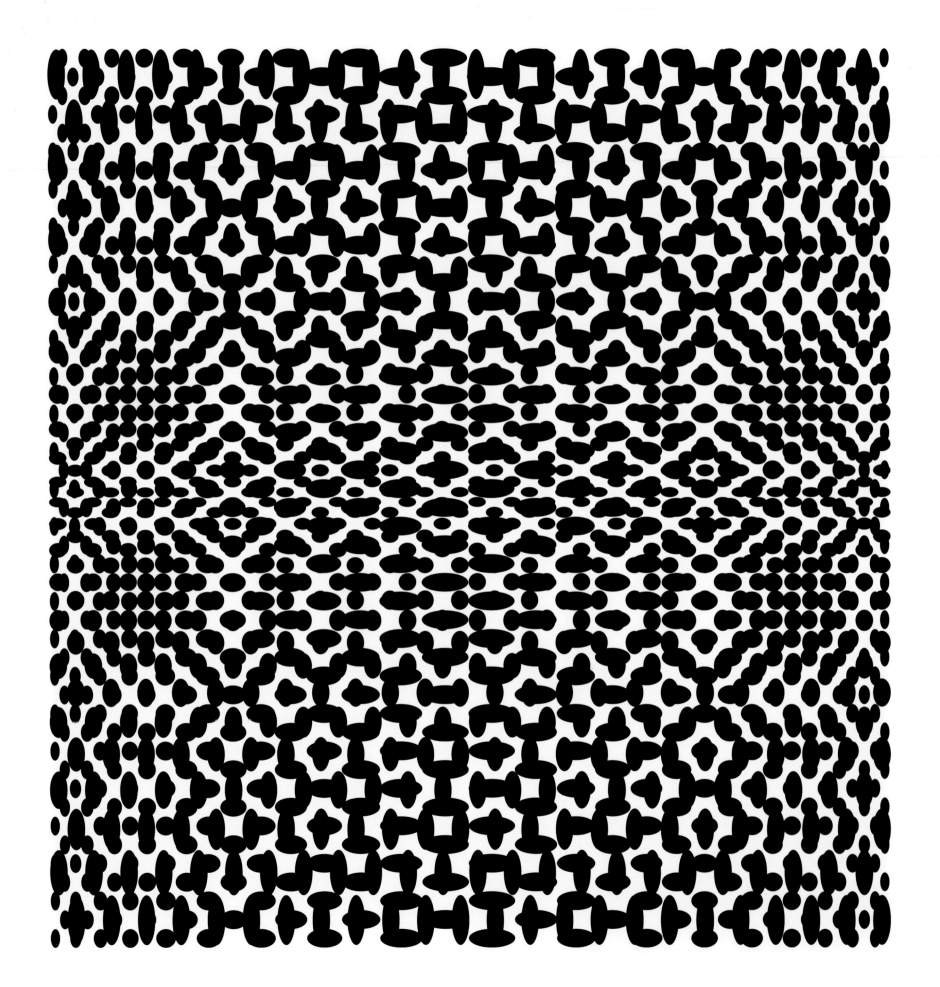

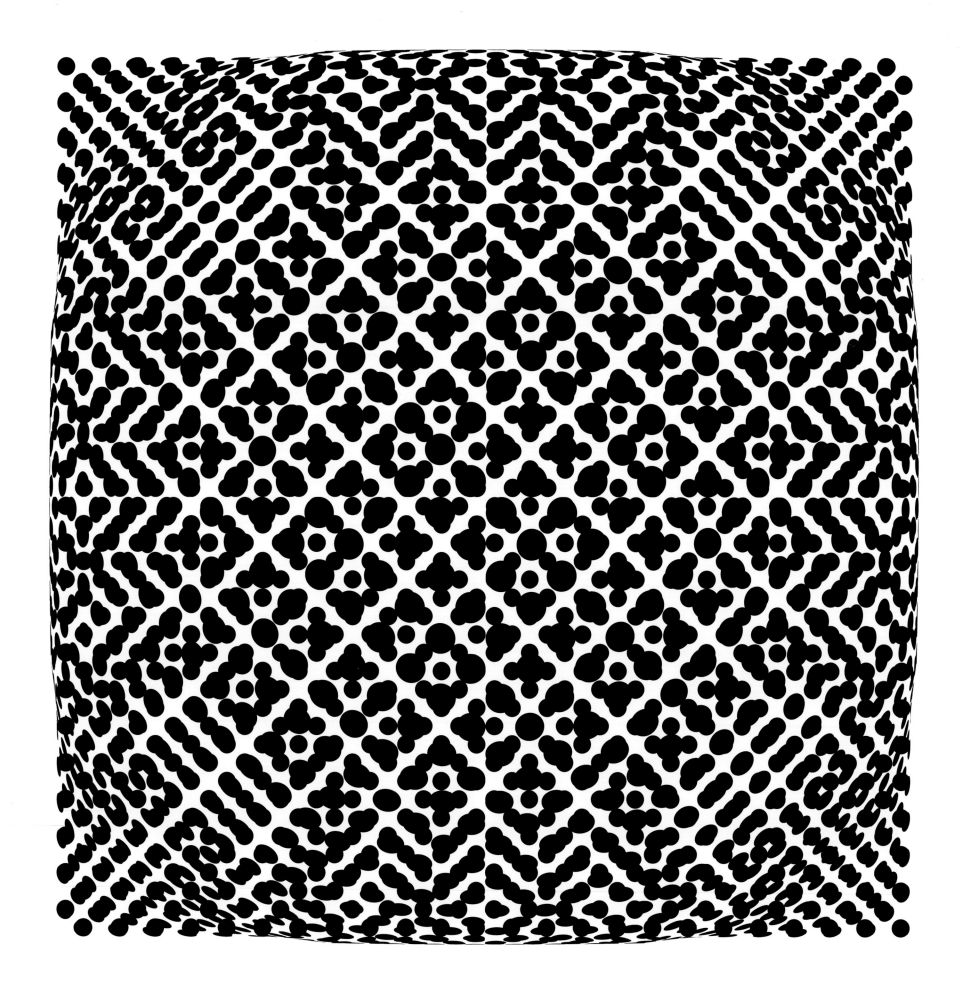

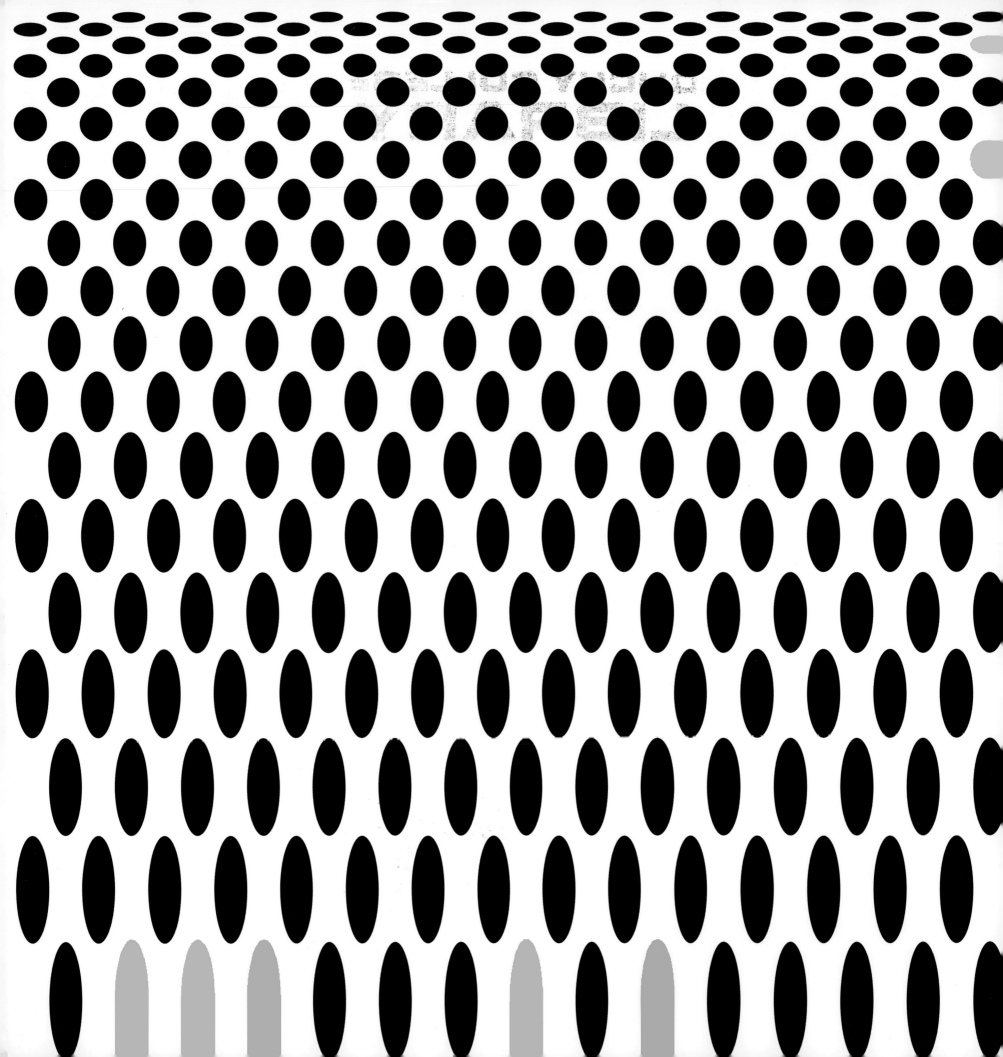

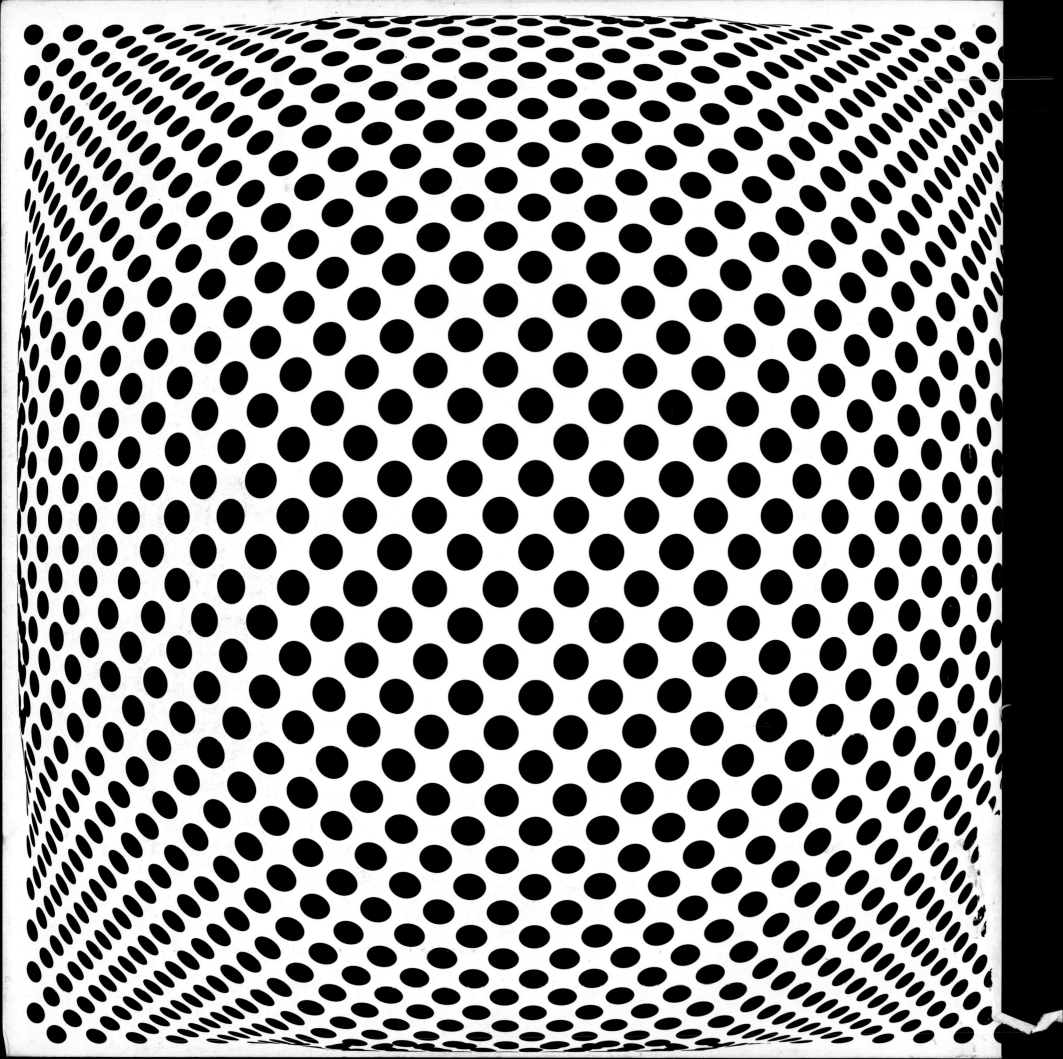